THE SHARK
HANDBOOK
SECOND EDITION

The Essential Guide for Understanding
the Sharks of the World

By Dr. Greg Skomal

CIDER MILL
PRESS

BOOK

Kennebunkport, Maine

page 1: A white shark breaches during an attack on a seal off South Africa.
pages 2–3: A blue shark cruises the offshore waters of New England.

The Shark Handbook

Copyright © 2008 and 2016 by Greg Skomal

13-Digit ISBN: 978-1-60433-634-4
10-Digit ISBN: 1-60433-634-X

This book may be ordered by mail from the publisher. Please include $5.95 for postage and handling.

Please support your local bookseller first!

Books published by Cider Mill Press Book Publishers are available at special discounts for bulk purchases in the United States by corporations, institutions, and other organizations. For more information, please contact the publisher.

Cider Mill Press Book Publishers
"Where good books are ready for press"
PO Box 454
12 Spring Street
Kennebunkport, Maine 04046
Visit us on the Web!
www.cidermillpress.com

Design by PonderosaPineDesign.com, Vicky Vaughn Shea

Cover design by Shelby Newsted

Photography and illustration credits on page 278

Library of Congress Cataloging-in-Publication Data is available.

Printed in China

1 2 3 4 5 6 7 8 9 0

CONTENTS

Foreword

With a history spanning 450 million years and a diversity comprised of species as different from one another as tigers and hedgehogs, sharks truly are remarkable animals—arguably the most remarkable animals on the planet. As important members of many marine (and even some freshwater) ecosystems, sharks are integral components of nature. However, their long-standing value as a source of food, materials, and recreation; their inspiration for art; and their serving as an object of myth set sharks apart from most other animals. Sharks remain undomesticated, and their occasionally violent behavior is not fully understood. Thus sharks remain a wild riddle of sorts, a kind of real-life monster that fuels the human imagination and makes life a bit more exciting.

So why do we need another book about sharks? For one, the mills of science are continually adding to our understanding of sharks, and some of this information needs to be faithfully transferred from the scientific to the public domain. Second, given sharks' diversity and depth of influence, no one book can possibly blanket the topic.

Generally speaking, shark books fall into one of four groups. The first is comprised of books written by scientists for scientists. While these books are extremely important, the information they contain is often difficult to comprehend or otherwise not very useful to the general public. The second group is regional or global

6

field guides. The third group is books written by sport fishermen, and the fourth group is books written by conservationists or otherwise energetic lovers of sharks. Of course, the books of each of these categories (yes, even the scientific ones) contain a certain amount of bias, and there is some overlap in agenda between them.

A category of shark book that has yet to establish itself is one written for the public by professional scientists whose bread-and-butter jobs focus on shark research in general and fisheries management in particular. I believe *The Shark Handbook* represents this new category—a category that promotes the transfer of useful scientific information from the professional perspective of having "been there" while appreciating that shark "user groups" span a continuum from shark killers to shark huggers and that fisheries managers play an important role in orchestrating human-shark interactions.

I can't think of a better author for such a handbook than my longtime friend and colleague Dr. Gregory Skomal. Greg and I met over twenty-eight years ago when we were both cutting our teeth as biology students working under the supervision of John "Jack" Casey. Since then, I have often had the pleasure of studying sharks with Greg as we sailed on research cruises, collected valuable data and biological samples at fishing tournaments, and even traveled to the Arctic. Through these experiences and more, Greg always proved himself to be reliable, skilled, knowledgeable, and adroit (and quite the wit, to boot). Those qualities facilitated Greg becoming a skilled SCUBA diver, accomplished photographer, fine scientist, and prolific author regarding a number of subjects—a true Renaissance man in many respects. And it's those same qualities that will no doubt make this book a fine success.

I have great confidence that readers will find this handbook interesting and useful, no matter if it is read cover to cover or used for occasional fact checking. But most important, I suspect that this nifty book will instill a balanced appreciation of sharks, and in doing so it will increase support for those who extend our knowledge of sharks through sound science.

In closing his treatise on cod, Mark Kurlansky provided an insightful contemporary perspective on mankind's continually evolving relationship with nature when he stated, "There is a big difference between living in a society that hunts whales and living in one that views them. Nature is being reduced to precious demonstrations for entertainment and education, something far less natural than hunting." In the face of an ever growing list of local and global challenges that divides humanity into numerous concern groups, I can only hope that the value of sharks in its entirety will ensure their survival for all user groups.

—**George W. Benz, Ph.D.**
Dept. of Biology, Middle
Tennessee State University
Murfreesboro, Tennessee
December 7, 2007

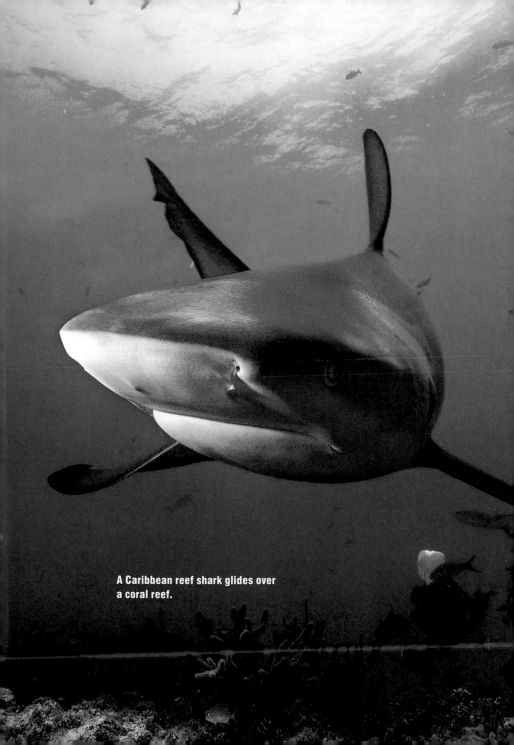

A Caribbean reef shark glides over a coral reef.

Introduction

About 450 million years ago, the ancestors of a unique group of fishes emerged, like so many others, to take a stab at survival. Over time, the group persisted, adapting, changing, and evolving as the earth convulsed through its growing pains. Major groups of animals, like the dinosaurs, came and went as catastrophic natural events wiped them away like bugs on an evolutionary windshield. But these fishes remained, changing again and again until their recipe for survival came out just right. This group is the sharks—an assemblage of fishes that has been honed by time and tested by the elements to reach the apex of evolutionary perfection while living and thriving in the silent world of the oceans.

Sharks predate humans by hundreds of millions of years. They have fascinated us, inspired us, fed us, protected us, and haunted us. We simultaneously revere and despise them, yet it makes no difference to them—that is, until they cannot find food, cannot find a mate, and cannot find clean habitat. At that point, they will not lash out, they will not seek retribution, and they will harbor no malice. They will simply die, and 450 million years of evolution would be wiped out.

We are all familiar with sharks. Some fear them, some eat them, some fish for them, some swim with them, some love them, and some

study them. I do all these things. This is a handbook of sharks, a simple guide to the most fascinating living creatures on earth. In this book, you will see sharks, lots of them, and you will learn how they live, where they live, and how we affect their lives. This is a book with its foundations in the hands-on field experience of someone who has watched sharks, held sharks, killed sharks, and saved sharks.

Part One of the handbook starts with a look at the evolution of sharks in chapter 1, followed by an anatomy lesson in chapter 2. In chapter 3, you will not only get a glimpse at how sharks live, but I'll tell you how scientists try to figure them out. Sharks are fish, and people eat fish, so we discuss shark fisheries and conservation in chapter 4. Although shark attacks are rare, no shark book would be complete without the discussion presented in chapter 5. In chapter 6, you will learn how sharks are classified in the science world.

Part Two (chapters 7–11) lists and describes the many orders, families, and species of sharks currently inhabiting the planet. I'll walk you through each of the currently recognized living species with highlights and personal experiences about those that I know and love.

As a child, I dreamed about studying sharks, and for more than 30 years that is exactly what I have been doing. I can truly say that I'm living a dream, which is a luxury not to be taken for granted. The purpose of this book is to share this dream with you and to bring you into the real world of a shark biologist. In doing so, I not only hope to impart what we know about these incredible creatures, I also want to reveal how we know what we know. You will find that for all we've learned about these amazing fish, we still know so little, and there is so much more that needs to be discovered.

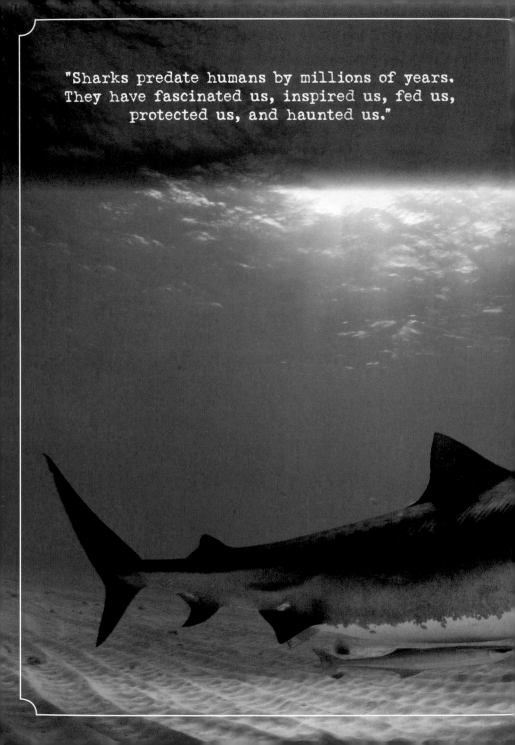

"Sharks predate humans by millions of years. They have fascinated us, inspired us, fed us, protected us, and haunted us."

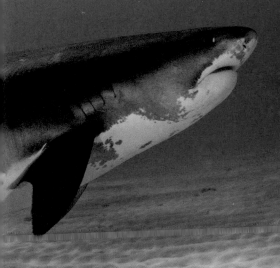

SHARK
CHARACTERISTICS

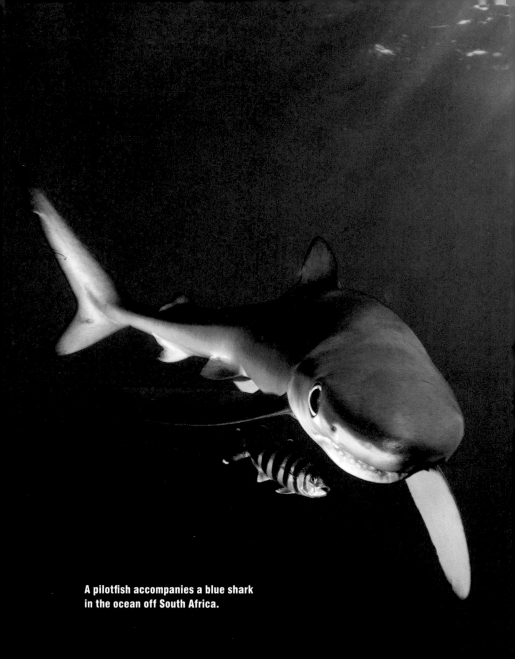

A pilotfish accompanies a blue shark
in the ocean off South Africa.

Shark Evolution

A common misconception is that sharks are not fish. Actually, sharks belong to a class of fishes known as Chondrichthyes, which is less formally referred to as the cartilaginous fishes. This class also includes skates, rays, chimaeras, and a huge number of extinct species

extending back over 450 million years. Although there are a whole bunch of technical ways to distinguish chondrichthyan fishes from all others, the most conspicuous characteristics include an internal skeleton composed of cartilage, toothlike scales called *denticles*, modified pelvic fins called *claspers* (males only) used for internal fertilization, and teeth in replicating rows. There are more than 1,100 living species of chondrichthyan fishes, but this number seems to keep growing each year, as more and more species are described.

Scientists further split the class Chondrichthyes into two subclasses called the *Holocephali* and the *Elasmobranchii*. The Holocephali comprise 40 or so living species of chimaeras, or ratfishes. These deepwater fish reach up to 6 feet in length and can best be distinguished from sharks and rays by their single gill covers, smooth skin, venomous spines, fixed upper jaws, and large tooth plates instead of teeth. The balance of the living chondrichthyans, the

The spotted ratfish, *Hydrolagus collei*, is related to sharks but belongs in a separate subclass, the Holocephali.

elasmobranch fishes, includes the sharks and their closest relatives, the skates and rays. The approximately 500 species of living sharks are easily distinguished from their raylike relatives by their general torpedo-like body shape. In contrast, most of the 600 species of skates, rays, guitarfishes, and sawfishes look very much like flattened sharks, with broad, winglike fins

This yellow stingray, *Urobatis jamaicensis*, is an elasmobranch, but not a shark.

attached to their heads. Although all the elasmobranchs are unique and interesting creatures, this book focuses on the eight orders of sharks: what they are, how they live, and from whence they come.

Origins and Ancestors of Modern Day Sharks

Sharks have prowled the world's waters for the last 450 million years. Since modern humans have only been around for about 200,000 years, it's pretty difficult for us to imagine just how long a million years actually is. Think of it this way: some of the shark species that swim in our oceans today were around when dinosaurs roamed the earth. So, if you were

around about 65 million years ago, you may have been lucky enough to see both *T. rex* and one of the modern cow sharks during your visit to Disney World. What is even more amazing is that the dinosaurs became extinct about 65 million years ago, but the sharks persisted and still dominate the watery world. Ironically, after all this time, the only threat to sharks is humans.

The very feature that binds all chondrichthyan fishes, namely cartilage, has also rendered their origins and ancestry very much a mystery. Unlike the bones of other fish species, cartilage does not preserve well in the fossil record. Therefore, with few exceptions, the trail of shark evolution is marked only by the fossilized remains of dermal denticles, teeth, and spines.

To really get a sense of where sharks fit into the fossil record, we must first put life on Earth in geologic perspective—this is done with a geologic time scale. Given our propensity to classify, organize, and count, it's no surprise that we have divided the 4.5-billion-year history of our planet into eons, eras, periods, and epochs. The Precambrian eons span about 80 percent of Earth's history, up to 540 million years ago. Life on Earth originated during this time and has become increasingly complex since. The ancient relatives of sharks first appeared in the fossil record about 450 million years ago during the Silurian period, but the fossilized teeth of what may be considered true sharks didn't appear until the Late Devonian, about 380 million years ago. Based on the size of these teeth, the early sharks were small, only about a foot long. It was during the Devonian period (about 419 to 359 million years ago), often referred to as the "Age of Fishes," that the number of fish species exploded and sharks were no exception. Among these earliest of sharks was *Cladoselache*, which was described from teeth, vertebrae, and rare fossilized impressions of

skin, kidneys, and muscle. With its sharklike body, sharklike fins, and sharklike large eyes, *Cladoselache* was likely about 6 feet long and a fast-swimming, predatory shark.

The Carboniferous period, about 359 to 300 million years ago, became what we now call the "Golden Age of Sharks." Although *Cladoselache* had come and gone by then, other species of sharks radiated from common ancestors. Among them were the earliest hybodonts, a group of sharks with fins, claspers, and teeth that more closely resembled those of the modern sharks that roam our oceans today. The rapid proliferation of sharks during this period also resulted in the development of adaptations and specializations that look nothing less than bizarre to the retrospective observer. Perhaps one of the most notable of these was the odd-looking *Stethacanthus* with a crown of tubercle-type teeth on its head and a thick, bony spine on its back, topped with an ironing-board-like platform covered in more sharp teeth, much like a dog brush mounted on a stick. The function of this armament remains a mystery, but many have speculated

Cladoselache was among the earliest of the sharks to appear in the fossil record.

The odd-looking *Stethacanthus*.

Helicoprion was over ten feet in length.

that this relatively small shark (about three feet long) used it during courtship or to deter would-be predators or maybe even to anchor itself to the underside of a larger fish. Another of the more eccentric shark species to first appear during the prolific Carboniferous was *Helicoprion*. Although much of the shark itself remains a mystery, it is best known for its characteristic ever-growing whorl of teeth erupting from the lower jaw and stored in a tight spiral, like a circular saw. This large shark (more than 12 feet long) likely used this structure during feeding to disable prey.

Shark diversity during the Carboniferous period was staggering, and the number of shark families at that time actually out-numbered those alive today. However, by the close of the next period, the Permian, about 252 million years ago, most of these sharks were eradicated by the most massive extinction event of all geological time. A domino-type series of climatic and geochemical changes caused by extensive volcanic activity spanning thousands of

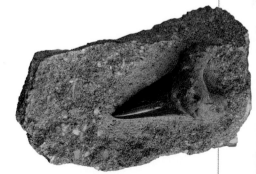

Fossil shark teeth provide clues to shark evolution.

years resulted in the loss of not only sharks, but as many as 95 percent of all marine species. Nonetheless, the adaptability and success of the shark design would persevere through this global catastrophe as a couple of shark groups emerged, quite literally, from the ashes to seed another burst in shark evolution. These groups included the hybodonts, which survived and roamed the seas for another 180 million years. The other, the xenacanth sharks, were small- to medium-sized sharks (3 to 6 feet long) that lived in freshwater and looked more like eels, with a single dorsal fin that wrapped around the tail and a conspicuous spine on the top of the head.

Although the Jurassic period (200 to 145 million years ago) is defined as the "Age of Dinosaurs," it also marked the appearance of the first modern sharks. At one time, it was thought that the hybodonts gave rise to the lineage of sharks that we see today, but this does not seem to be the

case. Instead, the hybodonts were being replaced by species with more flexible protrusible jaws, a characteristic that would chill the bones of many a human millions of years later. The species that emerged during the Jurassic and the following period, the Cretaceous (145 to 65 million years ago), are now typically referred to as the "neoselachians" or the "new sharks." Although not as prolific as the aforementioned Golden Age of Sharks 200 million years earlier, these periods mark the emergence of the major lineages of almost all of the sharks that we see today with incredibly diverse forms and lifestyles. To compete with the marine dinosaurs, the new sharks had to be streamlined, fast, large (some longer than 20 feet), and loaded with a complement of senses to assist with prey detection and capture. Probably the oldest of the neoselachians are the lineages that gave rise to our modern-day cow (Hexanchiformes) and bullhead (Heterodontiformes) sharks

about 95 to 150 million years ago. It was also during this time that the skates and rays appeared in the fossil record; some of these ultimately invaded and still reside in freshwater. The appearance of teeth that looked remarkably like those of our modern lamniforme sharks, like the sand tiger and mackerel sharks, marks the emergence of prototypes for these modern-day species as well.

But it is no secret to anyone who looks out their window that the Age of Dinosaurs did not persist to modern times. Indeed, another catastrophic extinction occurred at the end of the Cretaceous period about 65 million years ago. Whether caused by asteroid impacts, volcanic activity, or slow climatic changes, the Cretaceous-Tertiary extinction event resulted in the loss of all the dinosaurs, with the

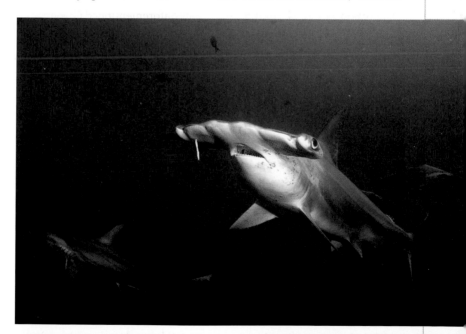

The hammerheads were the most recent of the modern sharks to emerge in the fossil record—about 50 to 35 million years ago.

exception of those giving rise to our modern birds. Although the declining hybodonts met their demise along with the dinosaurs, remarkably about 80 percent of the Chondrichthyan families survived the event. With the loss of the dinosaurs both above and below the surface, mammals flourished in both places, as access to vacated habitat was now possible, and the ancestors of marine mammals, like whales and dolphins, returned to the sea. These creatures provided ample fodder to fuel the development of larger predatory sharks like the great white shark. At the same time that filter feeding whales came onto the scene about 65 to 35 million years ago, three shark lineages shifted from active predation to planktivorous filter feeding, resulting in our modern whale, basking, and megamouth sharks. The most recent sharks in the fossil record, the bizarre-looking hammerheads, appeared about 50 to 35 million years ago—at least 33 million years before the group of primates called humans began their domination of the earth.

The Curious Megalodon

Considered by many to be one of the largest predatory fish to have ever lived, the megalodon shark, *Carcharocles megalodon*, lived from about 22 to 5 million years ago. The megalodon has the largest shark teeth (up to seven inches) ever examined, and they are remarkably similar in form to the triangular serrated teeth of the great white shark. For this reason, many researchers hypothesize that the megalodon shares a common lineage with the great white. However, recent studies suggest that megalodon evolution actually paralleled that of the modern white shark in a separate lineage. Regardless, the similarities between the great white and megalodon have prompted researchers to estimate the size of the latter based on the relative tooth size of the former. Given the

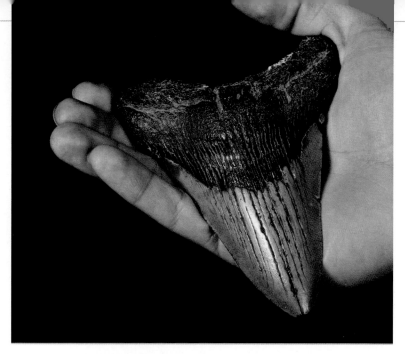

This fossilized tooth of *Carcharodon megalodon* indicates that the species may have been more than 50 feet in length.

size of megalodon's teeth, there are indications that this shark was more than 52 feet in length and 48 tons. This shark could have easily consumed the largest white shark at 21 feet. Megalodon's fossils are found worldwide and predominantly in coastal regions side by side with those of large sea mammals, their likely prey. At 6 feet across, the mouth of this shark was immense and more than capable of dispatching large creatures, even whales. Exactly what precipitated the extinction of megalodon remains a mystery, but it may have been associated with changes in prey distribution and climate. Although there are some who feel that a relict population of megalodon sharks exists deep in the world's oceans, this unfortunately can only be characterized as wishful thinking.

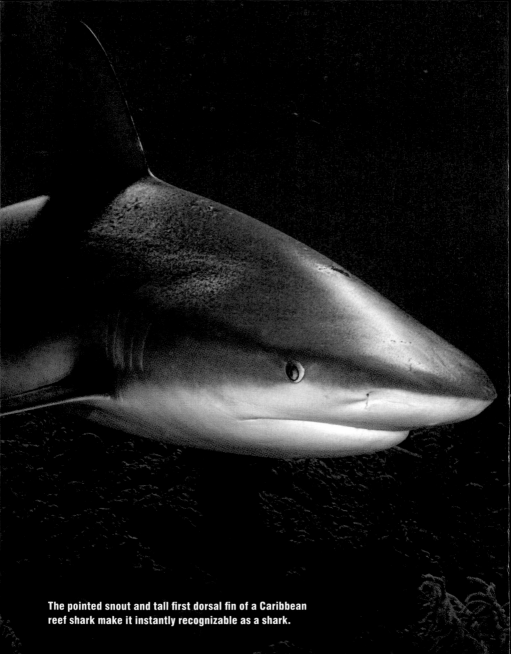

The pointed snout and tall first dorsal fin of a Caribbean reef shark make it instantly recognizable as a shark.

Anatomy of Sharks

Survival in the ocean is very different from living on land. Water is a thick medium, about eight hundred times denser than air, so movement through water requires quite a bit of work. Life in the ocean is not uniformly distributed, so if you're trying to make a living, you need to be at the right

place at the right time. This oceanic patchiness forces many marine animals to move seasonally to and from productive areas while keeping within their physiological limits. These movements must also coincide with reproductive timing. As a result, some marine species, like blue sharks and humpback whales, move great distances to feed and to reproduce, while others, like tropical reef fishes, stay put to do both. Survival in the ocean, therefore, hinges on energetic trade-offs between growth, foraging, predator avoidance, and reproduction in a dense medium and an environment with scattered resources. Moreover, that same medium, namely seawater, is loaded with salt, so all fish must deal with the physiological fact that their bodies are constantly losing freshwater to the environment. Add to this the odd properties of light and sound in water and the need to capture both in order to see and hear, and you have a world where making a living is not easy.

There are several major anatomical features of sharks that

make them unique among the fishes. Having a solid understanding of these features not only aids in classification and identification, but it also helps researchers investigate how sharks respond to and live in their environment. Exactly how a shark survives in the marine world is dictated by its morphology (form and structure), physiology (how its body works), and sensory systems. In the previous chapter, we learned that the basic shark form has changed little over hundreds of millions of years. Why? Because those attributes that define sharks have allowed these animals to survive and thrive in virtually all parts of the world, from the shallowest seas to the deepest oceans, and from the tropics to the poles.

There are eight general groups of sharks, called orders, each containing families and species that are related phylogenetically—that is, each has the same evolutionary lineage. Look at a shark in each of these orders and you will see dramatic differences between them. On the outside, body shape, tooth structure, fin size and placement, and even scale configuration are the most obvious features. If you could look on the inside, you would see variations in muscle and skeletal structure, reproductive and digestive systems, and nervous and sensory system arrangement, just to name a few. Simply put, because of this variation there is really no such thing as a generic shark. Each species has adapted to meet the challenges of living in the ocean. Most of these adaptations are associated with balancing energetic losses and gains. The shark scheme for doing so is unique, thereby uniting this highly diverse group.

Morphology

The general form and structure, or morphology, of a shark includes several features that differentiate it from all other fishes. As noted in chapter 1, this unique morphology includes an internal skeleton com-

ANATOMY OF SHARKS

posed of cartilage, toothlike scales called denticles, modified pelvic fins called *claspers* used for internal fertilization, and teeth in replicating rows. Sharks also lack a swim bladder, which is an important feature of many of the bony fishes.

BODY SHAPE AND FINS

The first features that anyone notices about most sharks are their streamlined torpedo-shaped (fusiform) bodies, subterminal mouths (under their heads), and fins. Sharks, like all fishes, have adapted to living in a dense medium. Every sweep of the tail for a shark is work, which requires energy, and, as we will see, most shark species must continuously swim to breathe. So, a shark's body shape, fin and tail shape, and even scale alignment and shape, are adapted for allowing water to flow over the shark, thereby reducing drag and energy consumption. For comparison, look at the efficient hydrodynamic shapes of a torpedo and a submarine. Of course, there

are exceptions: with their flattened bodies, angel and carpet sharks are not very hydrodynamic at all. But these kinds of sharks are benthic, meaning they spend most of their time associated with the bottom, in some cases waiting to ambush prey as it moves past them.

Other than the impressive jaws, the most famous part of a shark is probably the dorsal fin. All of us have seen those movies: somebody screams and points to a fin neatly slicing the surface of the water—the telltale sign of a shark. Of course, Hollywood doesn't particularly care to know that most sharks rarely, if ever, come to the surface high enough for their dorsal fin to break it. In addition to the first dorsal fin, sharks have a second dorsal; a caudal (tail) fin; an anal fin (in most species); and two sets of paired fins, the pectoral and pelvic fins. The relative placement on the body, shape, and internal support of these fins differ by species. The pectoral, pelvic, dorsal, and anal fins help

The Anatomy of a Shark

FINS

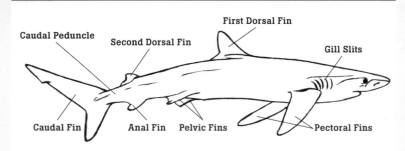

Caudal Peduncle

Second Dorsal Fin

First Dorsal Fin

Gill Slits

Caudal Fin

Anal Fin

Pelvic Fins

Pectoral Fins

SKELETAL SYSTEM

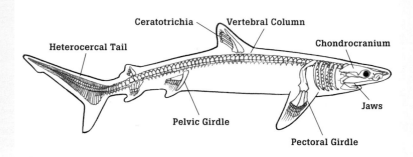

Ceratotrichia

Vertebral Column

Chondrocranium

Heterocercal Tail

Jaws

Pelvic Girdle

Pectoral Girdle

CIRCULATORY SYSTEM

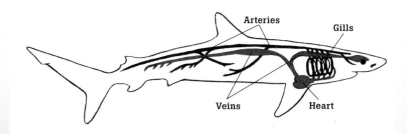

Arteries

Gills

Veins

Heart

DIGESTIVE SYSTEM

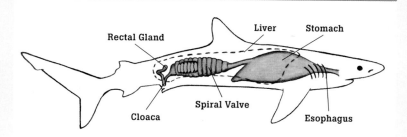

MALE REPRODUCTIVE SYSTEM

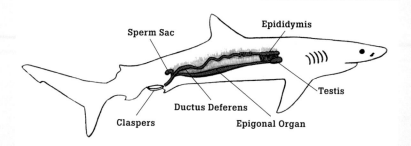

FEMALE REPRODUCTIVE SYSTEM

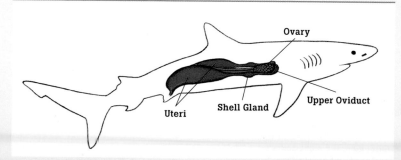

the shark to maneuver, rise and fall in the water column, to turn, and to swim straight. On most other fishes, these fins fold down, are very flexible, and can be readily manipulated to fine-tuning the placement of the fish in the water column. In contrast, shark fins are fixed in place and remain erect, but muscles in the fins do allow for subtle movements. These fins are supported by keratin-based supportive elements called *ceratotrichia*, which look a bit like dry spaghetti running through the fin.

The caudal fin is the shark's propeller, providing the thrust to move through the water. Shark tails are much different from those

Mackerel sharks, like this great white, have the most energy-efficient body design.

of most other fishes in that the vertebral column passes up into the upper lobe of the tail. This is called a *heterocercal* tail, and it usually results in the upper lobe being larger and longer than the lower lobe. Some species, like the mako and great white, have an enlarged lower lobe as well, but the tail is still internally heterocercal. The narrowing of the body where it meets the tail is referred to as the *caudal peduncle*. All the force generated by the shark's muscles is translated to the tail through the caudal peduncle.

In general, sharks have five basic body and fin arrangements, depending on their lifestyle. Fast-swimming, open-ocean species, like mako and great white sharks, have a conical head, a large deep body, large pectoral fins, a narrow caudal peduncle with keels, and a symmetrical caudal fin. This is the most efficient body design for moving quickly through the water, and small second dorsal, anal, and pelvic fins help to reduce drag.

Requiem sharks, like this blue shark, have
a broad range of swimming speeds.

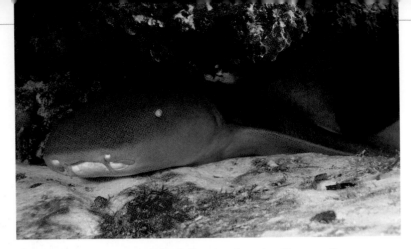

Nurse sharks have adaptations that allow them to rest on the ocean floor.

The Greenland shark and other dogfishes lack an anal fin.

More moderate swimmers, like the blacktip, tiger, and blue sharks, have a more flattened head, thinner body, thicker caudal peduncle with little or no keels, large pectoral fins, and a caudal fin in which the upper lobe is somewhat larger than the lower lobe. These sharks have the broadest range of swimming speeds, and their maneuverability is enhanced by moderately sized second dorsal, anal, and pelvic fins.

Slow-swimming sharks, like nurse and leopard sharks, typically have large heads with blunt snouts, pelvic fins set more forward, dorsal fins set farther back,

and a highly asymmetrical caudal fin with little or no lower lobe.

The dogfishes, which tend to live in deeper water, exhibit a fourth type of shark form. Although these sharks have a variety of body shapes, they lack an anal fin, and their broad tails have large upper lobes.

The fifth body shape is typical of sharks that live on the bottom, such as angelsharks, as well as shark relatives, including skates and rays. These sharks have a flattened body, enlarged pectoral and pelvic fins, and a much reduced tail section.

TOP: **Angel sharks are flattened for bottom living.**
BOTTOM: **The toothlike denticles of shark skin.**

SKIN

Covering the body, sharks have tiny toothlike scales, called *placoid scales* or dermal *denticles*, all pointing toward the tail of the shark. The denticles not only provide protection, but their shape allows water to flow more smoothly over the shark, reducing drag and making swimming more energetically efficient. This reduction in drag also dampens noise, so that sharks tend to move more quietly through the water—this is particularly helpful when moving in for a predatory attack. Denticles are basically tiny teeth composed of dentine, and on most shark species, their backward orientation results in the relatively smooth feel of a shark's skin when stroked toward the tail but the classic sandpapery texture when stroked

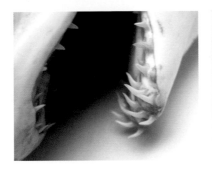

Multiple rows of teeth in the shortfin mako.

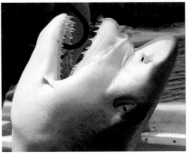

The protrusible jaw of a juvenile lemon shark.

toward the head—something you should know when petting a shark. In fact, the skin is so rough that it has been used as sandpaper. On more than one occasion, I have been abraded by the skin of a shark while handling it, and it's no different than swiping sandpaper over your skin, which can be a wee bit less than pleasant. Denticle shape differs by species, and some sharks can actually be identified based only on their skin.

TEETH AND JAWS

The business end of a shark is its mouth—there is probably no maw on the planet that is more feared. Lined with multiple rows of sharp teeth, the jaw of a shark is an efficient tool for biting, chomping, slicing, and crunching. Shark teeth come in all shapes and sizes, depending on species, and some are easily used to identify species. You can actually tell a lot about what a shark eats by looking at its teeth. For example, the molarlike crushing teeth of the smooth dogfish are ideally suited to their diet of crabs and lobsters, while the triangular, serrated teeth of the great white shark are perfect cutting tools for rending large chunks of flesh from seals and whales. Just as tooth shape differs by species, so does the number of rows of teeth. The bull shark has 12 or 13 rows of teeth, while the basking shark has more than 200 in each jaw. Unlike us, sharks don't

worry about losing their teeth. In fact, they literally lose thousands of teeth through their lifetime. If you imagine each row of teeth as a conveyor belt, sharks never stop growing teeth and always have a sharp set ready to go, as new fresh teeth replace the older, dull ones. These teeth are set in a jaw that is suspended by strong muscles and tendons and not attached to the shark's skull. Using these muscles, the shark can extend or protrude its jaw and teeth to more effectively grab, hold, and bite.

SKELETON

By definition, sharks have a cartilaginous skeleton. Touch the tip of your nose or your ear and you will have a sense of what cartilage feels like. It is pretty light and pliable. Hence, a skeleton of cartilage gives the shark great lightweight flexibility as well as strength and support. Again, for an animal that swims continuously through a dense medium, such a design increases energetic efficiency.

The shark skeleton is fairly straightforward. The jaw articulates with, but is not attached to, the skull of the shark, which is called the *chondrocranium*, literally "cartilage skull." The chondrocranium houses the brain and sensory centers of the shark. It is connected to a vertebral column ("backbone") that runs the length of the shark to the tip of the tail. The number of vertebrae is species-specific and defines the flexibility of a shark. The spinal cord and two major blood vessels run through the neural and haemal arches, respectively, of the backbone. The chondrocranium also articulates with the gill arches, curved structures that support the gills and their associated blood vessels. To round out the skeleton, the pectoral and pelvic fins are held in place by two girdles.

For anyone who has seen or held a preserved shark jaw, you can attest to the fact that it looks and feels like bone. Why? Because the cartilage of sharks is covered

with a thin, highly mineralized layer of calcium phosphate tiles called *tesserae*, which give shark cartilage the strength of bone without the weight.

Physiology

The basic morphology of a shark is interesting, but how it functions—its physiology—is even more intriguing. Telling you about muscle is pretty boring, but describing how it works will keep your attention.

Blood sampling a grey reef shark to study its physiology.

SWIMMING

As already noted, sharks have adaptations for keeping the energetic costs of swimming pretty low, including a fusiform body shape, a highly flexible, light-weight, cartilaginous skeleton, and drag-reducing skin. But before a shark can move a single inch, it needs to flex its muscles. Despite all the times I have lifted a shark out of the water, I'm always amazed by its muscle mass. This is further emphasized when I have had to restrain a shark for blood sampling. Nothing is more exciting, exhausting, or dangerous than trying to restrain an animal armed with sharp teeth and a body composed of over 60 percent muscle. Add to this their flexibility and you might as well be grabbing a tiger by the tail.

Like all fishes, sharks have two types of swimming muscles: red and white. If you go to the fish market and see fish fillets, you will easily be able to see the two kinds of muscle. The red muscle is typi-

cally less than 5 percent of muscle mass and is used for steady swimming at relatively slow speeds. This muscle is powered by oxygen (i.e. aerobic), so it is loaded with blood vessels for oxygen delivery—hence the color. The white muscle, sometimes called fast-twitch muscle, is by far the greatest proportion (more than 90 percent) of the total muscle mass. White muscle contracts rapidly with great force for bursts of speed, like those used to elude a predator or capture prey. A great white shark exploding through the surface of the water during an attack on a seal is using its white muscle mass. But white muscle is powered anaerobically, meaning that it is not oxygenated and does not have many blood vessels. Anaerobic muscle activity generates lactic acid and a considerable oxygen debt. When this happens to us during periods of extreme exercise, we call this *muscle burn,* and we are usually physically exhausted when it happens. The same is true for

sharks and other fishes, so periods of burst speed are usually pretty short, and sharks use them sparingly. Although we would like to think that sharks swim fast all of the time racing around the ocean, this is not the case. Sharks typically move steadily and slowly.

RESPIRATION

Sharks are animals, so they need oxygen to live. Like all fishes, sharks have gills that extract oxygen from the water. Unlike other fishes, sharks typically have five (in some species up to seven) gill slits on each side of the head, instead of just one. Also,

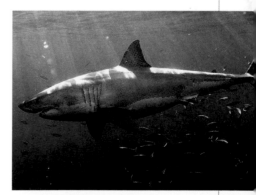

White sharks have large gill slits for maximum oxygen exchange.

The small eye, tilelike denticles, and spiracle of the nurse shark.

in contrast to many other fishes, most sharks need to swim forward in order to breathe. This is called *obligate ram ventilation*, meaning they're obligated to ram water over their gills to ventilate. As it swims, the forward motion of the shark forces water into the mouth, over the gills, and out the gill slits. As water passes over the gills, gas exchange of oxygen and carbon dioxide occurs across the very thin gill filaments, through which blood is flowing. The heart pumps oxygenated blood from the gills to the rest of the shark, where it is utilized to produce energy in a series of chemical reactions called *respiration*. If a shark stops its forward movement, it will actu-

ally drown, which sounds pretty weird for a fish. Since water contains much less oxygen than air, sharks must breathe ten to thirty times more water to get the same amount of oxygen than a land animal would get from air.

As you know by now, all sharks are not alike. And several components of the circulatory system differ between shark species. Not all sharks are obligate ram ventilators. Anyone who has been to an aquarium and seen nurse sharks lounging on the bottom can attest to this. These sharks have the ability to suck water into their mouth and pump it over their gills. In addition, in some species a pair of small openings, called *spiracles*, behind the eyes of most sharks, can draw in water and move it to the gills.

To enhance oxygen delivery to the tissues, large, active, fast-swimming sharks, like the mako, have more gill surface area, thicker hearts, and blood that holds more oxygen (more *carrying capacity*) than less active sharks, like the

leopard shark. To work more efficiently, the red muscle mass of these active sharks is positioned more centrally and forward in the body, and it has higher capillary density and myoglobin (oxygen-binding protein) concentrations for greater oxygen exchange.

ENDOTHERMY

With few exceptions, all fishes are *ectothermic*, which really just means cold-blooded. Ectothermic animals are unable to raise their body temperature more than a degree or two above the surrounding environment. Most sharks are no exception, and they must, therefore, stay in water that is within a specific temperature range. The blue shark, for example, migrates to northern areas in the late spring and summer as water temperatures rise, but they must also move back as these same waters cool down in the fall.

Of all the fishes, more than 25,000 species, there are only three major groups that have evolved *endothermy*, that is, the ability to elevate their internal temperatures above that of the ambient seawater. The scombroid fishes, which include the tuna, mackerels, and billfishes, have varying levels of endothermy ranging from the capacity to warm their eyes and brains to elevated muscle and visceral temperatures. The opah, *Lampris guttata*, keeps its entire body a bit warmer than the surrounding water. The other group is the shark family Lamnidae, which includes the closely related great white, mako, salmon, and porbeagle sharks.

The mechanism that keeps these fishes warm is quite amazing. When fish swim, they burn energy and create metabolic heat. In ectothermic fishes, this heat warms the blood but is lost when the blood reaches the gills, which are in contact with the surrounding (cooler) water. So, although all fishes generate heat, very few are able to retain it. The endothermic fishes have a complex of specialized

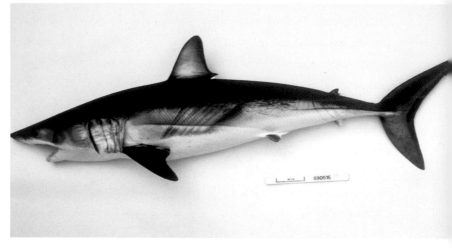

Mako sharks and other lamnids are endothermic.

blood vessels called the *rete mirabile* or "wonderful net," which is a mesh network of tiny veins and arteries that run side by side. Lamnid sharks have a retia mirabilia close to their red muscle. As warm venous blood leaves the muscle it flows through the rete, where the heat transfers to the incoming arteries, which go back into the muscle. This countercurrent heat exchange raises the body temperature, because the heat is not lost at the gills. The maximum elevation of body temperature over ambient water temperature is 14°F for shortfin mako sharks, 26°F for white sharks, and 38°F for salmon sharks. Warmer muscles produce more power and greater speed, and a higher body temperature allows these sharks to move over a much broader geographic range. Lamnid sharks also have retia mirabilia close to their eyes, brains, and viscera, warming these organs up to 12°F for better visual acuity and more efficient digestion. Because of these highly specialized adaptations, these sharks are among the fastest and the most broadly distributed of all the shark species.

DIGESTION

The digestive system of sharks and other elasmobranchs is unique. Prey items pass from the mouth into the esophagus then down into the stomach, where a great deal of the digestion takes place. Second only to the liver, the stomach is one of the largest organs in the shark's abdominal cavity. To aid in breaking down food items, the stomach walls are highly muscular, with folds called *rugae*, which allow for the stomach to expand when full. The sac-like stomach of a shark secretes powerful digestive enzymes and acids that break down most everything from invertebrate shells to marine mammal bones. Sharks need not be concerned with items that they cannot break down; most can quite literally throw up their stomachs to be rid of indigestible food items, like turtle shells or stones. This method of rinsing the stomach, then retracting it, is called *stomach eversion*.

Muscular contractions of the stomach, combined with the powerful compounds, reduce food to paste that passes to the next digestive organ, the *spiral valve*. The spiral valve is an organ unique to sharks and their relatives. In sharp contrast to our small and large intestines, the spiral valve of a shark is short and stout, only about a foot long in a six-foot shark. However, the spiral valve is not a simple tube, but rather a multilayered organ for maximum absorption of nutrients. Some spiral valves, like those of cow sharks and dogfishes, look

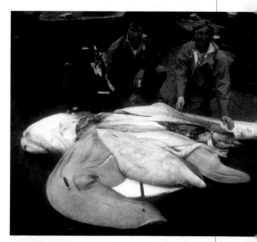

The scientific dissection of a large male tiger shark.

like big corkscrew pasta. Others, like those in requiem sharks, look like a rolled-up scroll. Regardless of the shape, spiral valves have a huge amount of surface area for absorbing nutrients as pasty digesta passes through them. The pancreas and the liver secrete enzymes and bile into the forward part of the spiral valve. After slow passage through the spiral valve, solid matter that is not absorbed or useable is excreted as waste through the cloaca, a common opening of the digestive, urinary, and reproductive systems.

BUOYANCY

Most species of fish have a specialized organ called the *swim bladder*, which allows them to adjust their buoyancy in the water column. By adding or removing gases from the swim bladder, fish can remain motionless and avoid floating or sinking. Sharks and other elasmobranchs lack a swim bladder and must swim forward or sink to the bottom. Although

they lack this buoyancy compensator, sharks have a massive liver, rich in oils, that provides lift. A shark's liver, composed of two major lobes, can account for as much as 30 percent of the total weight of the shark, depending on the species. The liver of a basking shark can weigh as much as a ton! Up to 90 percent of the liver weight is oil and up to 90 percent of that oil is squalene, which is much less dense than seawater. This, in turn, reduces the density of the shark by over 90 percent. The lift provided by the liver, therefore, reduces the amount of energy the shark must expend to maintain its position in the water column. This large reserve of oil is also an important source of fuel to power the shark. In addition, the liver acts as it does in other vertebrate species by storing other metabolic fuels and vitamins and acting as a detoxifier, keeping the shark's general biochemistry well balanced.

OSMOREGULATION

Due to osmosis, fish living in freshwater are constantly subjected to an influx of water, because their cells are more saline (have more salts) than their environment. On the other hand, marine fish, including sharks, are always threatened by the loss of water from their cells because their environment is more saline. To deal with this constant challenge, freshwater fish drink little water and produce large quantities of dilute urine, while most marine fish drink large quantities of water and eliminate salts in small amounts of highly concentrated urine and feces, as well as at the gills.

Sharks and other elasmobranchs are exceptions. They do not drink seawater. Instead, the tissues in a shark's body match the salinity of the surrounding water by retaining high concentrations of urea. To do so, sharks use their gills, kidneys, and a specialized organ called the *rectal gland*, which is connected to the lower part of the digestive tract. While the rectal gland removes excess salt, the kidneys retain urea, and the gills help to maintain ionic balance. Virtually all sharks live in the marine environment, but a few, like the bull shark, are capable of penetrating freshwater systems. The kidneys of these sharks retain and synthesize less urea and excrete large amounts of dilute urine, while the rectal gland becomes nonfunctional.

REPRODUCTION

All elasmobranchs reproduce through internal fertilization—that is, the male mates with the female to transfer sperm for egg fertilization. To do so, the male has two modified extensions to the pelvic fins called *claspers*, which rotate and insert, usually one at a time, into the female during mating. Without arms and legs, male sharks must rely on their teeth to hold on to females during mating; this results in mating wounds and scars. For this

Many female sharks, like this blue, exhibit mating scars.

reason, in some species of sharks, the females develop thicker skin to provide protection from the male's sharp teeth.

Males have two testes internally located in the forward part of the abdominal cavity. Packets of sperm, called *spermatophores*, are produced by the testes and move down to the claspers through the genital ducts. Sperm is hydraulically pumped through the clasper and into the female by the male's *siphon sacs*, which are located just under the skin forward of the claspers.

The female's reproductive system is comprised of one or two ovaries, oviducts, shell glands, and two uteri. Eggs produced by the ovary are transported down the oviduct, through the shell gland where the egg is enclosed

The reproductive tract of a pregnant shortfin mako shark.

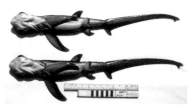

Embryonic bigeye thresher sharks are replicas of the adults.

The egg case of a bamboo shark.

by a membrane or shell, and down to the uterus. The shell gland is also a site for sperm storage and fertilization. Development of the fertilized eggs in the uteri varies between species and depends on whether the species is oviparous or viviparous. Families of sharks including the horn sharks, catsharks, and wobbegongs, are oviparous, which means that they lay eggs on the bottom, and the young hatch after a few months to a year. All other sharks are viviparous, meaning the female gives birth to fully developed young, or pups, after periods of several months to two years.

Viviparous sharks may be placental or aplacental depending on whether or not there is a placental connection between the developing embryo and the mother. Some aplacental species, like the spiny dogfish and whale shark, have no connection to the mother and rely solely on their yolk sac for nutrients. This is called *aplacental yolk sac viviparity* or *ovoviviparity*. In others, like the mako and great white sharks, the mother produces additional eggs, which are consumed by the embryos to augment their yolk sac nutrition; this is called *oophagy*. The sand tiger shark takes this to the extreme and consumes other embryos (*intrauterine cannibalism*), resulting in the birth of a single large (3 feet) pup from each uterus. In all other sharks (about 10 percent), developing young are nourished by the mother through a direct placental connection.

Most shark species grow slowly and do not mature until several years old. Some species of sharks reproduce annually while

others may only give birth every two or three years. The number of young differs markedly by species and is generally less than twenty, with ranges from two, as in the sand tiger, to over eighty, as in the blue shark. There is no parental care in sharks, and the newborn pups are on their own immediately after birth. When compared to other fish species, the relatively low reproductive rate, late age of maturity, and few young render shark populations particularly vulnerable to fishing pressure.

Sensory Systems

Sharks possess an incredible array of sensory capabilities that have allowed them to successfully exploit all kinds of diverse habitats. With at least six senses, sharks continually process incoming sensory information on light, sound, electricity, scent, water movement, and taste. To do so, sharks have large brains compared to those of other fishes, comparable in relative size to birds and mammals and largely committed to receiving and responding to sensory information.

SIGHT

Situated on the sides of the head, a shark's eyes allow for almost 360 degrees of vision. While the general anatomy of the shark's eye is similar to that of most fishes, there are some unique adaptations including a dynamic iris, large lenses with ultraviolet filters, and a reflective layer called the *tapetum lucidum*, which reflects light back into the retina for increased sensitivity. Some species of sharks, like hammerheads, have special protective eyelids, called *nictitating membranes*, which extend from the bottom of

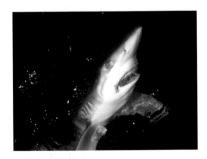

The nictitating membrane protects the eye of this blue shark.

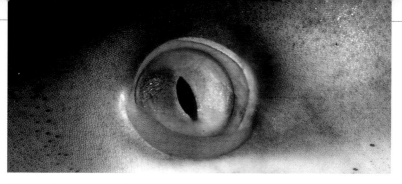

The eye of the grey reef shark.

the eye to protect it when feeding. Combined with the presence of both rods and cones in the retina, these adaptations result in an eye that is well adapted to very dim lighting conditions. However, there is mounting evidence that sharks are color blind. It is thought that sharks use their vision during their final approach to prey. In dim lighting conditions, like the periods around sunrise and sunset, they are aptly suited to ambush their prey.

SMELL

The sense of smell, or *olfaction*, has been characterized as the most powerful sense in sharks, to the extent that they have been called "swimming noses." Indeed, olfaction is essential for the detection of prey as well as predators and potential mates. Unlike our noses, the olfactory system of fish isn't attached to the respiratory system but remains isolated from the mouth and gills. All fish, including sharks, have external nostrils, called *nares*, which provide flow of the surrounding seawater to and from the olfactory organs. Shark nares, located at the tip of the snout in front of the mouth, are divided by a skin-covered flap into two areas for incoming and exiting water. Water flows through the nares and into a series of plates containing olfactory receptors, where odors are perceived and communicated to the olfactory bulb of the brain. It is thought that the relative size of the olfactory bulb is

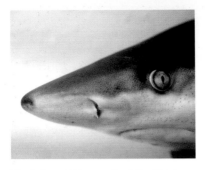

The left nostril or naris of the black-nose shark.

related to the importance of olfaction for any given species. So, a large olfactory bulb, like that of the great white shark (18 percent of the brain weight), indicates that smell is an important sense for this highly predatory species. It has been shown that some sharks, like the nurse shark, use the odor differences between their two nares to gradient search for the source of an odor trail, while others, like the lemon shark, simply move upcurrent once aroused by a scent. Much has been said about the ability of a shark to detect the smallest amount of an odor in the water column. Although analogies like "a drop of blood in a swimming pool" do characterize the sensitivity of a shark's nose, the extent to which sharks actually respond to these small concentrations remains poorly understood.

TASTE

Gustation is the sense of taste, and the extent to which sharks use it is not well known. While taste bud receptors have been mapped in the mouths of some sharks, sharks do not have what we would consider tongues, and there is no evidence that they can discriminate between bitter, sweet, salty, or sour. From the limited research that has been conducted, it would

This chum slick attracts sharks by olfaction.

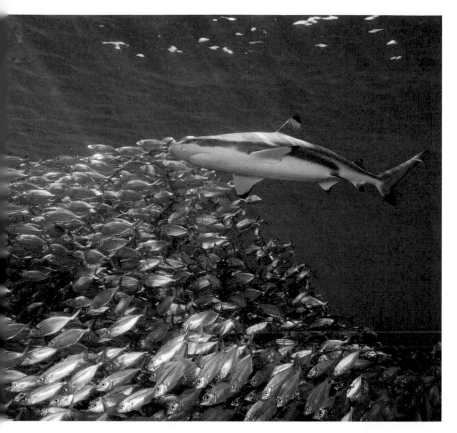

A blacktip reef shark glides over a school of fish.

appear that sharks use their taste buds primarily to determine what is and is not food. In my own experience, I have seen blue sharks approach and take both food and nonfood items in their mouths. In all cases, the latter were rejected and spit out, probably due to taste.

SOUND

Water is a much more efficient conductor of sound than air, so sound carries much farther and faster. Sharks do not make sounds, but their environment is loaded with sound generated by both living and nonliving things. Sharks

ANATOMY OF SHARKS

don't have external ears, but they have an inner ear that, like ours, is involved in both sound perception and balance. The auditory component of the inner ear consists of the *utriculus*, *sacculus* and the *lagena*, which house the sensory components of hearing, the *otoconia* and the *macula neglecta*. This inner ear structure allows for the directional detection of low-frequency sounds, like those generated by a wounded fish, from distances in excess of 270 yards.

TOUCH

All fish have a specialized sensory system called the *lateral line*, which allows them to detect water movements; this is called *mechanoreception*. Sensory receptors lying along the surface of the shark's body in low pits or grooves detect water displacement and, therefore, give the fish the sensation of feeling its surroundings, a bit like our sense of touch. This allows the shark to orient to water currents, avoid predators, detect prey,

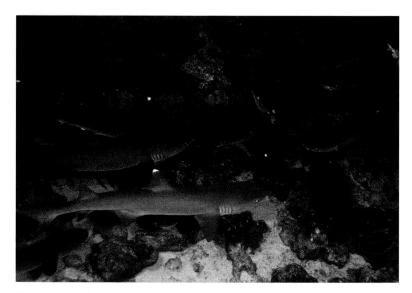

This pack of whitetip reef sharks relies heavily on sound and olfaction to hunt at night.

Inside this bull shark's nares, olfactory receptors perceive odors and communicate with the brain.

avoid obstacles, move in schools, and physically interact with other sharks. The mechanoreceptors are called *neuromasts*, which are composed of a group of sensory hair cells covered with a gelatinous *cupula*. On sharks, neuromasts can be found in a number of different arrangements. Those found in lateral line canals run along the length of the body to the tip of the tail as well as traversing various parts of the head. Individual neuromasts, called *pit organs*, are positioned all over the body of the shark, on the tail, and between the pectoral fins. This configuration can differ between species. For example, the spiny dogfish has less than eighty pit organs per side while the scalloped hammerhead has more than six hundred.

ELECTRORECEPTION

The ability of sharks, skates, and rays to detect electrical fields is a unique sensory capability. To do so, the fish have sophisticated electro-

sensory organs called the *ampullae of Lorenzini*, which allow them to detect weak, low-frequency electrical fields. Imagine being able to find your prey by sensing the incredibly low level of electricity that it generates. This would allow you to hunt at night or to detect a creature that is hiding in the sand. The electroreceptors also allow sharks to orient to local magnetic fields, which give them the ability to navigate. Each ampulla of Lorenzini, so named for the scientist who described them in 1678, is a small gel-filled chamber with sensory cells and a tubelike canal to the surface of the skin. On sharks, the ampullae are distributed and clustered all over the top and bottom of their heads. The sensitivity of these organs is amazing; research shows that sharks are able to detect electrical fields as low as one billionth of a volt. Although this low level of voltage is equivalent to a couple of small batteries spread thousands of miles apart, this is a near-field sense (within a few feet) that is not used by sharks to find prey over great distances.

The pores of the ampullae of Lorenzini dot the snout of this great white shark.

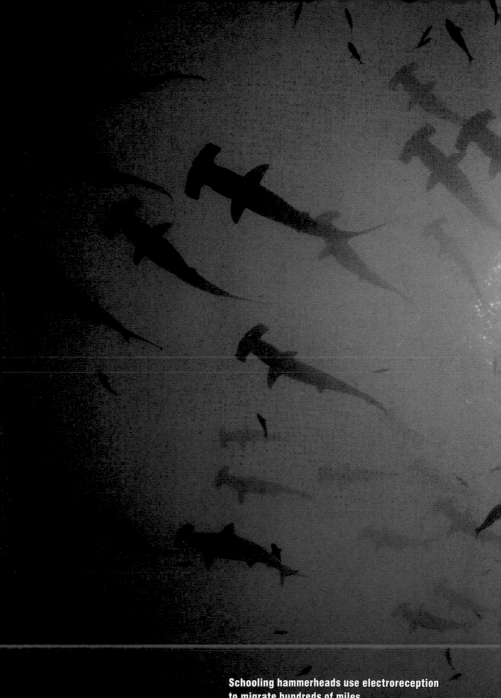

Schooling hammerheads use electroreception to migrate hundreds of miles.

What is the life history of this blue shark?

Life History of Sharks

Sharks are difficult to study. Consider this: a twelve-foot male blue shark is swimming 35 miles off the coast of Massachusetts in deep blue water. Where did he come from, and where is he going? Is he is going anywhere at all? How old is this big fish, and how long does he live?

How fast does he grow? Is he mature? If so, when and where will he find a female to mate with? How does he mate? What does he eat and how often? How does he spend his day, swimming at the surface or on the bottom? How fast is he? Does he have any predators? How does he interact with the environment and with other sharks?

These are all questions related to the life history of this shark. How would you answer these questions? The shark is too big to keep in captivity. The shark is too far offshore to directly observe. Even if you could find him, it's unlikely that you would be able to stay with him without influencing his behavior. The truth is, we know little about the life history of the 500 or so shark species because they are not easy to study.

In this chapter, we take a closer look at the life history and ecology of

Blood sampling a sandbar shark pup.

sharks—what we know and what we don't. In doing so, I'll give you a sense of how we go about answering these questions.

Distribution and Habitat

Sharks are distributed all over the world, from the tropics to the poles and from the shallowest seas to the deepest oceans. They've even penetrated freshwater lakes and rivers but not to any large degree. However, not all sharks live everywhere. In fact, each species is adapted to a specific habitat, and not all habitats are alike. The deep ocean is very different from the continental shelves. For anyone who has been to the tropics, you know that the warm crystal-clear waters are much more comfortable—for us at least—than the cool green temperate waters to the north. But if you can characterize a marine habitat, you can probably find a shark species that lives in it. In general, 50 percent of all elasmobranchs (including skates

and rays) live in waters bordering continents, while only about 5 percent live in the open ocean, and 5 percent live in freshwater. Only one group of sharks, the sleeper sharks, lives in polar waters. The deepest dwelling sharks, which include the sleeper, lantern, roughskin, cat, sixgill, gulper, and kitefin sharks, live below 3,000 feet deep. The deepest observed shark, a Portuguese shark, was at 12,000 feet, but this is rare.

As we learned in chapter 2, the morphology and physiology of a shark dictate how and where it lives. Nurse sharks, with their ability to stop swimming and their thick skin, prefer shallow coral reefs, while the porbeagle, with its sleek design and the ability to raise its body temperature, prefers cool temperate waters. Rarely would these two fish be found together. Closely related sharks, even from the same family, can live very different and separate lives. For example, two species of thresher sharks (family Alopiidae),

the common thresher and the big-eye thresher, live in very different parts of the same ocean. The common thresher is found from coastal areas to offshore and tends to associate with the upper parts of the water column. The bigeye thresher is named for its huge eyes, which it uses in the deep water habitat where it lives. It is, in fact, the ability of sharks to adapt to very different habitats that ultimately led to the diversity of species that we see today.

By far, most of our knowledge about shark distribution has come from those who make their living from the sea: fishermen. For as long as humans have gone to sea, they have encountered sharks. Over the centuries, fishermen's logs have helped us to map the distribution of sharks, to quantify the relative abundance of sharks, and even to conduct research on the life history of sharks. To this day, by knowing where and when fishermen catch sharks, we can get a sense of how shark populations are structured and whether or not they are changing.

Movements

Knowing where sharks live is one thing; figuring out their movements is another. Taking the tiger shark, for example, we can place small dots on a map of the Atlantic Ocean and say "this is where tiger sharks are found." That will give us their distribution but not information on their movements. However, there are ways to find out.

CONVENTIONAL TAGGING

The traditional method to investigate shark movements is called *conventional tagging*. The National

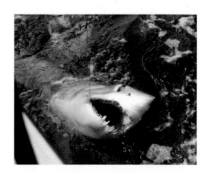

Much of what we know about sharks comes from the efforts of fishermen.

Marine Fisheries Service Cooperative Shark Tagging Program in Rhode Island is the largest and longest-running shark tagging program in the world. Since 1962, more than 8,000 cooperating recreational and commercial fishermen, fisheries observers, and biologists have participated in this tagging program. Through their efforts, more than 200,000 sharks of 52 species have been tagged, and 12,000 sharks of 33 species have been recaptured. When a shark is tagged, a small coded marker is placed on the fish, held in place by a dart inserted into the muscle, and the shark is released. If it is recaptured and reported, scientists have two data points, which give them not only distribution data, but movement over

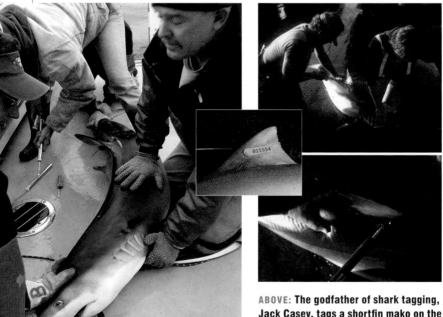

A blue shark is tagged with a satellite tag off the coast of New England.

ABOVE: The godfather of shark tagging, Jack Casey, tags a shortfin mako on the deck of a research vessel with the help of the author.
INSET: A roto-tag in the fin of a lemon shark.

time between the two points. For example, a blue shark tagged off of New York in August 1990 was recaptured off Portugal in January 2005. This not only showed that this species moves across the Atlantic but that the movement may also be related to time of year. By tagging and recapturing hundreds of blue sharks, a pattern of migration emerges.

Tagging data also yield rough estimates of swimming speed. On average, about 4 percent of the tagged sharks are recaptured, so this method does require a lot of tagging. Ultimately, tag-recapture data yield information on the horizontal movements of sharks from point A to point B but no sense of what the shark did vertically in the water column.

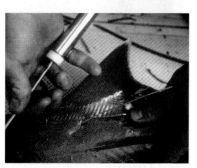

This tagging sequence shows a smooth dogfish being captured and tagged with a conventional tag before being released.

ACOUSTIC TELEMETRY

To examine minute-by-minute movements of sharks in three dimensions of the water column, we use acoustic telemetry, which simply involves placing a transmitter on a shark and following, or tracking, it. For example, we were interested in the behavior of blue sharks off the coast of Massachusetts, so we caught one, placed a pressure-sensitive transmitter on it, and followed the shark for several hours using an acoustic receiver and a hydrophone (underwater microphone). The high frequency sound pulses emitted by the transmitter were picked up by the hydrophone, relayed to the receiver, and broadcast to us. By pointing the vessel in the direction of the sound, we were able to follow the shark. After the tracking was over, we had information on where the shark moved and its swimming speed. The pressure-sensitive transmitter told us how deep the shark was swimming. We learned that this blue shark moved only about 1 to 2 miles per hour and spent much of its time swimming up and down from the

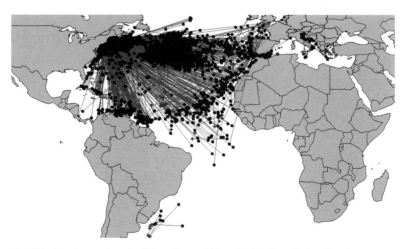

Tag (blue) and recapture (red) locations of blue sharks show their extensive movements and distribution in the Atlantic Ocean.

A receiver used for following acoustic signals.

surface to 60 to 80 feet deep. Dozens of shark species have been tracked with acoustic telemetry all over the world, ranging from the ever-exciting great white shark to the mysterious deepwater sixgill shark. While many species, particularly in warmer coastal waters, prefer to move along the bottom, others, like those that inhabit the open ocean, routinely move from the surface to great depths of 1,000 feet or more. Swimming speeds derived from these studies show that most sharks swim relatively slowly, only 2 to 5 miles per hour, most of the time.

Acoustic telemetry has its limitations: it's expensive, time consuming, and terribly short-term, lasting typically only a couple of days. So, you may get great high-resolution, three-dimensional data but only over small periods of time. While new technology now allows scientists to set up listening stations for sharks, this only works if the shark remains within the range of the station. This is ideal for baby sharks, which tend to remain in coastal estuaries, but most large sharks travel too far offshore for this to be feasible.

SATELLITE TAGGING

A more advanced, long-term tag can give you three-dimensional

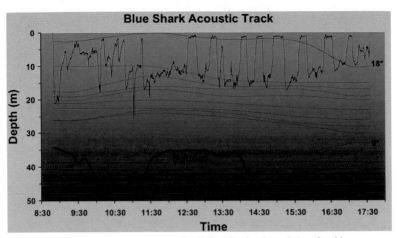

Blue Shark Acoustic Track

Depth (m)

18°

Bottom

9°

Time

8:30 9:30 10:30 11:30 12:30 13:30 14:30 15:30 16:30 17:30

The vertical movements of a blue shark off New England, as determined by acoustic tracking.

movement data and even water temperature, without having to remain with the shark. These tags are called *pop-up satellite archival tags* and, as the name implies, rely heavily on satellite communication to do most, if not all, of the work. These tags are placed externally on the shark like conventional and acoustic tags, but they contain a microcomputer that allows the researcher to program the tag to release from the shark. While on the shark, the tag collects and stores (archives) water temperature, depth, and light level data. After release, the tag floats to the surface and transmits this information to a satellite, which relays it to the researcher. With these data, you can see where the shark traveled both horizontally and vertically as well as those temperatures that it preferred. This technology has been around for about 20 years, and we have learned a lot about shark movements from these tags. For example, one of the big questions about basking sharks is where they go in the winter. Using these tags, we found that this species, the world's second largest fish, moves from its summer grounds off New

England to as far south as Brazil in the winter. What is even more fascinating is that once they leave New England, basking sharks spend all their time at depths of 1,000 to 3,000 feet. No wonder we didn't know where they went!

The latest and greatest innovation in tagging technology allows researchers to follow tagged sharks in near-real time. Smart Position and Temperature (SPOT) tags regularly transmit data to satellites, but their use is limited to animals that typically swim at the surface. While that excludes a great many sharks species, surface-swimming sharks have been outfitted with SPOT tags successfully. Enhanced with GPS technology, some of these tags can locate sharks within 30 meters. A quick search on your Internet browser will let you track some of these sharks, too.

There are trade-offs with each of these technologies and none of them are perfect. For example, real-time tags give great tracking data and can last for years, but yield no

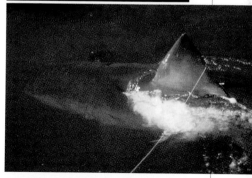

Pop-up satellite archival tags (middle photo) are used to study sand tiger (top), mako (middle) and great white (lower photo) sharks.

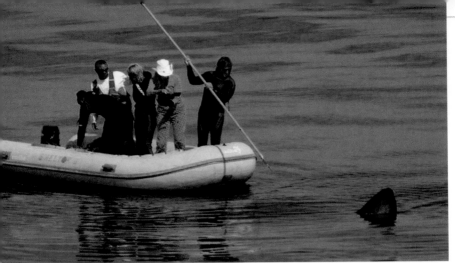

A basking shark is tagged by the author with a pop-up satellite archival tag.

The autonomous underwater vehicle SharkCam tracks and films white shark behavior.

depth information. On the other hand, pop-up tags collect lots of depth and temperature data, but poor position estimates and last less than a year.

Some new technology lets researchers see what's going on below the surface. Underwater drones such as the REMUS "SharkCam" which I developed with engineers at the Woods Hole Oceanographic Institution are equipped with multiple video cameras, and are able to locate, track, and videotape the behavior of tagged sharks. So far, the

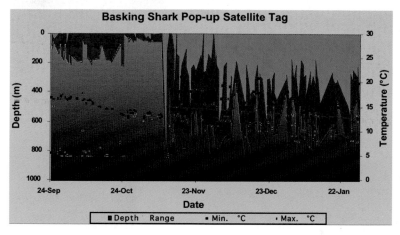

Basking Shark Pop-up Satellite Tag

■ Depth Range • Min. °C • Max. °C

The long-term vertical behavior of a basking shark as determined by pop-up satellite archival tagging.

REMUS SharkCam has been tested on basking sharks and great white sharks. The footage is remarkable, but the duration of these tracks is only up to several hours due to battery and camera limitations. One memorable deployment astounded us when we reviewed the video footage: the white shark had repeatedly attacked the drone, and it was all caught on tape! Luckily, the drone survived the attack.

Using all these methods, we now know that some species of sharks, like blue, tiger, mako, and sandbar sharks, make long seasonal migratory movements

(greater than 2,000 miles). The blue shark is good example. The same blue sharks that we see off the U.S. east coast move across the Atlantic Ocean to the other side and, in some cases, into the Mediterranean Sea. Great white sharks off California move as far west as Hawaii, and those off South Africa go to Australia and back again. But some sharks, particularly those living in the tropics, like great hammerhead, spinner, and blacktip sharks, make much smaller movements, typically less than 1,000 miles. Unfortunately, for most species, we haven't got a clue.

Feeding Ecology

What do sharks eat? As we saw in chapter 2, sharks display a wide variety of jaws and teeth, which are tightly associated with

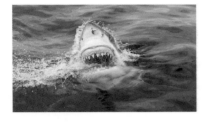

A white shark

what they eat. Sharks either ram, suction, bite, filter, or use a combination of these behaviors to capture prey. Ram and bite feeders, like great white, tiger, and blue sharks, use the subterminal (under-the-head) placement of the mouth to generate large biting forces with the huge muscle mass supporting the jaws. Coupled with protrusible jaws that can be extended forward, this great

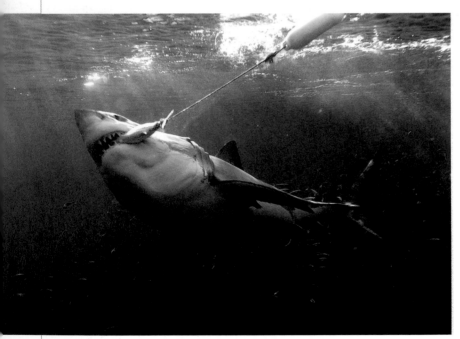

This great white shark bites down on a tuna bait with incredible force.

LIFE HISTORY OF SHARKS

force allows these sharks to cut through the hardest of prey items, including the bone, skin, shell, and muscle of fish, marine mammals, and turtles. Suction feeders, like nurse and horn sharks, can generate powerful suction to literally inhale their food, which includes lobsters and crabs, from the bottom. Filter feeders, like basking and whale sharks, have huge jaws but tiny nonfunctional teeth. These sharks push their way through the water with wide-open mouths sifting tiny marine animals, called *zooplankton*, with highly developed combs called *gill rakers*. It is incredible that the two largest fish in the world attain sizes in excess of thirty feet feeding on the smallest prey in the world.

There are some who believe that sharks eat people. This is simply not true. If sharks ate people, we would have a lot more shark attacks every year. In fact, with so many people flocking to the beaches, we would be providing plenty of food for them every day.

The basking shark (top) feeds exclusively on tiny plankton, while many other species, such as the lemon shark (bottom), prey on schooling fishes (middle).

By far, most shark species eat other fish and invertebrates, while a couple of species routinely consume marine mammals, marine reptiles, birds, or garbage.

While it would be great fun to swim with sharks all day and observe what they eat, this is hardly the easiest or the most realistic way to examine their diets. With over 30 years of experience diving with sharks, I've never seen one eat unless I or somebody else was feeding it. The traditional way to study what a shark eats is to look in its stomach, so for decades scientists have been cutting open shark stomachs to examine the contents. To avoid having to kill the sharks, some scientists are taking advantage of the fact that sharks can evert their stomachs. By inserting a tube down a live shark's throat and slowly retracting it, the stomach is pulled out and its contents removed. Although this sounds pretty traumatic, it does not cause damage to the shark, and it is much better than killing it. Of course, this does not work well on

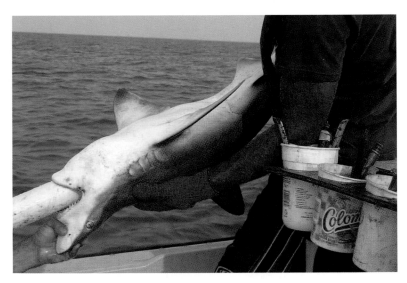

This tube is being used to examine the stomach contents of this live sandbar shark.

Some tropical sharks hunt nocturnal reef fishes.

large sharks for obvious reasons.

A very new way to see just what a shark's been eating involves DNA analyses of its stomach contents or fecal material. This method can identify species that can't otherwise be recognized and has enhanced our knowledge of feeding relationships. Another technique for examining the nature of what a shark eats involves examining the nitrogen and carbon composition of its tissues. This method, called *stable isotope analysis*, does not give you detailed information on diet, but it does reveal where the species fits into the food web.

Sharks in general are considered apex predators, meaning they are at the top of a food web. All are carnivorous, and don't eat plants. At least 70 percent feed on other fishes. While some appear to be pretty particular about what they eat, others will eat almost anything. Shortfin mako sharks living off the east coast of the U.S. prefer to feed on bluefish, which has been found in over 80 percent of the mako stomachs that have been examined. On the other hand, tiger sharks seem to eat anything, including fish, turtles, birds, seals, and garbage thrown from boats. By the way, sharks are fish too, so it is certainly not uncommon to find a shark in the stomach of another shark—sometimes it's the same species. At least one group of sharks, called cookiecutter sharks, is parasitic. These sharks, which are less than three feet long, swim up to whales, dolphins, and large fishes like tunas to gouge a nice melon ball-sized chunk of meat out of them with razor-sharp, lower teeth, then swim away.

The diet of a shark also depends on where it lives. Sharks are largely opportunistic feeders, meaning that they take what they can get and they feed when the feeding is good, but they may also have to fast for days if the feeding isn't good. For this reason, shark digestion is relatively slow when compared to other fishes. Less

Bluefin tuna and other large prey are known to be parasitized by cookiecutter sharks.

active, sedentary sharks, like the nurse shark, on average eat less than 1 percent of their body weight per day and may require three to four days to digest a meal. On the other hand, more active sharks, like the mako, tend to consume about 3 percent of their body weight per day, which for a 300-pound shark is about nine pounds of food; this is digested in a day or two. This amounts to about ten times its body weight per year. This sounds like a lot, but other fishes actually eat about twice as much food to meet their energetic needs.

Some sharks, like great whites, sixgills, tigers, and makos, change their food preferences as they get older and larger. All four of these sharks switch from small prey like fish and invertebrates to larger prey like marine mammals and turtles. This is largely because there is a greater energetic payoff for the energetic cost. Why chase

A belly full of sea lion (top) or dead whale (bottom) will sustain a great white shark for over a month.

around a whole bunch of small fish when you can effectively fill your belly with a single item? It's a bit like trying to make a meal out of lots of finger food instead of eating a big steak. But sharks can't just go to a restaurant and order; they need to work hard for each and every meal—so they might as well try to minimize the cost of feeding.

As I've tried to emphasize, sharks are all about energy efficiency, whether swimming or feeding. The ability to sustain themselves on small and infrequent meals and their slow digestive rates mean that sharks burn their fuel (oxygen and food) very efficiently. This "burn rate" so to speak, is called *metabolic rate*. Think of it as the fuel efficiency of your car. Some cars burn a lot of gas to get from the house to the grocery store, and some don't. Sharks are very efficient cars—their metabolic rates are low when compared to other fishes. For example, a fourteen-foot great white shark scavenging a whale carcass will consume sixty pounds of

Porpoises and dolphins are on the menu of large predatory sharks like shortfin makos.

meat and blubber. It has been estimated that this belly full of food may sustain the sharks for up to a month. So, you can imagine that a white shark is better off looking for (actually, smelling for) a whale carcass than chasing small fish.

Reproduction

We learned in chapter 2 that the reproductive strategy of sharks varies from egg laying to giving birth to live young, depending on the species. Regardless of how the young are born, all sharks must mate to make baby sharks. For many species of other fish, schooling facilitates spawning, so when the time is right, external fertilization takes place. (Eggs and sperm are released in the water, where they mix.) Most species of sharks, however, do not form schools and, therefore, must seek out mates when the time is right. There are exceptions. Scalloped hammerheads form schools numbering in the hundreds, and this is thought

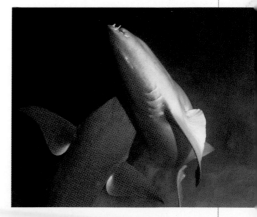

The nurse shark is one of the few species ever observed mating.

LIFE HISTORY OF SHARKS

to facilitate mating. Nonschooling sharks have evolved a number of strategies that put them in the right place at the right time for mating. This usually involves the migratory movement of a species to a specific area where mating occurs. For example, adult male blue sharks move into the offshore waters of the northeastern U.S. to mate with females during the spring and summer. Similarly, male nurse sharks in the Florida Keys move into the shallows to seek out and mate with females. In fact, the nurse shark is one of the few species of sharks ever observed mating. In essence, the male, sometimes with the help of other males, holds the female tightly by taking her pectoral fin into his mouth, then by twisting his body around hers, he is able to line up and insert a clasper into her cloaca.

In general, sharks do not mature until they are over 4 or 5 years old and, in some cases, in

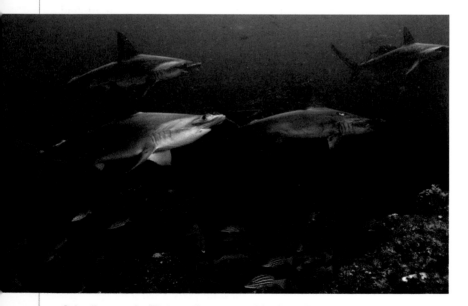

Schooling may facilitate mating opportunities in scalloped hammerheads.

This embryonic mako shark absorbs its large yolk sac before it is born.

excess of 20 years old—which is pretty late in life for a fish. Once mature, sharks typically mate in the spring and summer. Gestation, development of the young, typically requires 9 to 12 months, but can be up to two years, and the pups are born as tiny replicas of their parents. Males mate with multiple females, and females do the same. In some species, like the grey reef shark, pregnant females form groups, segregate from the males, and move to an area where they and their developing young are more protected. After birth, there is no parental care in sharks, so the young are completely on their own. In fact, the biggest enemy of a young shark is

a large shark. I once saw footage of a sandbar shark give birth in an aquarium. Before the pup could orient itself in the water column, a bull shark literally sucked the entire shark into its mouth and swallowed it. Life can be brutal in the shark world.

Had that pregnant sandbar shark given birth in the wild, she probably would have done so in or just outside of an estuary, where the young shark would have been afforded protection from larger sharks and other predators. The large bays and estuaries along the east coast of the U.S. provide important nursery habitat for a number of shark species, including the sandbar. Although the mother

Pregnant grey reef sharks form large aggregations to protect their developing young.

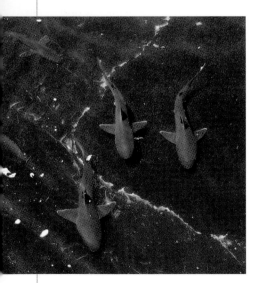

Newborn sandbar sharks cruise the shallow nursery habitat of Delaware Bay.

doesn't protect her young whatsoever, by pupping in or around these embayments, she is giving her young a much better chance of survival. In these areas, like Chesapeake Bay and Delaware Bay, young sharks have access to plenty of food as well as protection. The young sharks remain in these areas for the first summer or longer as they grow larger and more prepared for the open ocean. Shark nursery areas exist all over the world and, like most coastal waters, are becoming threatened

by human impacts. To protect the sharks, we need to protect their nurseries as well.

Age and Growth

Let's go back to that blue shark swimming off Massachusetts. We have already determined that we need to tag and track it to figure out where it goes, how it spends its time, and how fast it swims. We know now that we need to check its stomach to find out what it eats, which includes schooling fish, squid, and whatever it can scavenge, like dead whales. We also know that large adult males mate with females off the northeastern U.S., but nobody has ever seen two blue sharks mating. Now, how do we figure out how old it is? Well, there are a couple of ways to determine the age and, hence, growth rates of sharks.

The most obvious method would be to keep the shark in an aquarium and see how fast it grows and how long it lives. But most sharks, like the blue, don't survive in captivity. Moreover, even if they do, growth in captivity is typically faster than in the wild, because sharks are fed more frequently. The next best method is to use conventional tagging. Imagine that if we tagged and released a blue shark and measured it at about 3 feet when we did. Then the shark was recaptured 8 years later and it was 9 feet long. From this single tag-recapture, we can estimate growth rate and a minimum age. The shark grew 6 feet in 8 years (9 inches per year) and was at least 8 years old.

The most frequently used method, however, involves the

Rings in the cross-sectioned vertebra of a blue shark.

use of the shark's backbone, which grows much like a tree, laying down rings that can be counted to estimate age. So, a blue shark with twelve rings in its backbone might be twelve years old. This sounds like a pretty simple method, but sharks are not trees, so we really don't know if one ring is equal to one year. Also, you can't count the rings unless you remove the backbone, so you have to kill the shark.

Because these methods are difficult, we know the age and growth rates of only a fraction of the 500 or so species of sharks. However, from what we do know, sharks grow very slowly when compared to other fishes. In general, there is an initial phase during which sharks grow faster, about 6 inches to 2 feet per year, depending on the species, but this slows after the first couple of years to as low as just a couple of inches per year. Slow growth is probably

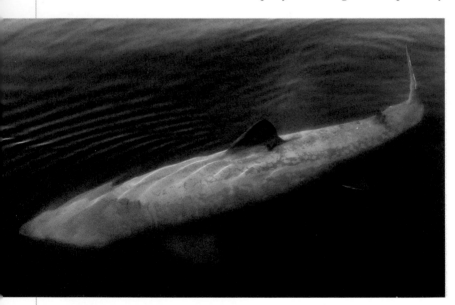

The age and growth rates of the basking shark remain a mystery because their vertebrae are difficult to interpret.

LIFE HISTORY OF SHARKS

a result of the low metabolism in many shark species. Also, when you consider that most sharks are born at pretty big sizes—1 to 3 feet—they have a much better chance of survival than tiny larval fishes. As you would expect, slow growing sharks also live a long time. For most species, we simply don't know, but we do know that sandbar sharks live over 30 years, lemon sharks over 50, whale sharks over 60, spiny dogfish over 80, and Greenland sharks over a 100 years.

In looking at the life history of sharks, we see a strategy emerge that is very much different from other fishes. The slow growth, late ages of maturity, high longevity, and low numbers of well developed young is in stark contrast to fast growth, high numbers of larval young, and short lives of most other fishes. Indeed, shark life history is remarkably similar to another group of successful animals; mammals. It was these same characteristics that led to

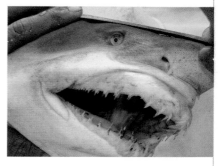

This young sand tiger needs sharp teeth and a full complement of senses to survive its early years.

the depletion of whales when they were hunted in the nineteenth and twentieth centuries. We must be vigilant to make sure the same does not happen to the sharks.

Natural Predators

Born at relatively large sizes, armed with toothlike skin, and more than capable of eluding most predators, sharks have few natural enemies. In the oceanic world, the general rule is if an animal is bigger than you, you just can't eat it. By far, most sharks are the hunters instead of the hunted. That's not to say that sharks don't end up on the dinner plate in the natural world. Certainly, sharks eat other sharks, and newborn pups

and young sharks are particularly vulnerable. All sharks are fair game to a bigger shark. Spiny dogfish are relatively small sharks (3 feet), and I've found their remains in blue sharks, threshers, and great whites.

But you don't have to be a small shark to be food. I once removed a 6-foot blue shark from the stomach of a 12-foot mako. Sharks also end up occasionally in the stomachs of other species. Again, this is particularly true of smaller sharks. Bluefin tuna in excess of 300 pounds are known to feed on spiny dogfish. There are also accounts of killer whale attacks on large sharks. In 1997, scientists watched a killer whale attack and consume a 12-foot great white shark off the coast of California. In 1998, four killer whales were observed attacking a group of six 7-foot-long sevengill sharks off the coast of Argentina. In New Zealand, researchers have observed killer whale attacks on five species of sharks, including blue sharks and mako sharks.

Parasites

The ocean is full of parasites, and sharks are in no way exempt from playing host to hundreds of species. There is almost no part of the shark, inside or out, that is not vulnerable to parasitic infestation. There are small shrimplike parasites, called *copepods*, that are perfectly adapted to securing themselves to the denticles of sharks. These parasites also live inside the mouth, swim up into the nasal cavities, and hang onto the gills. There is even one species that bores into the cornea of the Greenland shark's eye. Other small parasites include tapeworms, called *cestodes*, and roundworms, called *nematodes*, that infest the digestive tract, particularly the spiral valve. Sea lampreys will parasitize large sharks. I've seen 1- to 2-foot-long sea lampreys on basking sharks, feeding on skin and muscle, creating large white patches. Parasites have also been found in the muscle, liver, and kidneys of sharks. In one extreme case, two 9-inch eels

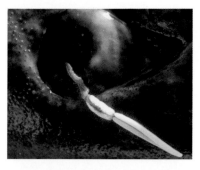

This parasitic copepod bores into the cornea of the Greenland shark's eye, rendering it virtually blind.

The sharksucker or remora (middle) uses its modified head to hitch a ride. Some sharks, like hammerheads, routinely visit cleaning stations to have parasites removed (bottom).

were found in the heart of a mako shark. Despite the downright ugliness of parasites, it is not in their best interest to do mortal harm to their hosts. Why kill the hand that feeds you? Therefore, sharks are not likely to be killed by their parasites. But that's not to say that sharks wouldn't mind getting rid of them. There are instances where sharks visit "cleaning stations" to have their parasites removed. Scalloped hammerheads are known to seek the assistance of small cleaner fishes that remove external parasites as the shark swims by.

Other fishes that associate with sharks include remoras, often called shark suckers, and pilot fish.

Remoras have a modified head that allows them to latch onto the surface of sharks and hitch a ride. Pilot fish swim close to sharks and are so named because they look like they are providing guidance. These species are not parasites. Instead, they opportunistically feed on the shark's table scraps, much like the way your dog snatches up food that drops to the floor.

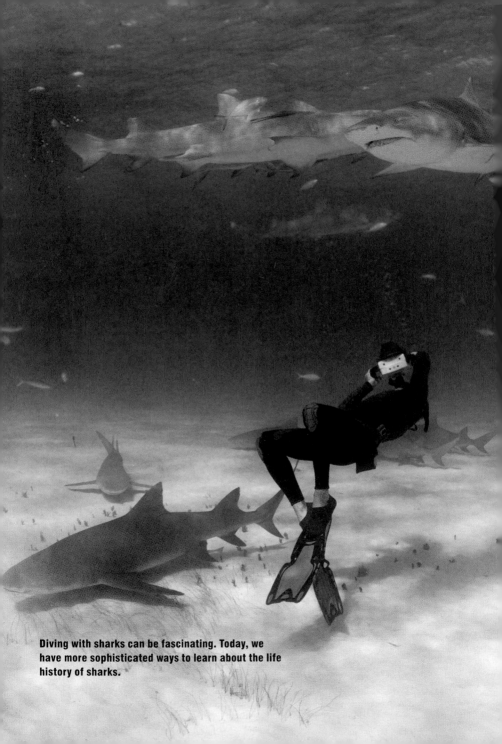

Diving with sharks can be fascinating. Today, we have more sophisticated ways to learn about the life history of sharks.

Shark Conservation and Use

Sharks have always fascinated humans. Indeed, history is full of shark folklore, as many primitive peoples worshipped, feared, and deified these fishes. But sharks have been hunted by humans as well—sometimes for products, sometimes for fun, and sometimes just because of the

misconception that sharks are bloodthirsty killers. Fortunately, the more we learn about sharks, the more people come to the realization that sharks are not really what we once thought they were. They are evolutionary marvels and critically important members of the marine ecosystem. Unfortunately, this has not stopped the killing of sharks. We now face the greatest level of shark exploitation by humans in history. Driven by growing populations and the fin trade, commercial landings of sharks and shark parts continues to grow. Without international management and conservation, the 450-million-year history of some shark species can come to an abrupt end.

Fisheries

Sharks are caught on all kinds of fishing gear, for both commercial and recreational purposes. Sometimes, they are caught intentionally in a directed fishery, or they may be caught unintentionally as bycatch. Regardless, fisheries for sharks have exploded over the last few decades.

This pilot fish stays close to a blue shark, but couldn't keep it from being hooked.

RECREATIONAL FISHERIES

Fishing is fun, so there are a lot of folks who go shark fishing for the enjoyment of reeling in a big fish. For much of the twentieth century, traditional big-game fishing did not include sharks; it centered on marlin, tuna, and swordfish. It was not until Hollywood portrayed the shark as a menacing maneater in the mid-1970s that sport fishing for sharks really took off. At that time, shark fishing tournaments, particularly off the east coast of the U.S., attracted hundreds of big game fishermen each year in competition to catch the biggest shark. In those days, there were no regulations pertaining to sharks, and it was not unusual to see dozens dead on the dock during one of these events. Harpooning big great white sharks

was also popular at this time. In 1983, I had the opportunity to examine and dissect a 17-foot great white that had been harpooned off New York. Aside from the scientific value of this shark, much of it, except for the jaws, ended up in the dumpster.

In the early 1990s, the U.S. government began to regulate shark fishing, but much of the data needed to do so were lacking. Given the popularity of sharks, it was remarkable that we knew so little about how they live. So,

research began to focus on shark life history, thereby shifting from the previous emphasis on shark attacks. Early regulations placed limits on both recreational and commercial fishing. As we learned more and more about sharks, public attitudes started to shift from the feeling that the only good shark is a dead shark. Recreational fishing ethics also changed, and more and more fishermen began to practice catch-and-release. Many joined the Cooperative Shark Tagging

Recreational fishing for sharks, like this blue, is popular off the eastern U.S.

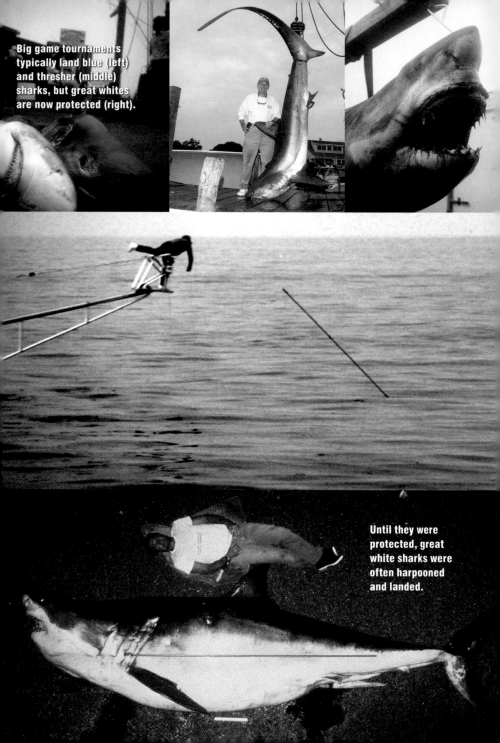

Big game tournaments typically land blue (left) and thresher (middle) sharks, but great whites are now protected (right).

Until they were protected, great white sharks were often harpooned and landed.

Program, and shark tournaments implemented high minimum sizes, bag limits, and awards for catch-and-release. Although shark tournaments remain—after all, shark fishing is still fun—most follow strict conservation-based rules, thereby reducing the number of sharks brought to the dock.

COMMERCIAL FISHERIES

Sharks have been harvested for commercial products for centuries. The most obvious is meat for food, but skin has been used to make leather called *shagreen*, teeth to make weapons and tools, livers for oil and vitamins, cartilage for health pills, jaws and teeth for curios and jewelry, and fins for soup.

Despite the long history of shark exploitation, it was not until the 1980s that directed fisheries for sharks exploded. For the most part, shark meat was considered unpalatable because of its high urea content. However, a decline in traditional food fisheries and the development of new techniques for preparing and preserving shark meat made it more marketable. At the same time, opening trade opportunities in China and the dramatic growth in the consumption of shark fin soup in the Far East fueled the rapid proliferation of shark fisheries throughout the world. Driven by these forces, worldwide shark landings are now thought to be in excess of 100 million sharks per year, including skates and rays. These numbers may not take into consideration those sharks killed as bycatch.

The bycatch (unintended capture of a shark) may result in the shark being released alive, discarded dead, or finned. Shark finning involves the capture of a shark, the removal of its fins, and the subsequent discard of the rest of the shark. In many cases, the shark is still alive when discarded, but it will not survive for long; the shark either drowns or starves to death because it cannot swim properly.

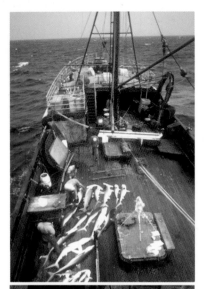

Worldwide, millions of sharks are killed each year by commercial fishing operations.

By the end of the 1990s shark management measures that placed strict controls on commercial fisheries were implemented in the U.S. Shark landings were reduced substantially, and the practice of finning was outlawed. Commercial fishermen also joined the Cooperative Shark Tagging Program, thereby contributing to research as well as the management process.

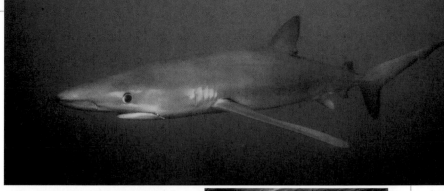

Many species of sharks, like the blue sharks shown here, are caught as bycatch, and then released or finned.

Diving with Sharks

I've been diving with sharks for over 30 years; most of this has been to photograph them, to study them, or both. There was a time when the only people voluntarily swimming with sharks were those, like me, who were studying them or filming them. However, in the age of bungee jumping, sky diving, and X Games, diving with sharks is just another fun thing to do. This has been facilitated by the discovery of shark hotspots, where it is economically feasible for a dive operator to consistently take clients to dive with sharks.

Shark diving has taken off all over the world. You can dive with great white sharks in Australia, South Africa, and Mexico; Caribbean reef and tiger sharks in the Bahamas; scalloped hammerheads in the Galapagos; grey reef sharks in Palau; or blue sharks in New England. Just pack your gear and bring your camera—your wallet will be needed as well. These adventures are exciting, safe, and expensive, but in most cases, worth every penny.

With few exceptions, these operations generally involve boarding a boat, steaming to a site, and chum-

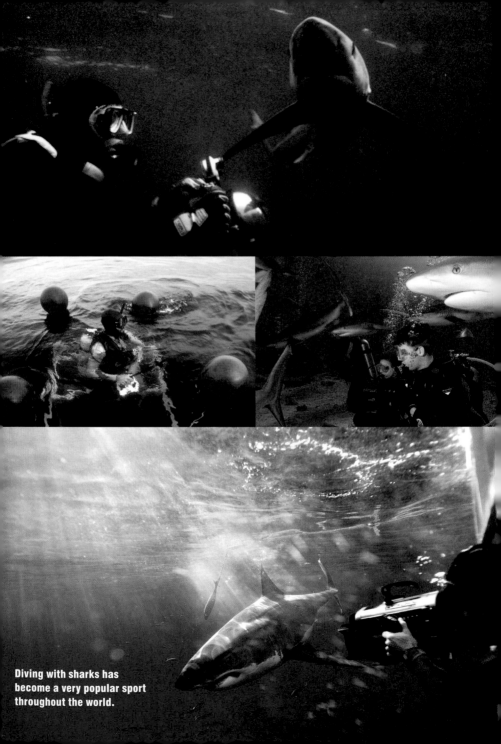

Diving with sharks has become a very popular sport throughout the world.

ming the waters to attract sharks. For some dives, particularly those with great whites, protective cages are necessary. There is some concern among researchers and others that shark diving operations draw sharks into coastal waters and stimulate them to feed, thereby increasing the risk of shark attacks in nearby areas. Others feel that conditioning sharks to the presence of divers with food can increase the potential for shark attacks on div-

ers. With the jury still out and little or no data to support these contentions, shark dive operators believe that the experience of diving with sharks far outweighs these risks.

Shark Conservation

COUNTING SHARKS

How many sharks live in the Atlantic Ocean? We are not even sure how many species of sharks live in the Atlantic, so you can imagine that counting the actual number

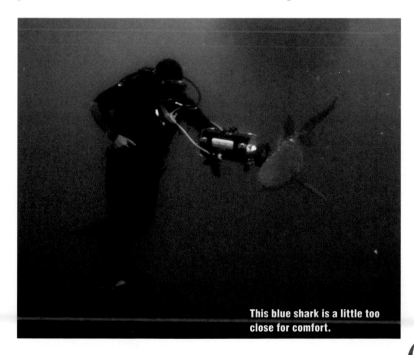

This blue shark is a little too close for comfort.

within each species is even more problematic. Unfortunately, as long as sharks are harvested or even just interact with fishing gear, we need to know the answer to this question. Since it is virtually impossible to actually count sharks, we rely quite heavily on estimating their

A blacktip shark poses for a photographer in French Polynesia.

population size by counting the number of sharks landed by fishermen and taking into consideration the rates at which they are caught. For some species, research cruises are conducted to assess the relative abundance of sharks in a particular region. For example, if a research or fishing vessel sets 1,000 hooks in the same place every year and catches 200 sharks the first year, then progressively fewer and fewer sharks until the tenth year when it catches only 20 sharks, then this time series of data indicates that the relative abundance and perhaps the population may be declining.

Estimates of shark populations are critical to conservation. If we don't know how many sharks are out there, then we can't estimate the impact of fishing on shark populations. But we also need to know basic life history information, like age and growth, reproduction, distribution, and movements. In essence, we need to know how fast a species can replace itself in the face of exploitation. Incorporating life history information, landings, and relative abundance estimates to assess the status of a species involves a lot of complex math, assuming we know all this information, which for most sharks, we don't. Ultimately, in the ideal world, information based on assessments allows governments to set limits on commercial and recreational fishermen so that utilization is balanced with conservation, and shark populations are maintained at sustainable levels. Unfortunately, the real lack of species-specific assessments makes it difficult to set limits and implement management. For

Shark research cruises must also deal with foul weather.

many shark species, the problem is further complicated by the fact that fish know no boundaries. So, a species may be conserved in one country but harvested without limits in another.

MANAGEMENT

For those shark species that have been assessed, there are strong indications that populations are not healthy. While one or two studies indicate that certain species, like the great white shark, have been depleted by over 75 percent, others indicate that declines are not that extreme. The general life history characteristics of sharks noted in the last chapter mean that most shark populations cannot tolerate a lot of fishing pressure. Given the numerous historical examples where shark populations have crashed due to an unsustainable harvest, we know that a precautionary approach to management is warranted. For many shark species, which do not stop at the border, we need an oceanwide

approach to conserve them. For example, we know from tagging data that the blue shark traverses the Atlantic and is harvested by no less than twenty-five countries. Without the cooperation of all or most of these countries, conservation efforts may fail.

Because real estimates of population size are lacking for most shark species, the International Union for the Conservation of Nature and Natural Resources (IUCN) has assembled as much information as possible in an effort to evaluate their conservation status. To date, the IUCN has evaluated 475 shark species. Fifteen percent were categorized as Critically Endangered, Endangered or Vulnerable; 13 percent as Near Threatened; 29 percent as Least Concern or lower risk (of extinction); and 43 percent lack sufficient data to draw conclusions.

In the U.S., shark management is the responsibility of the National Marine Fisheries Service and coastal states. The U.S. has imple-

mented a number of measures to control shark fishing activities and promote conservation. Several species, including the great white shark, have been protected from harvesting, and finning is not a legal fishing activity. U.S. fishermen are doing their part, but few countries have followed suit, and global shark management is lacking. In an effort to jump-start a global initiative, the United Nations Food and Agricultural Organization adopted a voluntary measure calling for countries to initiate shark management. However, only a handful of the 113 countries known to have shark landings have reported any progress.

Around the world, fish markets offer a variety of species for sale as food.

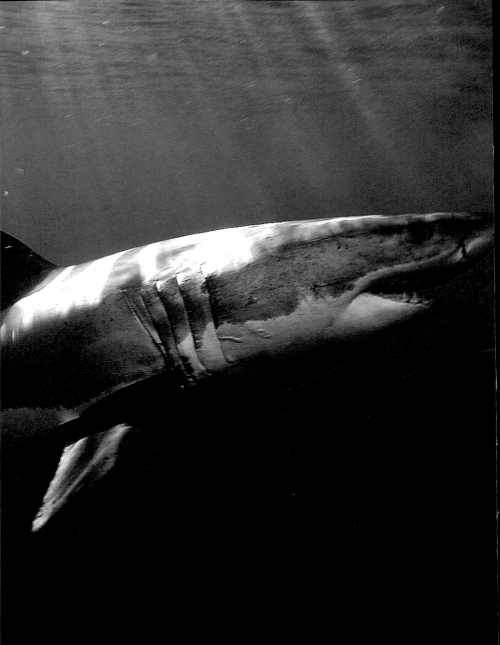

The great white shark has been implicated in
more shark attacks than any other species.

Shark Attacks

Nothing chills the bones more than the thought of being attacked by a wild animal. While most people know that they will never encounter a lion or grizzly bear, somewhere in the back of some folks' minds is the feeling that being attacked by a shark is within the realm of possibility.

This cannot be further from the truth. In fact, the probability of shark attack is so low that I hesitate to discuss the subject. When I lecture to general audiences, I rarely mention or discuss shark attacks, simply because I know that virtually everybody in the room is more susceptible to harm from their own toilets than from sharks. Yet when I poll those same audiences, I am always surprised at the number of people who fear sharks to the extent that they will not go swimming at any beach at any time.

The File

In the late 1950s a group of shark researchers started the International Shark Attack File (ISAF), an authoritative compilation of all known shark attacks. With reports dating back to the late 1500s, the ISAF is housed at the Florida Museum of Natural History and administered by the American Elasmobranch Society, a professional organization of shark scientists. To date, the file houses over 4,000 shark attacks, each based on eyewitness accounts, newspaper articles, and/or photos.

Some areas are more prone to shark encounters than others.

Shark attacks on humans are quite rare, but some situations are riskier than others.

The long-term trend indicates that the number of shark attacks has increased from less than 50 during the first decade of the twentieth century to over 700 during the last decade. ISAF researchers, though, are quick to point out that this rise is likely associated with an upsurge in the number of people going in the ocean and not an increase in the rate of shark attacks. People are drawn to the shoreline—just look at any tourist agency ad and you will see white sandy beaches synonymous with relaxation and vacation. Throw in all the new and exciting water sports that have developed over the last century, like scuba diving, surfing, and spearfishing, and

you have millions more people in the water than a hundred years ago. It only makes sense that as more and more people go in the water, the chance that they are going to encounter sharks is likely to increase. This growth in shark attack reports is also related to the fact that the ISAF has gotten much better at tracking shark attacks. In the early part of the century, there was no ISAF, so they had to rely on published reports during a time when communication was nothing like it is today.

From 2005 to 2014, 702 shark attacks were recorded by the ISAF worldwide. Most of these (31 percent) were reported from the state of Florida, but others occurred frequently in Australia (18 percent), Hawaii (8 percent), South Africa (6 percent), South Carolina (5 percent), and California (5 percent). On average, about 70 shark attacks were reported worldwide every year, but there are probably another 25 to 50 attacks that are not reported. Most victims are surfers, followed

by swimmers and then divers. It is important to note that by far most of these attacks are minor, resulting in flesh wounds and abrasions that are quickly and easily treated. This is further supported by the fact that only about 10 percent of all the shark attacks reported to the ISAF since 1990 have been fatal. When you consider that over 33,000 people die in car crashes, and thousands of people die from the common flu every year in the U.S. alone, you can see that shark attack is not the reason to run out and buy life insurance. Putting this into the context of beach-related fatalities, the ISAF

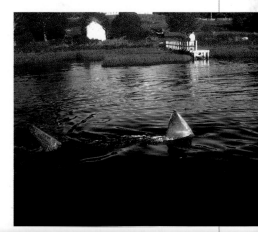

A white shark off New England.

concluded that the odds of suffering a drowning or other beach-related fatality were 1 in 2 million, whereas the risk of being attacked by a shark was 1 in 11.5 million and the odds of a shark-inflicted fatality were 1 in 264.2 million.

The Suspects

It is extremely difficult to positively identify the species involved in a shark attack, but the ISAF has been able to do so in more than 1,200 cases. If we only examine those that were positively unprovoked (about 50 percent), during which the victim did not instigate the attack in any way, then the most frequent species implicated in the attacks were: great white (38 percent), tiger (13 percent), bull (12 percent), unidentified requiem sharks (6 percent), blacktip (4 percent), sand tiger (4 percent), wobbegongs (3 percent), unidentified hammerheads (2 percent),

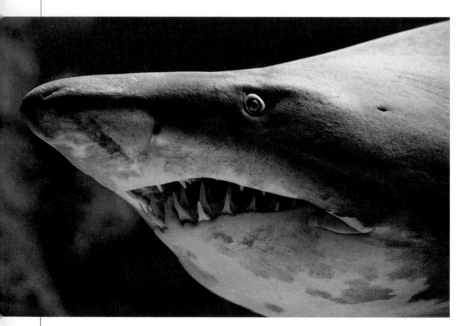

An arsenal of shark teeth make sharks like this sand tiger formidable predators, but attacks on humans are rare.

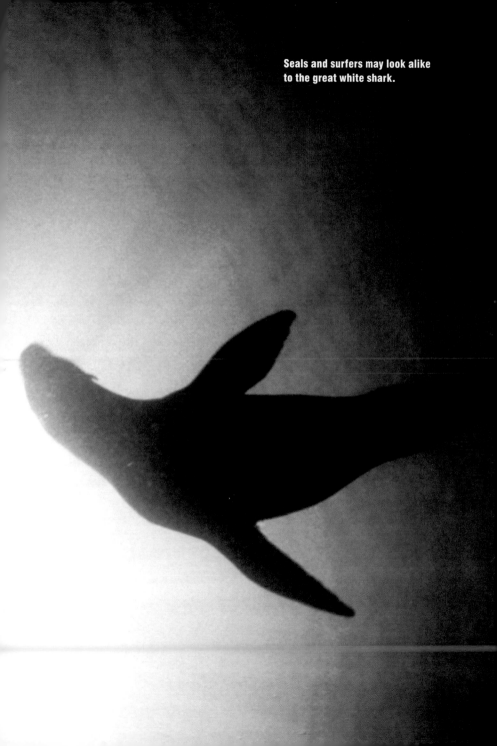

Seals and surfers may look alike to the great white shark.

and 25 other species. ISAF personnel acknowledge that the list may favor those species that are easy to identify, but there is strong evidence, nonetheless, that the great white, tiger, and bull sharks are the top three species most likely to be implicated in attacks on humans.

The Motives

The study of shark attacks is a largely inexact science because it is virtually impossible to determine the motives for such attacks. In almost all cases, the perpetrator of the attack is not apprehended and in those cases when it is, it's simply not talking. Scientists can only really examine the various aspects and details of the attack and compare them to what is known about the behavior, life history, and ecology of the shark species that are implicated.

What do we know about the life history of great whites, tigers, and bulls that would help us to determine why these three species are occasionally, albeit rarely, motivated to attack humans? In

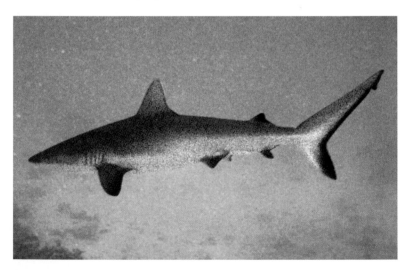

The grey reef shark often changes its swimming behavior before an attack. Its agonistic behavior serves as a warning to human divers.

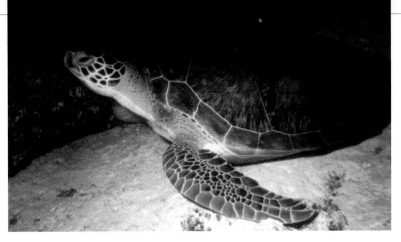

Large sea turtles are commonly natural prey for tiger sharks.

looking at the diet and feeding ecology of great white, tiger, and, to a lesser degree, bull sharks, we know they feed on large prey, including marine mammals, when they attain sizes greater than 8 feet. We also know that they ambush their prey with speed and stealth, typically producing a large wound, which causes the victim to bleed to death. This information has led researchers to conclude that attacks by these species are likely associated with mistaken identification for different prey, namely a seal, sea lion, turtle, or dolphin. The fact that most victims are not consumed suggests that the shark may realize

that it has made a mistake, based on taste or texture, and abandons the prey or that rescuers intervene before the hungry shark could have its meal. Unfortunately, a bite from one of these sharks is significant and results in victim mortality about 25 percent of the time.

Bull and other requiem sharks typically feed on a variety of fish species in shallow waters with poor visibility during periods of low light, namely at dawn and dusk. Shark attacks are known to occur in coastal areas during this time of day as well as in murky waters. I have personally caught and tagged bull sharks off the coast of Louisiana in

water that looked like coffee—I did not want to fall overboard. It is certainly possible that attacks in these areas at this time of day are also related to feeding behavior by bull and other requiem sharks.

There are also indications that shark attacks may be related to some kind of territorial defense. Some sharks, like the grey reef shark, display conspicuous swimming patterns that are seemingly meant to warn a trespasser. Such agonistic displays often result in an attack if the intruder does not leave the area immediately. Shark attacks, therefore, may result from a victim's unintentional infringement on a shark's space. The fact that male bull sharks are known to have higher levels of testosterone than other species may exacerbate the situation and predispose this species to be more defensive.

Avoiding Shark Attacks

Although the risk of shark attack is incredibly low, there are times and places where the probability of a shark attack moves above zero. It is best for logic to prevail. For example, you should not be concerned about shark attack in places where aggressive coastal sharks simply do not occur in large numbers. However, if you are in an area where shark attacks have been documented, knowing that coastal sharks tend to feed at dawn or dusk is something to keep in mind when swimming. Since sharks are more likely to attack individuals, swim in groups—this is a good safety measure regardless. Stay close to shore, do not swim with an open wound, and avoid wearing shiny jewelry. Murky waters and sandbars are good feeding areas for sharks, because they can ambush prey, so don't put yourself in the position of becoming prey. Finally, don't harass, bother, touch, or grab a shark in any way—this may provoke an attack. Although this seems like common sense, many a fool has done it.

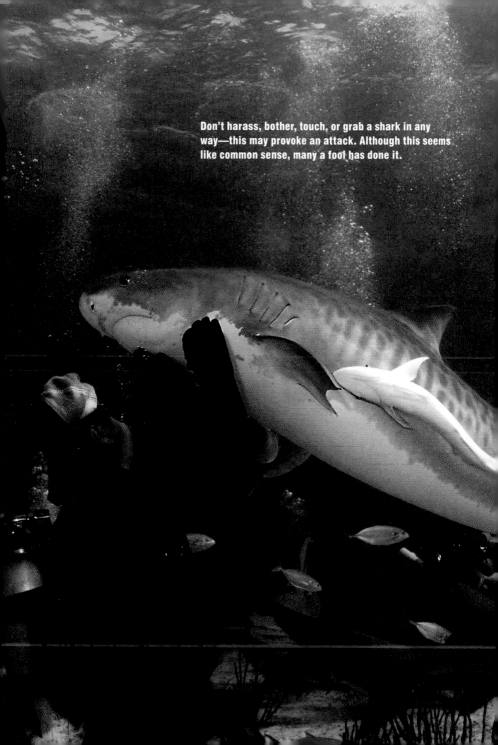

Don't harass, bother, touch, or grab a shark in any way—this may provoke an attack. Although this seems like common sense, many a fool has done it.

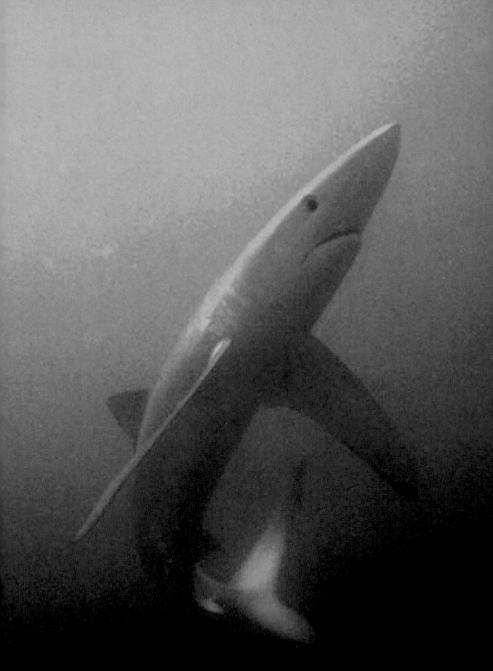

This graceful blue shark is one of over
500 species of sharks.

Shark Classification

Scientists classify all living things on earth, and sharks are no exception. Since the balance of this book lists and describes over 500 species of sharks, it is important to have an understanding of how these fish are classified. I'm going to review the taxonomy, or classification, of sharks. Like all

fishes, sharks are classified using similar attributes, like various morphological characteristics including skeletal shape and number of vertebrae. In recent times, genetic analyses have allowed researchers to examine the evolution and relationships among living as well as fossilized sharks. While there is always ongoing debate and discussion about how sharks are related and named, I'm going to present the most widely accepted classification.

Taxonomy

Because humans speak so many different languages, the naming of living creatures can be a problem. For example, *shark* in English is *tiburon* in Spanish. To get around the confusion associated with language differences, a Latin-based scientific naming scheme, now called *binomial nomenclature* ("two names"), was established by Carl Linnaeus in 1735. The Linnaean system classifies all living things in a hierarchy. At its lowest level,

an individual type of creature is given a scientific name composed of two parts, the genus and species. Very closely related species belong to the same genus. For example, the genus *Carcharhinus* contains at least 31 closely related species including the bull shark *Carcharhinus leucas* and the dusky shark *Carcharhinus obscurus*. If you look at these two fish, you can see that they are extremely similar.

This classification scheme continues as you group similar genera (plural for *genus*) into families. Then you group similar families into orders, similar orders into classes, and similar classes into phyla (singular is *phylum*). All the different phyla make up the kingdom that we call Animalia for the animals. There are also subdivisions of these categories, like suborder and infraclass. The basis of establishing these groups rests on the phylogeny, or ancestral lineage, of these animals. Taking this into consideration, we can assume that families and orders of sharks

are grouped in such a way as to imply that they evolved from similar common ancestors.

Living Sharks

As we saw in chapter 1, sharks and their cartilaginous cousins belong to the class Chondrichthyes. The chondrichthyan fishes are vertebrates, like mammals, reptiles,

Stingrays of the superorder Batoidea are the closest relatives of sharks.

birds, and amphibians, belonging to the subphylum Vertebrata, which belongs in the phylum Chordata. All the chordates are animals, so, as opposed to plants, these critters belong to the Kingdom Animalia.

This is a shark book, so let's talk sharks. Since sharks, rays, and chimaeras look very different, the class Chondrichthyes is subdivided into the subclasses Elasmobranchii, which includes the sharks and rays, and Holocephali, the chimaeras. To further differentiate between the sharks and the rays, the elasmobranchs are broken into the Superorder Batoidea, the skates and rays; and the Superorder Selachimorpha, which are the sharks.

We know from the previous

chapters that not all sharks look, live, or act alike, so science has grouped them based on those attributes that they share. Superorder Selachimorpha (sharks) contains eight orders: Carchariniformes, Lamniformes, Squaliformes, Pristiophoriformes, Orectolobiformes, Hexanchiformes, Heterodontiformes, and Squatiniformes. All of the 500 or so species of living sharks are grouped into families that fall under one of these orders.

For example, the great white shark has the genus and species name *Carcharodon carcharias*. It belongs to the family Lamnidae, the order Lamniformes, the superorder Selachimorpha, the subclass Elasmobranchii, the class Chondrichthyes, the superclass Gnathostomata, the subphylum Vertebrata, and the phylum Chordata. By tracing this hierarchy, we can trace the evolution of this species and its closest relatives.

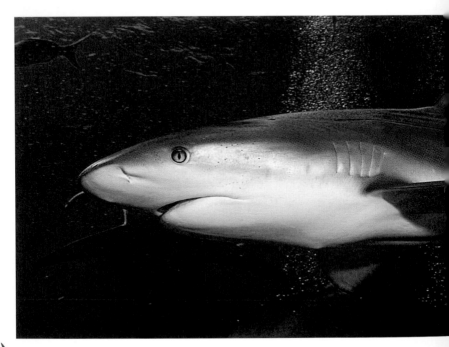

SHARK CLASSIFICATION

Shark Orders

The balance of this book takes a look at all the shark species recognized to date. In total, 513 sharks in 34 families are listed. This, however, does not represent all known living sharks, because there are more species that have been identified and have yet to be properly named.

To add some order, so to speak, to the balance of the book, I've listed the sharks by taxonomic grouping. The next five chapters cover the eight recognized orders. Each order is broken down by family, then genus and species. Don't fret—for each of the shark species, I refer to them by their most common name, so you won't have to learn Latin. Because it is beyond the scope of this book to examine each species in detail, I have featured those sharks that are most common, least common, most unusual, or just plain interesting.

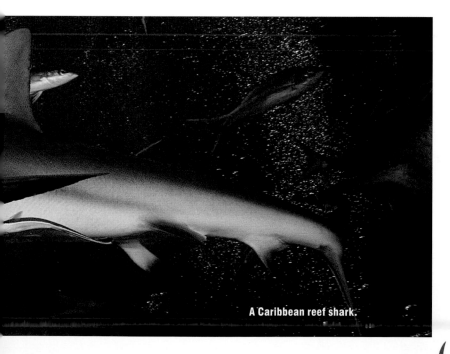

A Caribbean reef shark.

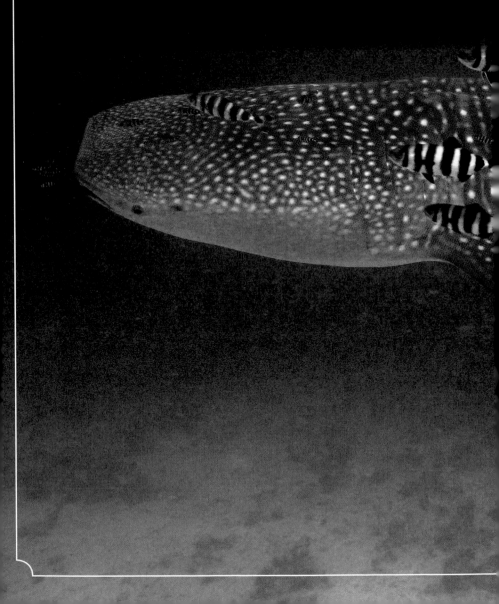

"Sharks remain a wild riddle of sorts, a kind of real-life monster that fuels the human imagination and makes life a bit more exciting."

TYPES OF SHARKS

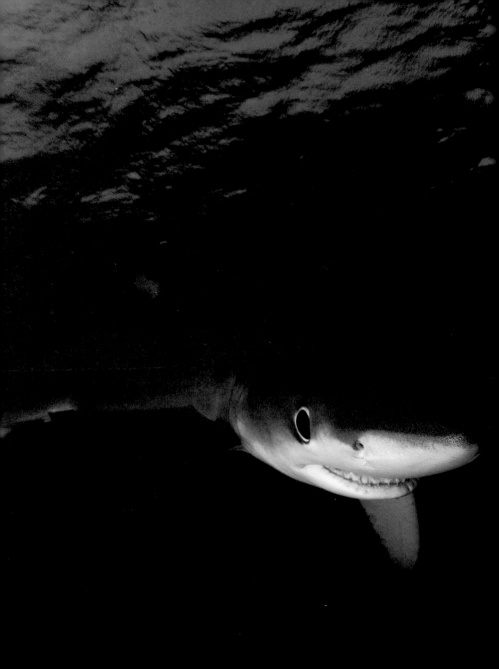

The blue shark is probably the most abundant large shark in the world.

Ground Sharks
Order Carcharhiniformes

Commonly called the ground sharks, this order contains 56 percent of all living sharks and is comprised of nine families, over fifty genera, and at least 289 species. These sharks have the classic shark shape with two dorsal fins, an anal fin, five gill slits, a mouth that sits under the eyes (a position referred to as *subterminal*), and nictitating membranes to protect the eyes. This order contains one of the most popular families, the Carcharhinidae, which includes sharks like the tiger, the bull, and the blue.

FAMILY: Requiem Sharks (Carcharhinidae)

- **Number of Species:** 59+
- **Size:** Small (3 feet) to very large (20 feet).
- **Distribution:** Worldwide in tropical and temperate waters.
- **Habitat:** Shallow coastal waters to surface waters of the open ocean; rivers and estuaries; coral atolls and lagoons; family includes only known freshwater sharks.
- **Behavior:** Highly active sharks; many are migratory and capable of long oceanic voyages; many travel alone, but some form social groups; many are nocturnal; some have been implicated in attacks on humans.
- **Reproduction:** Placental and aplacental viviparity.
- **Feeding:** Very broad range of prey items including fishes, seabirds, marine reptiles, invertebrates, marine mammals, carrion, and garbage.
- **Population Status:** Most are fished commercially and recreationally throughout the world for fins, meat, liver oil, and skin.

TIGER SHARK

Galeocerdo cuvier

The tiger shark, *Galeocerdo cuvier*, is a robust species of shark that is very easy to identify with its characteristic tiger stripes and large blunt head. It is also a species that has a very unique tooth shape that cannot be confused with that of any other shark.

Sometimes referred to as the "swimming garbage can," the tiger shark is not incredibly selective about what it consumes. In the mid-1900s, it was well-documented that tiger sharks took up residence around slaughterhouses that routinely discharged their scraps into the ocean. It was also not unusual for boat captains to report the presence of tiger sharks following their vessels, gobbling up garbage and waste as it was disposed at sea. Personally, I've had the chance to examine a few tiger shark stomachs over the last 30 years. During one research cruise off the coast of North Carolina, we found a tiger shark stomach containing the remains of a sea turtle, five horseshoe crabs, a sea bird, and a fast-food wrapper. Not only does this confirm that the tiger shark will eat just about anything in the ocean, it also indicates that it will move from the surface (bird) to the bottom (crab) to feed.

Tiger sharks can be found in shallow, coastal waters.

Second only to the great white shark, the tiger shark has been implicated in more documented attacks on humans than any other species. This is likely related to two aspects of the shark's biology. First, as previously noted, it will eat almost anything. Second, there is strong evidence that the tiger shark eats larger prey as it grows.

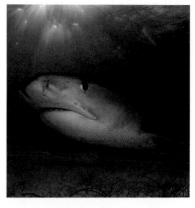

With its large blunt head, the tiger shark is easy to identify.

TIGER SHARK

- **Identification:** Large head with blunt squared-off snout, wide mouth with upper labial furrows that reach eyes, large spiracles, notched teeth with heavy serrations and cusplets, weak caudal keel. Grey dorsal surface with characteristic dark, vertical tigerlike bands that fade with increasing size.

- **Size:** Birth: 2.1–2.8 ft.; Maturity: 9.5 ft. (male), 9.5 ft. (female); Maximum: 20 ft.

- **Distribution:** Worldwide from warm tropical waters seasonally to warm temperate zones.

- **Habitat:** Shallow coastal waters to surface waters of the open ocean; river estuaries; coral atolls and lagoons.

- **Behavior:** Highly migratory; capable of long oceanic voyages; occurs singly, but may form aggregations when feeding; nocturnal, moving inshore during the night; typically exhibits slow cruising behavior, but capable of bursts of speed during feeding; attacks on humans are well documented.

- **Reproduction:** Ovoviviparous; 12-month gestation; 10–80 pups.

- **Feeding:** Very broad range of prey items including fishes, other sharks, sea birds, turtles, sea snakes, invertebrates, marine mammals, and garbage.

- **Population Status:** Common in many areas, but population estimates are unknown; fished commercially and recreationally throughout the world; IUCN Red List: Near Threatened.

Therefore, large tiger sharks may confuse a human being for large prey, like a seal or turtle. However, like all shark attacks, those of the tiger must be put into perspective. From 1580 to 2014, only 111 unprovoked tiger shark attacks have been documented by the International Shark Attack File. Therefore, there is a very low probability of being attacked by a tiger shark. I've always said that it is more probable that you will be hurt in a car on the way to the beach than by a shark attack when you get there.

The tiger shark is currently taken by commercial and recreational fishermen all around the world. Some countries, like the United States, have catch limits and quotas for sharks, but most countries do not. Scientists have yet to conduct a formal assessment of regional tiger shark populations, but there are indications that declines have occurred in some areas. Clearly, international shark management is much needed.

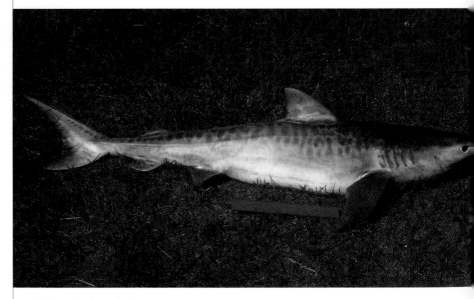

A juvenile tiger shark.

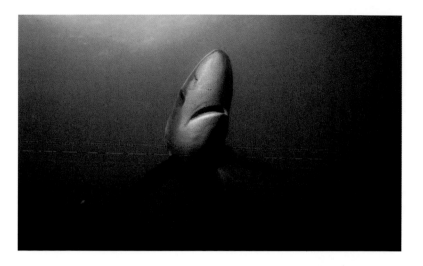

BLUE SHARK

Prionace glauca

The blue shark is probably the most abundant large shark in the world, dominating most of the world's offshore waters. With its brilliant blue color, sleek body shape, and long pectoral fins, the blue is also one of the most beautiful. Tagging studies have shown that the species makes large transoceanic migratory movements as part of its natural history. In the North Atlantic, for example, blue sharks are primarily born in the central and eastern areas, where they remain for the first year or two before spreading across the ocean.

Large adult males are found in the western North Atlantic, where they mate with sub-adult females in the spring and summer. These females store sperm in their shell glands, fertilize their eggs over the next year, and move east to give birth. The complex life cycle of the blue shark in the North Atlantic, therefore, occupies the entire ocean and likely takes advantage of ocean currents.

Because of the blue shark's high regional abundance, I have had the opportunity to study and dive with this species more than any other. Although it has been

implicated in attacks on humans, I have never been harassed by these sharks, and in contrast, they tend to be rather timid when approached. Acoustic tracking work that we have conducted off New England indicates that blue sharks move vertically between the surface and about 60 to 80 feet when over the continental shelf. We know from other studies that this behavior changes when the shark moves off the shelf into oceanic waters. Their vertical diving becomes more dramatic, to depths in excess of 1,800 feet and temperatures as cold as 45°F. It is thought that this change in behavior is associated with a change in feeding strategy as they move from shelf waters rich in

BLUE SHARK

- **Identification:** Thin-bodied shark with long conical snout, large eyes, no spiracles, long pectoral fins; bright blue dorsal coloration with white undersurface; females with mating scars and bite marks.
- **Size:** Birth: 1.1–1.6 ft.; Maturity: 7.1 ft. (male), 7.5 ft. (female); Maximum: 12.5 ft.
- **Distribution:** Worldwide from warm tropical waters seasonally to temperate zones.
- **Habitat:** Oceanic offshore waters.
- **Behavior:** Highly migratory with seasonal movements and distribution related to size, sex, and reproduction; makes frequent transoceanic voyages; occurs singly, but may form aggregations; found at the surface and also exhibits frequent deep (more than 1,800 feet) diving behavior.
- **Reproduction:** Placental viviparity; 9- to 12- month gestation; 4–135 pups.
- **Feeding:** Broad range of prey items, including schooling fishes, squid and other invertebrates, small sharks, sea birds, carrion, and garbage.
- **Population Status:** Common worldwide, but heavily fished and taken as bycatch for fins and meat; population estimates uncertain, may be depleted in some areas; IUCN Red List: Near Threatened.

surface prey to less productive oceanic areas, thereby requiring more extensive search behavior.

Although blue sharks are not typically targeted by commercial fisheries, they are taken as bycatch by high seas fishermen targeting swordfish and tunas. While U.S. fishermen release these fish, those from many other countries continue to land and/or fin them in high numbers. Some studies in the Northern Pacific suggest that the blue shark population there may be in slow decline, but there is still much uncertainty. Although some countries have implemented measures to control fishing mortality, the highly migratory nature and complex life history of the blue shark points to a major need for international coordination.

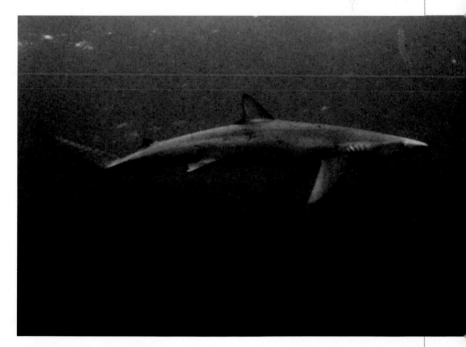

The blue shark is a species of the open ocean.

BULL SHARK

Carcharhinus leucas

The bull shark is one of just a few shark species that can inhabit freshwater bodies like rivers and lakes. They have been reported over 2,000 miles up the Amazon River as well as over 1,800 miles up the Mississippi River. There is a well-studied population in Lake Nicaragua (Central America), which is connected to the Caribbean Sea via the 180-mile-long San Juan River.

My own experience with bull sharks is limited to acoustic tracking and abundance sampling conducted in the bayous of Lake Pontchartrain near New Orleans as well as off the coast of Louisiana in the Gulf of Mexico with Louisiana State University researchers. One look at the habitat where this spe-

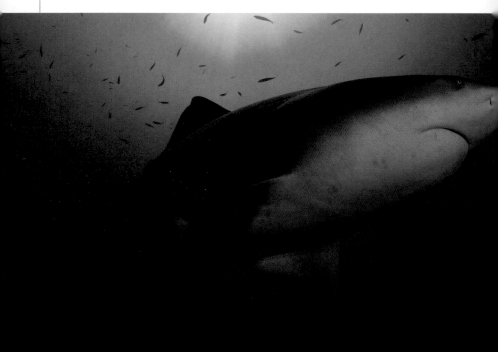

Bull shark, *Carcharhinus leucas*.

cies resides gives you a great sense of how capable it must be in detecting prey. In all the areas where we caught bull sharks, we found coffee-colored muddy water that was virtually impossible to see through. These were areas where saltwater from the Gulf of Mexico mixed with freshwater from inland rivers and lakes. They teemed with marine catfishes loaded with spines, alligator gars bearing reptilian teeth, and bull sharks. This shark is also one of the top three species implicated in unprovoked attacks on humans. Needless to say, this was one area where I felt it best to work from a boat and not in the water.

BULL SHARK

- **Identification:** Heavy-bodied shark with short blunt snout and thick head, small eyes, broad triangular dorsal fin, no inter-dorsal ridge; greyish coloration with white belly, black-tipped fins in juveniles fading to dusky coloration with age.

- **Size:** Birth: 1.8–2.6 ft.; Maturity: 6.6 ft. (male), 6.8 ft. (female); Maximum: 11.0 ft.

- **Distribution:** Worldwide in tropical and temperate waters.

- **Habitat:** Shallow coastal waters, estuaries, bays, and rivers.

- **Behavior:** Can tolerate fresh water and frequently enters rivers and moves upstream; newborns and juveniles frequently found in bays and estuaries; aggressive shark implicated in multiple attacks on humans.

- **Reproduction:** Placental viviparity; 10- to 11-month gestation; 1–13 pups.

- **Feeding:** Broad range of prey items including fishes, invertebrates, sharks, sea birds and turtles, carrion, and garbage.

- **Population Status:** Infrequently taken in commercial fisheries and more commonly in recreational fisheries; population estimates uncertain; IUCN Red List: Near Threatened.

GREY REEF SHARK

Carcharhinus amblyrhynchos

The grey reef shark is one of the most common and abundant species inhabiting the coral atolls and lagoons in the Indian and Pacific Oceans. The species is well known for threat displays that it exhibits when disturbed or approached too closely. During these displays, the shark exaggerates its swimming by wagging its head and tail in broad sweeps; it arches its back, lifts its head and depresses its pectoral fins, and sometimes corkscrews horizontally through the water.

Grey reef sharks that exhibit this behavior either flee from the area or attack with incredible speed. It is thought that the threat display is a warning to would-be predators or competitors. Needless to say, this warning should also be heeded by divers.

Working at Johnston Atoll in the central Pacific with Boston University researchers, I have had the opportunity to catch, blood sample, tag, and track grey reef sharks over the course of three years. Although I have been in

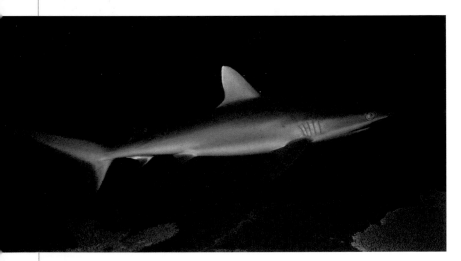

Grey reef shark, *Carcharhinus amblyrhynchos.*

the water countless times with hundreds of grey reef sharks, I have yet to see any one of them exhibit this behavior. In contrast, the species tends to be inquisitive but timid when approached. More typically, we found that grey reef sharks exhibited two kinds of behavior. Some (mostly males) remained solitary, roaming the reefs, while others (largely females) formed tight synchronized schools. It may be possible that the female schooling behavior is associated with the protection of their developing young, i.e. safety in numbers.

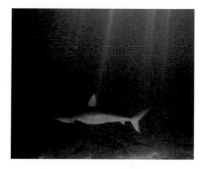

The grey reef shark prefers coral atolls.

GREY REEF SHARK

- **Identification:** Moderate-sized shark with broadly rounded snout, round eyes, narrow pectoral fins, no interdorsal ridge; greyish coloration with white undersides, black-tipped fins and caudal fin with broad black edge.

- **Size:** Birth: 1.5–2.5 ft.; Maturity: 3.6 ft. (male), 3.9 ft. (female); Maximum: 8.4 ft.

- **Distribution:** Warm tropical waters of the Indian and Pacific Oceans.

- **Habitat:** Shallow coastal waters, shelves, atolls, coral reefs, lagoons, adjacent oceanic waters.

- **Behavior:** Highly social species forming large groups during the day, but also found alone; active at night; known to display agonistic behavior, exaggerated swimming, and threat posturing when approached or startled; implicated in some attacks on humans.

- **Reproduction:** Placental viviparity; 12-month gestation; 1–6 pups.

- **Feeding:** Prey includes tropical fishes and invertebrates.

- **Population Status:** Commonly taken by commercial fisheries; population estimates uncertain; IUCN Red List: Near Threatened.

SANDBAR SHARK

Carcharhinus plumbeus

Like many species of large sharks, the sandbar shark is an incredibly slow-growing species that lives in excess of thirty years. It doesn't mature until it is at least 15 years old, and it only gives birth to a dozen or so pups every other year. Unfortunately, the species is heavily exploited throughout its range for meat and fins. Despite strict quotas and because of its low rate of replacement, the sandbar shark is now considered severely over-fished off the U.S. east coast and in the Mediterranean Sea, and fisheries management agencies are taking drastic measures to protect them. Even with such measures in place, it is projected to take decades for the species to recover.

The two largest nursery areas for the sandbar shark on the east coast

SANDBAR SHARK

- **Identification:** Moderate-sized shark with broadly rounded snout, large broad first dorsal fin, interdorsal ridge; grey to brown coloration with white undersides, no black tips on fins.

- **Size:** Birth: 1.8–2.5 ft.; Maturity: 4.0 ft. (male), 4.5 ft. (female); Maximum: 7.5 ft.

- **Distribution:** Worldwide from tropical waters to warm temperate waters.

- **Habitat:** Shelves, oceanic banks, islands, harbors, estuaries, bays, river mouths, and adjacent offshore waters.

- **Behavior:** Bottom-dwelling migratory species with seasonal north-south movements; young sharks form schools and live in coastal nurseries including estuaries and bays, moving offshore in winter; sexes generally segregate except during mating periods in spring and summer.

- **Reproduction:** Placental viviparity; 8–12-month gestation; 1–14 pups.

- **Feeding:** Prey includes small bottom fishes and invertebrates.

- **Population Status:** Commonly taken in coastal commercial and recreational fisheries; prized for fins; overfished in many areas; IUCN Red List: Vulnerable.

of the United States are the Chesapeake and Delaware bays. Adult females give birth to their pups either in or just outside these bays in the spring. The newborn pups then seek protection and feeding opportunities in these embayments over the course of the summer before moving out and south for the winter. Clearly, anything that degrades these two major estuaries will impact this vital habitat for juvenile sandbar sharks, thereby further impacting the species. Sandbar shark protection must also extend to habitat protection in these important areas. Without viable nurseries, the sandbar shark will not recover.

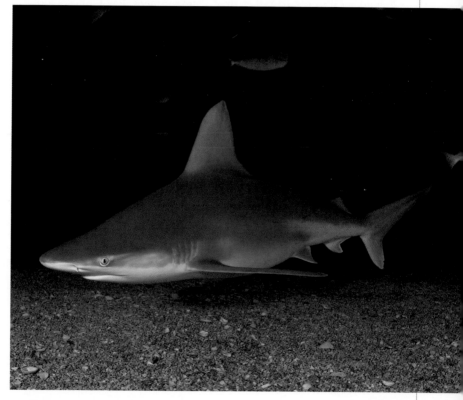

Sandbar shark, *Carcharhinus plumbeus*.

LEMON SHARK

Negaprion brevirostris

So named for their yellowish coloration, lemon sharks are abundant in tropical areas where coral reefs and mangrove trees flourish. This is perhaps one of the most well-studied species of sharks because of the research that has been conducted on it in the Bahamas over the last 25 years by researchers from the University of Miami. Unfortunately, despite years of research, human development continues to impact and destroy critical habitat for this species.

Lemon sharks, like many others in this order, rely on bays and estuaries during the early years of their lives. Working with NMFS researchers, I have been looking at the movement patterns and

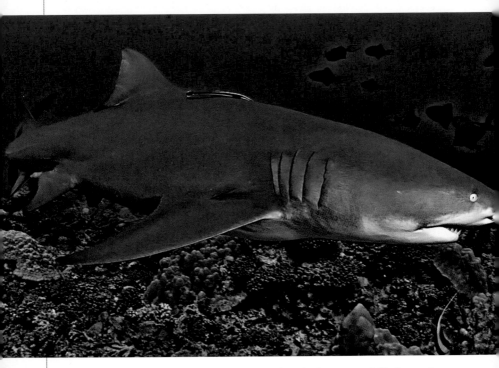

The sharptooth lemon shark, Negaprion acutidens, looks very much like its cousin the lemon.

GROUND SHARKS

relative abundance of lemon and blacktip sharks in St. John, Virgin Islands. By catching and tagging newborn and juvenile lemon and blacktip sharks, we have been able to identify important nursery areas in this region. We have also shown that these two species appear to have different habitat preferences within any particular bay. Lemons remain closely associated with mangrove trees and sea grasses, while blacktips move more broadly within the bay. By defining this critical habitat, we are better prepared to protect it.

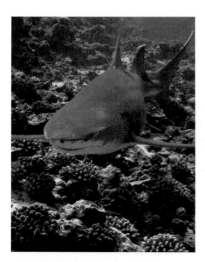

The lemon shark is a tropical species.

LEMON SHARK

- **Identification:** Large-bodied shark with blunt snout, two large dorsal fins almost equal in size; yellowish-brown to drab green dorsal coloration fading to light yellow on belly.

- **Size:** Birth: 1.5–2.1 ft.; Maturity: 7.3 ft. (male), 7.8 ft. (female); Maximum: 11.0 ft.

- **Distribution:** Tropical and subtropical waters of the Atlantic and eastern Pacific.

- **Habitat:** Shallow coastal waters of coral reefs and keys, mangroves, bays, and river mouths.

- **Behavior:** Occurs alone, but also forms loose aggregations based on size and sex; active at dawn and dusk; young sharks are segregated from adults and inhabit nursery areas of dense sea grass and mangroves; routinely rests on bottom.

- **Reproduction:** Placental viviparity; 10- to 12-month gestation; 4–17 pups.

- **Feeding:** Prey includes fishes and crustacean invertebrates.

- **Population Status:** Commonly taken in coastal commercial and recreational fisheries; population estimates unknown; IUCN Red List: Near Threatened.

WHITETIP REEF SHARK

Triaenodon obesus

The whitetip reef shark is one of the few shark species that clearly demonstrates the pack mentality when it comes to feeding. Dense groups of these sharks have been seen and filmed ravaging a reef at night in search of hidden fishes and invertebrates. Once prey is detected using keen olfactory and acoustic cues, a feeding frenzy ensues until the prey is consumed. During the day, the exhausted pack settles in caves and under coral structures to rest up for the next big night out, sometimes piled on top of each other like cordwood.

WHITETIP REEF SHARK

- **Identification:** Thin-bodied shark with short flattened snout, two large dorsal fins almost equal in size; greyish-brown dorsal coloration with light belly; sometimes scattered dark spots on sides; white-tipped first dorsal fin and upper lobe of caudal fin.

- **Size:** Birth: 1.7–2.0 ft.; Maturity: 3.4 ft. (male), 3.4 ft. (female); Maximum: 7.0 ft.

- **Distribution:** Tropical and subtropical waters of the Indian and Pacific Oceans.

- **Habitat:** Shelves, island terraces, shallow coastal waters of coral reefs, lagoons, and caves.

- **Behavior:** Bottom-dwelling shark that lives alone or in aggregations, which may be found in caves where they routinely rest on the bottom during the day; active at night hunting in packs capturing prey in coral crevices; exhibits fidelity to small home ranges.

- **Reproduction:** Placental viviparity; 5-month gestation; 1–5 pups.

- **Feeding:** Prey includes bottom- and reef-dwelling fishes and invertebrates.

- **Population Status:** Commonly taken in coastal commercial fisheries; population estimates unknown; IUCN Red List: Near Threatened.

A complete list of the ground sharks is on pages 214–224.

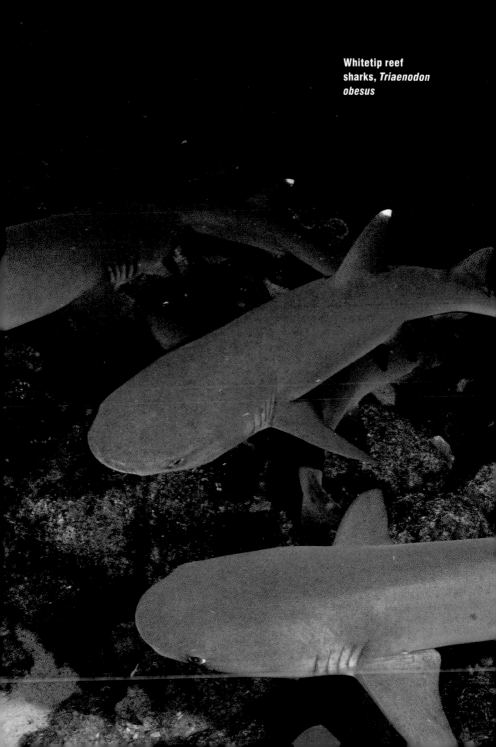

Whitetip reef sharks, *Triaenodon obesus*

FAMILY: Weasel Sharks (Hemigaleidae)

◻ **Number of Species:** 8

◻ **Size:** Small (3 feet) to moderate (8 feet).

◻ **Distribution:** Tropical and subtropical waters of the eastern Atlantic, western Pacific, and Indian Oceans.

◻ **Habitat:** Continental shelf waters.

◻ **Behavior:** Largely unknown.

◻ **Reproduction:** Viviparous.

◻ **Feeding:** Largely unknown, but one species has a strong preference for squid, octopuses, and small fishes.

◻ **Population Status:** Some are taken by commercial fishing operations. Populations have not been assessed.

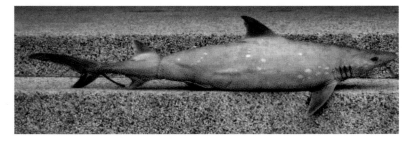

Sicklefin weasel shark *Hemigaleus microstoma*

A complete list of weasel sharks is on page 216.

FAMILY: Barbeled Sharks (Leptochariidae)

¤ **Number of Species:** 1 (Barbeled Houndshark *Leptocharias smithii*)

¤ **Size:** Birth: unknown.; Maturity: 1.8 ft. (male), 1.7 ft. (female); Maximum: 2.7 ft.

¤ **Distribution:** Eastern Atlantic, Mediterranean.

¤ **Habitat:** Continental shelf waters, off river mouths.

¤ **Behavior:** Bottom dwelling.

¤ **Reproduction:** Viviparous.

¤ **Feeding:** Prey includes small fishes, crustaceans, and skates.

¤ **Population Status:** Taken by commercial fisheries; population estimates unknown; IUCN Red List: Near Threatened.

FAMILY: Finback Catsharks (Proscylliidae)

¤ **Number of Species:** 7

¤ **Size:** Very small (0.5–2.0 feet).

¤ **Distribution:** Small tropical regions of the western Atlantic, Indian, and western Pacific Oceans.

¤ **Habitat:** Deepwater continental and island slopes.

¤ **Behavior:** Bottom-dwelling.

¤ **Reproduction:** Most ovoviviparous; one species is oviparous.

¤ **Feeding:** Small fishes and invertebrates.

¤ **Population Status:** Unknown.

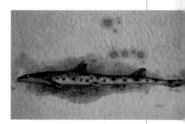

Graceful catshark
Proscyllium habereri

A complete list of finback catsharks is on pages 216–217.

FAMILY: False Catsharks (Pseudotriakidae)

- ¤ **Number of Species:** 4

- ¤ **Size:** Small (3 feet) to moderate (9.5 feet).

- ¤ **Distribution:** Patchy worldwide.

- ¤ **Habitat:** Deepwater continental and island slopes.

- ¤ **Behavior:** Unknown.

- ¤ **Reproduction:** Ovoviviparous.

- ¤ **Feeding:** Unknown.

- ¤ **Population Status:** Unknown; some taken as bycatch in commercial fisheries.

A complete list of false catsharks is on page 217.

FAMILY: Catsharks (Scyliorhinidae)

- ¤ **Number of Species:** 149+

- ¤ **Size:** Small (1–5 feet).

- ¤ **Distribution:** Patchy worldwide.

- ¤ **Habitat:** Most deepwater continental and island slopes.

- ¤ **Behavior:** Most unknown.

- ¤ **Reproduction:** Most unknown, some oviparous, some ovoviviparous.

- ¤ **Feeding:** Most unknown, some prey on small fishes and invertebrates.

- ¤ **Population Status:** Most unknown. Some are taken by commercial fishing gear.

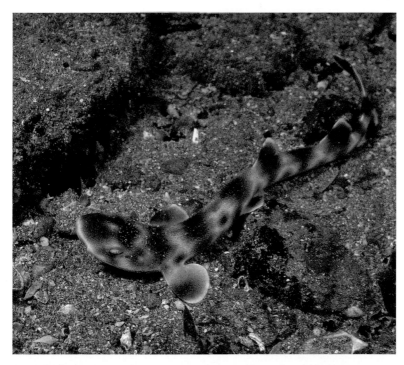

The Gulf catshark, *Asymbolus vincenti*, belongs to the largest shark family.

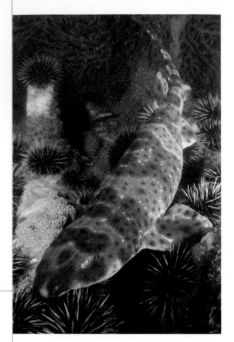

Swellshark, *Cephaloscyllium ventriosum*

SWELLSHARK
Cephaloscyllium ventriosum

Although the swellshark lives primarily on the bottom to depths of 1,500 feet, it is most common at depths around 100 feet. This largely nocturnal shark hides in caves and rocky crevices by day and searches the bottom by night. While resting during the day, the species is known to pile on top of each other. The species is so named for its ability to inflate its stomach with water. When threatened, the swellshark grabs its caudal fin with its mouth and swallows enough

SWELLSHARK

- **Identification:** Large-bodied catshark, first dorsal fin larger than second, eye ridges present. Variegated yellow-brown coloration with dark brown patches and spots over most of body.

- **Size:** Birth: 0.5 ft.; Maturity: 2.7 ft (male); Maximum: greater than 3.0 ft.

- **Distribution:** Eastern Pacific.

- **Habitat:** Coastal waters in kelp beds and on rocky bottom.

- **Behavior:** Occurs singly or in small groups; lies on bottom by day, active at night; when disturbed, inflates stomach to "swell" for protection.

- **Reproduction:** Oviparous; 7.5–10 months to hatch.

- **Feeding:** Prey includes fishes and invertebrates.

- **Population Status:** Unknown; IUCN Red List: Least Concern.

water to swell its body to twice its normal size. This sudden change not only makes a swellshark look bigger than it is, it may also make it difficult for a predator to remove the swell shark from a crevice. When the threat passes, the swellshark expels the water.

If brought to the surface, a swellshark will inhale air instead of water. I was once diving with great white sharks off Mexico when I saw a shark floating on the surface. Upon retrieving it, I saw that it was a swell shark that had been caught by fishermen and discarded. The shark apparently inhaled air once on the surface and was unable to dive. Using a wooden spoon, we opened the shark's esophagus and released the air before ultimately releasing the shark.

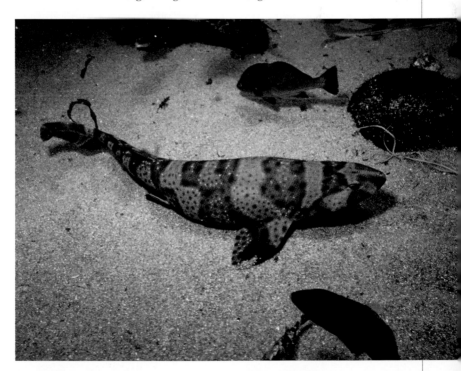

The swellshark inhales water to inflate its body and deter predators.

CHAIN CATSHARK

Scyliorhinus retifer

Sometimes referred to as the chain dogfish, the chain catshark is one of the few deepwater sharks that have been successfully kept in captivity. Hence, much of what is known about the reproductive biology and growth rates of this species comes from captive animals. Chain dogfish are oviparous, which means that gravid females deposit eggs on the substrate. Commonly referred to as a mermaid's purse, each yellowish egg case is about 2 inches long, 1 inch wide, and has long tendrils at each corner. The egg case is amber in color. When gravid females deposit the egg cases, the tendrils wrap around bottom corals, rocks, or sponges and secure them to the substrate. The embryo continues to develop for the next seven months or so before it hatches. Once the eggs are deposited, the females provide no further protection or care.

Chain catshark, *Scyliorhinus retifer*

CHAIN CATSHARK

- **Identification:** Thin-bodied catshark, two dorsal fins set close to tail. Yellow-brown coloration with dusky patches and black chain pattern over most of body.

- **Size:** Birth: 0.3 ft.; Maturity: 1.2 ft (male), 1.1 ft. (female); Maximum: 2.0 ft.

- **Distribution:** Tropical and temperate water of the western North Atlantic

- **Habitat:** Deepwater continental shelf and slope.

- **Behavior:** Sluggish, rests on bottom.

- **Reproduction:** Oviparous; 7 months to hatch; 44–52 eggs per year.

- **Feeding:** Prey includes small fishes and invertebrates.

- **Population Status:** Unknown; IUCN Red List: Least Concern.

A complete list of catsharks is on pages 217–222.

FAMILY: Hammerheads (Sphyrnidae)

- ¤ **Number of Species:** 10

- ¤ **Size:** Small (3 feet) to very large (20 feet).

- ¤ **Distribution:** Worldwide in tropical and warm temperate waters.

- ¤ **Habitat:** Continental and island shelves, shallow coastal and adjacent offshore waters.

- ¤ **Behavior:** Some are highly migratory; most travel alone, but some form large social groups; many are nocturnal; some have been implicated in attacks on humans.

- ¤ **Reproduction:** Placental viviparity.

- ¤ **Feeding:** Broad range of prey items including bony fishes, sharks, rays, and invertebrates.

- ¤ **Population Status:** Most are taken as bycatch in commercial fisheries, and some are targeted by recreational fishermen; population estimates indicate dramatic declines.

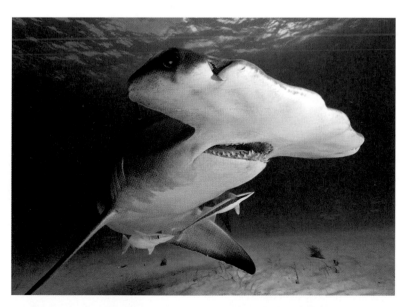

Hammerheads are among the most easily recognized species of sharks.

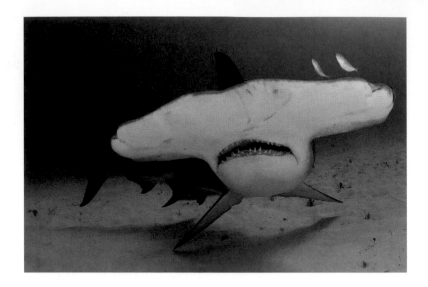

GREAT HAMMERHEAD SHARK

Sphyrna mokarran

At 20 feet in length and close to 1,000 pounds, the great hammerhead, *Sphyrna mokarran*, is not only the largest of the ten hammerhead species, but it is also among the largest of the sharks. Size, head shape, and sicklelike fins differentiate this hammerhead from its cousins. For those who have seen photos or video of large schools of hammerheads, this is not the same species—the great hammerhead is not a schooling fish.

Stingrays are among the favorite food items of this hammerhead, and they are consumed whole, including the venomous tail spine, which has been found embedded in the mouths of many a hammerhead. Great hammerheads are known to feed on stingrays on the sea floor by using the highly sophisticated electrosensory system located on their heads. It is thought that the shape of the hammerhead's head, called a *cephalofoil,* helps the shark to fully use these sensory capabilities, like a treasure hunter uses a metal detector on the beach.

While the great hammerhead can be dangerous, few attacks can be directly attributed to it, because many of the hammerheads look so similar. This also contributes to the lack of population data on this species, thereby making it difficult to manage and conserve.

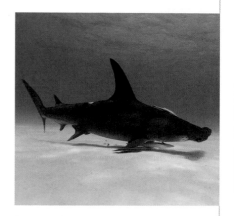

The great hammerhead has a sickle-shaped dorsal fin.

GREAT HAMMERHEAD SHARK

- **Identification:** Large broad hammerlike head with almost straight anterior margin and middle notch; tall and pointed first dorsal fin with strongly falcate posterior margin. Grey to brown dorsal surface and white ventral surface.

- **Size:** Birth: 2.0–2.3 ft.; Maturity: 7.4 ft. (male), 6.9 ft. (female); Maximum: 20 ft.

- **Distribution:** Worldwide in tropical waters seasonally to warm temperate zones.

- **Habitat:** Shallow coastal waters to offshore oceanic areas; coral atolls and lagoons; island shelves and coral reefs.

- **Behavior:** Highly migratory and nomadic, showing seasonal poleward movement; occurs singly and not known to form aggregations; some attacks on humans are documented.

- **Reproduction:** Viviparous; 11-month gestation; 6–42 pups every two years.

- **Feeding:** Wide variety of marine organisms from invertebrates to fishes, including sharks and stingrays; cannibalistic.

- **Population Status:** Population estimates are unknown; fished commercially and recreationally throughout the world; IUCN Red List: Endangered.

SCALLOPED HAMMERHEAD

Sphyrna lewini

For those who have ever seen large schools of hammerhead sharks patrolling off sea mounts or along deep drop-offs, these are scalloped hammerheads. So named for the scalloped appearance of the leading edge of its head, the scalloped hammerhead is the only large member of this family to exhibit such behavior. While swimming in these schools, scalloped hammerheads have been observed tilting their bodies, head shaking, corkscrew swimming, hitting other hammerheads with their snouts, opening their jaws, and flexing their claspers. These

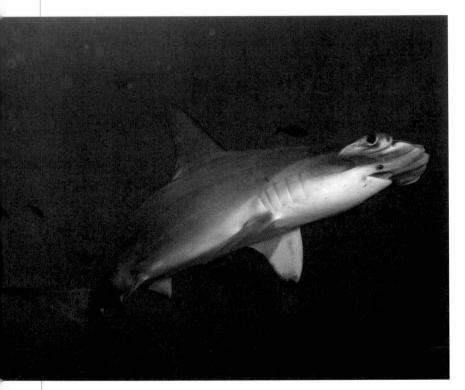

Scalloped hammerhead, *Sphyrna lewini*

various behaviors may be associated with courtship and mating or competition for food.

Many have questioned the advantage of having the head shape characteristic of the hammerheads. It has been put forth over the years that the hammer-shaped head may improve maneuverability and enhance vision, olfaction, and electroreception.

The eye and naris of the hammerhead.

SCALLOPED HAMMERHEAD

- **Identification:** Broad, arched, hammerlike head with "scalloped" indentations and a prominent middle notch; pelvic fins with straight rear margins. Deep olive to brown dorsal surface fading to white undersides; dusky or black-tipped pectoral fins.

- **Size:** Birth: 1.4–1.8 ft.; Maturity: 5.9 ft. (male), 8.2 ft. (female); Maximum: 12 ft.

- **Distribution:** Worldwide from tropical waters seasonally to warm temperate zones.

- **Habitat:** Continental and island shelves, shallow coastal and adjacent offshore waters; juveniles near shore in bays and estuaries.

- **Behavior:** Highly migratory, showing seasonal movement; occurs singly, but also known to form large schools for courtship and mating; life history includes sexual segregation; nursery areas include bays, harbors, and estuaries.

- **Reproduction:** Placental viviparity; 9- to 10-month gestation; 12–38 pups.

- **Feeding:** Prey includes bony fishes, invertebrates, other sharks, and rays.

- **Population Status:** Population estimates are unknown; fished commercially and recreationally throughout the world; IUCN Red List: Endangered.

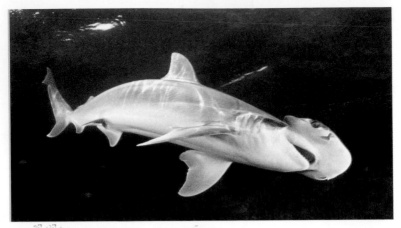

BONNETHEAD SHARK

Sphyrna tiburo

The bonnethead shark is one of the smaller hammerheads found in coastal waters, bays, and estuaries. The shark is typically seen in groups of 3 to 15 individuals. Bonnetheads exhibit complex behaviors associated with activity levels and a dominance hierarchy within a particular group.

The smoothhound, *Mustelus mustelus*, is a common houndshark.

A complete list of hammerhead sharks is on pages 222–223.

BONNETHEAD SHARK

- **Identification:** Small hammerhead species with rounded, shovel-shaped head lacking middle notch. Grey to tan dorsal surface fading to pale undersides; back and sides with small black spots.

- **Size:** Birth: 1.2–1.3 ft.; Maturity: 2.0 ft. (male), 2.8 ft. (female); Maximum: 5 ft.

- **Distribution:** Tropical waters seasonally to warm temperate zones of the western Atlantic and eastern Pacific.

- **Habitat:** Continental and island shelves, shallow coastal waters, bays, harbors, and estuaries.

- **Behavior:** Seasonally migratory from lower to higher latitudes; forms small schools of several individuals to groups of hundreds during migration; exhibits sexual segregation; birth occurs in shallow nurseries.

- **Reproduction:** Placental viviparity; 5-month gestation; 4–14 pups.

- **Feeding:** Prey includes small bony fishes and crustacean invertebrates.

- **Population Status:** Population estimates are unknown; taken by commercial and recreational fisheries; IUCN Red List: Least Concern.

FAMILY: Houndsharks (Triakidae)

- **Number of Species:** 46

- **Size:** Small (3 feet) to moderate (6 feet).

- **Distribution:** Worldwide in tropical and temperate waters.

- **Habitat:** Continental and island shelves, shallow coastal and adjacent offshore waters, bays, estuaries, and river mouths.

- **Behavior:** Some species are highly active, others routinely rest on bottom; many are seasonally migratory; many travel alone, but some form social groups; many are nocturnal.

- **Reproduction:** Placental and aplacental viviparity.

- **Feeding:** Prey items include bottom invertebrates and bony fishes.

- **Population Status:** Most are taken by commercial and recreational fisheries throughout the world; population assessments are lacking for most species.

TOPE OR SCHOOL SHARK

Galeorhinus galeus

The tope is one of the first sharks to be heavily exploited for commercial purposes. Over the last century, these sharks have provided meat for consumption, fins for soup, liver oil for vitamin A, and skin for leather. The species was targeted by the soupfin shark fisheries off California and South Africa during the 1930s and 1940s. In both places, the fisheries declined and collapsed, because,

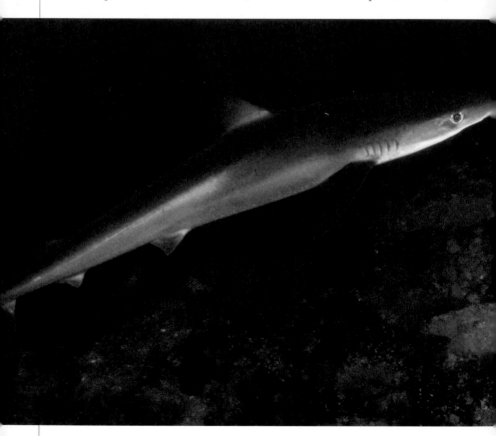

Tope or school shark, *Galeorhinus galeus*

like other sharks, the school shark cannot sustain heavy exploitation. The shark continues to be harvested off California as well as South America and Australia with continued signs of depletion.

TOPE OR SCHOOL SHARK

- **Identification:** Slender shark with long snout and conspicuous nasal flaps; large spiracles behind eyes; second dorsal same size as anal, but smaller than first dorsal; large caudal lobe. Grey to blue tinted dorsal surface with white underside.

- **Size:** Birth: 1.0–1.2 ft.; Maturity: 5.0 ft. (male), 5.8 ft. (female); Maximum: 6.4 ft.

- **Distribution:** Worldwide in temperate waters.

- **Habitat:** Continental shelves, shallow coastal waters and bays.

- **Behavior:** Seasonally migratory from lower to higher latitudes; forms schools of individuals segregated by size and sex; birth occurs in shallow estuaries where young remain for one to two years.

- **Reproduction:** Ovoviviparous; 12-month gestation; 6–52 pups.

- **Feeding:** Prey includes bony fishes and invertebrates.

- **Population Status:** Taken worldwide by commercial and recreational fisheries; populations considered depleted in some areas; IUCN Red List: Vulnerable.

SMOOTH DOGFISH OR DUSKY SMOOTHHOUND

Mustelus canis

Smooth dogfish are quite common off the east coast of the United States to the extent that both commercial and recreational fishermen find it difficult to avoid them while fishing for other species. The shark moves from southern wintering grounds off North Carolina to as far north as Massachusetts waters in the spring and summer. At this time, pregnant females give birth to 4 to 20 pups in coastal sounds, bays, harbors, and estuaries after an 11- to 12-month gestation. The young sharks remain in these areas for the summer before moving, like the adults, to southern wintering grounds.

By all accounts, smooth dogfish are largely nocturnal, resting on the bottom during the day and becoming active and feeding on crabs, lobsters, and other invertebrates at night. Large spiracles provide canals to move water over their gills, thereby allowing them

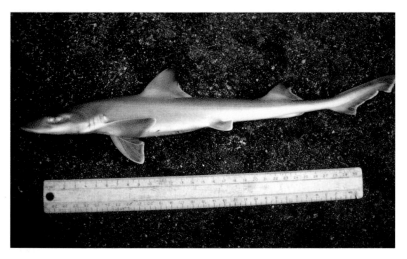

A newborn smooth dogfish.

to remain motionless for extended periods. While tracking smooth dogfish in a Massachusetts estuary, we found that some sharks remained in a small area for days, while others moved throughout the embayment.

The smooth dogfish is an excellent example of a species that is not yet overexploited but has the potential to be. Some commercial fisheries land smooth dogfish, and management has now been implemented to control landings by these fisheries.

SMOOTH DOGFISH OR DUSKY SMOOTHHOUND

- **Identification:** Slender shark with short snout; pavementlike teeth; large spiracles behind eyes; second dorsal almost same size as first dorsal. Grey dorsal surface with white underside.

- **Size:** Birth: 1.0–1.2 ft.; Maturity: 2.6 ft. (male), 3.1 ft. (female); Maximum: 5.0 ft.

- **Distribution:** Temperate waters in western Atlantic.

- **Habitat:** Continental shelves, shallow coastal waters, sounds, bays, harbors, and estuaries.

- **Behavior:** Active shark; seasonally migratory from lower to higher latitudes; nocturnal; birth occurs in shallow estuaries.

- **Reproduction:** Placental viviparity; 11- to 12-month gestation; 4–20 pups.

- **Feeding:** Feeds primarily on crustacean invertebrates, which it grinds with pavementlike teeth. Also feeds on small fishes.

- **Population Status:** Taken by commercial and recreational fisheries; IUCN Red List: Near Threatened.

LEOPARD SHARK

Triakis semifasciata

Because of its relatively small size, high abundance, and hardiness in captivity, the leopard shark has been one of the lab rats of the shark world. Much of what we know about shark swimming, metabolic rate, feeding kinematics, and countless other aspects of morphology and physiology have come from studies on live captive leopard sharks. While it is always dangerous to assume that the results of these studies apply to all sharks, in many cases, these are the only data we have, because most species of sharks will never be kept in captivity.

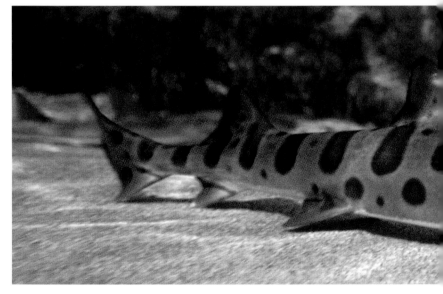

Leopard shark, *Triakis semifasciata*

A complete list of houndsharks is on pages 223–224.

LEOPARD SHARK

- **Identification:** Slender shark with short snout and broad head. Grey to tan dorsal surface with large leopardlike black blotches and spots fading to white underside.

- **Size:** Birth: 0.7 ft.; Maturity: 2.6 ft. (male), 3.5 ft. (female); Maximum: 6.0 ft.

- **Distribution:** Temperate waters in eastern Pacific.

- **Habitat:** Continental shelf, shallow coastal waters, bays, and kelp beds.

- **Behavior:** Active shark; occurs singly, but also forms large schools.

- **Reproduction:** Ovoviviparous; 10- to 12-month gestation; 4–33 pups.

- **Feeding:** Prey includes bottom fishes and invertebrates.

- **Population Status:** Taken by commercial and recreational fisheries; effective U.S. management in place; IUCN Red List: Least Concern.

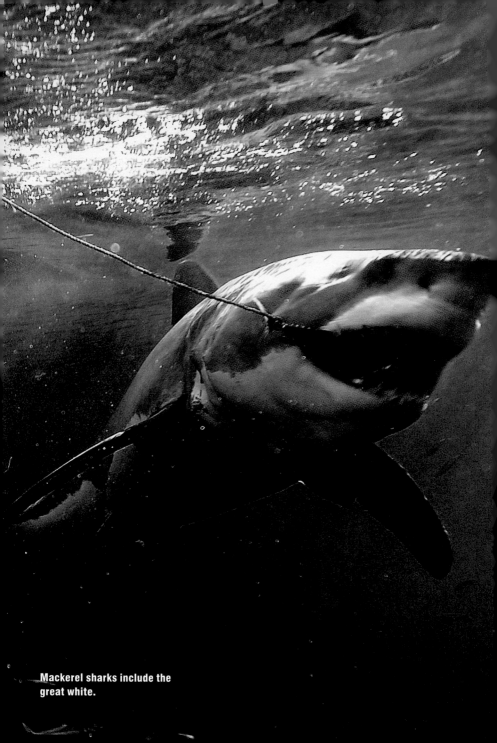

Mackerel sharks include the great white.

Mackerel Sharks
Order Lamniformes

The mackerel sharks are among the fastest fish in the ocean and look like it. Most have streamlined, torpedo bodies with two dorsal fins, an anal fin, and five gill slits, but no nictitating eyelids. This group contains seven families, ten genera, and fifteen species including the great white, mako, and thresher sharks.

FAMILY: Thresher sharks (Alopiidae)

- ¤ **Number of Species:** 3
- ¤ **Size:** Very large (20 feet)
- ¤ **Distribution:** Worldwide in tropical and temperate waters.
- ¤ **Habitat:** Continental and island shelves and slopes, coastal and oceanic waters, sea mounts.
- ¤ **Behavior:** Highly active sharks; many are migratory and capable of long oceanic voyages; occur singly; use long upper lobe of caudal fin to stun prey; known to leap out of the water.
- ¤ **Reproduction:** Ovoviviparous; 2–6 pups.
- ¤ **Feeding:** Very broad range of prey items, including fishes, sea birds and reptiles, invertebrates, marine mammals, carrion, and garbage.
- ¤ **Population Status:** Unknown; most are fished commercially and recreationally throughout the world.

COMMON THRESHER SHARK

Alopias vulpinus

The most conspicuous attribute of the thresher sharks is the very long upper lobe of their caudal fin, which is about as long as their body. When someone tells me that they caught a 16-foot thresher shark, I know that about 8 feet of that fish was tail. Threshers use this tail to herd and stun their prey, which typically includes schooling fish, like bluefish or squid. Numerous observations by fishermen can attest to this behavior. The simple fact that more thresher sharks caught on rod and reel off the coast of California are hooked in the tail than in the mouth supports the notion that threshers attack first with the tail. Tuna fishermen trolling plastic lures have had thresher sharks swim into their rigged lures and strike them with their tail. This is remarkable behavior given that

COMMON THRESHER SHARK

- **Identification:** Blunt head with short snout; small mouth with labial furrows; large eyes; long upper lobe of caudal fin almost as long as body length. Dark grey dorsal surface, silvery blue sides, and white underside.

- **Size:** Birth: 3.7–5.0 ft.; Maturity: 9.8 ft. (male), 12.1 ft. (female); Maximum: 20 ft.

- **Distribution:** Worldwide in tropical to temperate waters.

- **Habitat:** Continental and island shelves and slopes, coastal and oceanic waters.

- **Behavior:** Highly active shark; makes seasonal migrations; occurs singly; uses long upper lobe of caudal fin to herd and stun prey; known to leap out of the water.

- **Reproduction:** Ovoviviparous; 2–6 pups.

- **Feeding:** Prey includes schooling bony fishes and invertebrates.

- **Population Status:** Unknown; taken by commercial and recreational fisheries throughout the world; IUCN Red List: Vulnerable.

Common thresher shark, *Alopias vulpinus*

the boat and lures are moving at 6 to 10 miles per hour.

I've seen threshers use their tails to subdue their prey on two occasions off the coast of New England. One time I was on a boat steaming offshore in search of tunas and saw what I thought was 2- to 3-foot bluefish jumping 4 to 6 feet out of the water. Knowing very well that bluefish are not prone to high jumping, we moved the boat toward the commotion, and I saw what appeared to be a long sicklelike tail slashing back and forth across the surface. It turns out that the tail belonged to a sizeable thresher shark who was "motivating" the bluefish to go airborne. Once stunned or disoriented, the bluefish were easy prey for the thresher shark.

The other incident occurred just before I entered the water to film blue shark behavior. About a hundred yards from the boat, down the chum slick, we saw a thresher striking bluefish with its powerful tail. When I jumped in the water, I had mixed emotions ranging from excitement in seeing a feeding thresher underwater to sheer terror associated with the potential of feeling the sting of the whip. Sadly and gratefully, neither happened, and the thresher moved off before we could get to it.

A complete list of thresher sharks is on page 225.

¤ **Number of species: 1**

BASKING SHARK

Cetorhinus maximus

I've always felt that the basking shark is a whale trapped inside the body of a shark. With its huge size, planktonic diet, and propensity to beach itself, the basking shark is somewhat of an ecological analog to the filter-feeding whales. However, unlike its mammalian counterparts, basking sharks are ectothermic (cold blooded), have modified gillrakers instead of baleen to sift plankton, and inherently look, feel, and operate like sharks.

Although the life history of the basking shark is poorly understood, we know just enough to intrigue even the most casual shark enthusiast. On both sides of the North Atlantic, basking sharks appear in northern latitudes in the spring, summer, and fall to feed on zooplankton (animal plank-ton) in highly productive areas off the coast. On the western side, these areas include the coast of New England to the Canadian Maritime provinces. During this time, large aggregations of basking sharks can be seen feeding side by side with whales passively sifting zooplankton from the water while moving forward. When feeding, these sharks expand their mouths to maximize the amount of water they can take in. Water passes into their mouths and out their gill slits where large comblike gillrakers attached to the gill arches strain the copepods, which are funneled down the esophagus. While in these areas, basking sharks display a variety of behaviors, the meanings of which have yet to be interpreted. The most conspicuous is when several sharks swim in a circle following each other nose to tail. Some have attributed this behavior, called

cartwheeling, to courtship and mating, but I have found when diving with these sharks that all these fish are females. You can't have mating and courtship without males. Basking sharks are also known to breach, moving their massive multiton bodies up and out of the water at tremendous speed. Having been in the water with this species, this is one of my greatest fears—either to have one hit me on the way up or the way down. Neither is an attractive thought.

Perhaps the greatest mystery of the basking shark is where it goes in the winter. Because basking sharks seem to disappear in the winter and some lose their gillrakers, scientists put forth the hypothesis in the 1950s that basking sharks moved to deep water,

BASKING SHARK

- **Identification:** Massive shark with pointed snout, huge mouth with tiny teeth; large gill slits extend from top of shark to underside; lateral keels on peduncle; lunate tail. Dark grey to brown mottled dorsal surface fading to lighter undersides.

- **Size:** Birth: 5.0–5.6 ft.; Maturity: greater than 20.0 ft. (male and female); Maximum: 32 ft.

- **Distribution:** Worldwide in tropical to cool temperate waters.

- **Habitat:** Continental and island shelves and slopes, coastal and oceanic waters.

- **Behavior:** Highly migratory, seasonally moving to higher latitudes; exhibits deep diving behavior when in low latitudes; uses modified gill rakers to filter feed; occurs singly, but also forms small to large feeding aggregations and schools in northern latitudes; known to breach.

- **Reproduction:** Largely unknown; ovoviviparous; 6 pups.

- **Feeding:** Prey is exclusively planktonic animals, primarily calanoid copepods.

- **Population Status:** Unknown; taken as bycatch in commercial fisheries; IUCN Red List: Endangered in the Northeast Atlantic and the North Pacific Oceans. Vulnerable everywhere else.

Basking sharks are known to move alone or in groups of as many as a hundred individuals.

stopped feeding, and hibernated. Although no species of shark has ever been known to hibernate, this postulate persisted for decades until the invention of satellite-based tagging technology in the late 1990s. This new technology has allowed us to follow the behavior and movements of these sharks in recent years to unravel this long-standing mystery of the basking sharks. Over the last several years, we have been tagging basking sharks in the western North Atlantic with these tags, while our counterparts in the east have been doing the same. Remarkably, it appears that there are two different stocks. While some of the sharks we tagged moved to the coastal and offshore waters off the southeastern United States, most moved south to tropical waters in The Bahamas, the Caribbean, and off the coast of South America. These incredible new findings were the first to show that basking sharks occur in these areas. The fact that they had not been previously seen in tropical waters is because basking sharks spend all of their time at depths in excess of 1,000 feet when they are there. Hence, they go unnoticed. Of course, these results have raised a lot more questions: Why do they move so far south? Are they giving birth to their young in those areas (since we have never seen a newborn basking shark)? What are they feeding on at those depths?

FAMILY: Mackerel sharks (Lamnidae)

- ¤ **Number of Species:** 5

- ¤ **Size:** Large (12 feet) to very large (21 feet).

- ¤ **Distribution:** Worldwide in tropical and temperate waters.

- ¤ **Habitat:** Continental and island shelves and slopes, coastal and oceanic waters.

- ¤ **Behavior:** Highly active sharks; fast swimming; migratory and capable of long oceanic voyages; most occur singly; some leap out of the water; all are endothermic.

- ¤ **Reproduction:** Ovoviviparous; 12-month gestation; 2–24 pups, depending on species.

- ¤ **Feeding:** Very broad range of prey items, including fishes, invertebrates, marine mammals, and carrion.

- ¤ **Population Status:** Most are fished commercially and recreationally throughout the world. Some showing population declines.

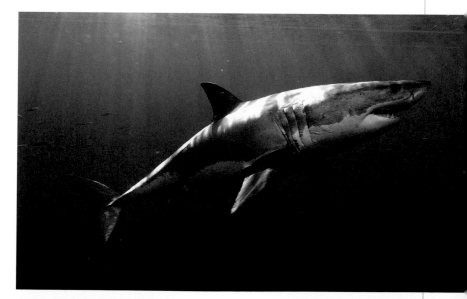

Great white shark, *Carcharodon carcharias*

SALMON SHARK

Lamna ditropis

Like their cousins the makos and great whites, salmon sharks are unusual in the fish world in that they can keep their internal temperature higher than the surrounding seawater. Most species of fish, including sharks, are ectothermic or "cold-blooded," which means that their body temperature is always within a couple of degrees of their environment. This limits the movements of most species to areas within a narrow temperature range.

Circulatory system adaptations of salmon sharks and other mackerel sharks allow these sharks to retain some of the heat they generate from swimming and digesting food.

The salmon shark is the most amazing example of a "warm-blooded" shark. Studies have shown that salmon sharks can maintain a body temperature as high as 38 °F warmer than the sea in which it swims. This adaptation has enabled the salmon shark to expand its habitats into chilly temperate waters.

SALMON SHARK

- **Identification:** Heavy-bodied shark with pronounced keels at the base of the crescent-shaped tail; dark blotches on the light-colored, lower part of the body.

- **Size:** Birth: 16 to 33 in.; Maturity: 6 ft. (male), 7.3 feet (female); Maximum: 10 ft.

- **Distribution:** Northern Pacific Ocean

- **Habitat:** Oceanic and coastal in cool temperate waters

- **Behavior:** Fast-swimming sharks that maintain a body temperature well above water temperature; segregate by size and sex—males are more common in the Western Pacific, and females are more common in the Eastern Pacific.

- **Reproduction:** Ovoviviparous; probable 9-month gestation; two to five pups

- **Feeding:** An important predator of Pacific salmon; prey also includes other bony fishes, spiny dogfish, and squids.

- **Population Status:** population estimates unknown; small commercial fishery in the Northwest Pacific; IUCN Red List: Least Concern.

GREAT WHITE SHARK

Carcharodon carcharias

Carcharodon carcharias, the great white shark, is undoubtedly the most infamous and well-recognized shark in the world. With powerful jaws chock-full of large, serrated teeth, and a body size reaching over 20 feet and 4,000 pounds, this shark conjures up images of a ravenous predator perched on the top of the ocean's food web. Although nicknames like "white death" and "maneater" portray the great white as a mindless consumer of human flesh, this is not the case. The great white is a selective predator that remains largely misunderstood.

By examining the stomach contents of great white sharks, we know that they feed on a wide variety of prey items ranging from squid to seals to other sharks. As they grow larger, great whites augment their diet of small prey, like fishes, with larger, more active prey, like dolphins and seals.

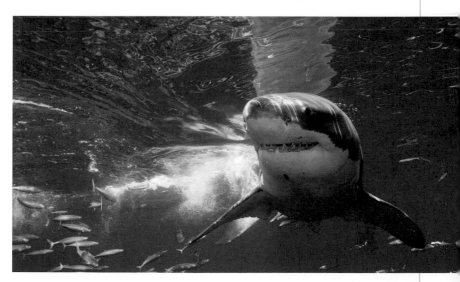

The white shark is likely the most recognizable of all shark species.

Remarkably, this change in diet coincides with a change in tooth structure. Young white sharks possess teeth that are sharply pointed and ideally suited to grasping fish, but at about 9 to 10 feet in length, white shark teeth change dramatically to the classic triangular shape with fine serrations. The teeth of these larger white sharks are perfectly adapted for rending large chunks of flesh

GREAT WHITE SHARK

- **Identification:** Large bodied shark with conical snout; triangular serrated teeth; long gill slits; large first dorsal fin with dark free tip; very small second dorsal and anal fins; strong caudal keel; no secondary keels. Grey to black dorsal surface sharply separated from white underside.

- **Size:** Birth: 3.5–5.0 ft.; Maturity: greater than 12 ft. (male), greater than 15 ft. (female); Maximum: 21 ft.

- **Distribution:** Worldwide in temperate and sometime tropical waters.

- **Habitat:** Continental and island shelves and slopes, coastal and oceanic waters.

- **Behavior:** Highly migratory; nomadic with some individuals demonstrating short- and long-term fidelity to feeding sites, which are typically large pinniped colonies; slow cruising with high-speed predatory bursts and occasional breaches; occurs singly or in pairs with no evidence of polar schooling; documented social behavior including agonistic displays and competitive interactions; attacks on humans are well documented.

- **Reproduction:** Ovoviviparous; 18-month gestation; 2–10 pups every 2–3 years.

- **Feeding:** Broad range of prey items. Young great whites eat fish and invertebrates. Great whites larger than about 10 feet eat larger prey, including marine mammals.

- **Population Status:** Rare; population estimates are largely unknown; fished commercially and recreationally throughout the world; protected in some countries; IUCN Red List: Critically Endangered in the Mediterranean and in the Northeast and Central Atlantic Ocean. Vulnerable elsewhere.

from larger prey like dead whales, dolphins, and seals.

Much of the life cycle of the great white shark remains a mystery, but new technology coupled with the discovery of great white shark "hot spots" around the world are now allowing researchers to reveal the secret world of these much-maligned fish. For example, using satellite tracking tags, scientists have demonstrated that white sharks seasonally move between shallow coastal waters to the deep ocean. One tagged great white shark moved from where it was feeding at a seal colony in South Africa across the Indian Ocean to Australia and back again—a round trip of over 12,000 miles in less than nine months! Although that particular shark averaged 3 miles per hour, we estimate that white sharks are capable of burst speeds in excess 30 miles per hour when attacking seals. At some seal colonies, it is not unusual to see white sharks rocket completely out of the water as they attack a seal at such speed.

Although it's tempting to generalize about great white sharks from the results of research in a particular location, it's best to keep in mind that great whites occur in geographically—and at least in some cases, genetically—distinct populations, which may have vastly different life histories. Still, research on some of the better-known populations of great white sharks may shed light on their biology. Tagging studies on white sharks in the Northeastern Pacific have shown that adult great whites spend part of their time around one of two aggregation sites at the coast (in Central California or at Guadalupe Island, Mexico), near seal and sea lion rookeries, and part of their time far offshore in the open ocean. In the open ocean, the movements of males and females differs somewhat. Both converge in a core area of the Pacific Ocean that has been termed the Shared Offshore Foraging Area (SOFA), where they make repeated vertical movements that are likely associ-

ated with prey. Male great whites seem to arrive at the SOFA sooner than females, who spend less total time there, and more time in other parts of the Pacific.

The great white shark is considered the most dangerous species of shark because it has been implicated in numerous documented, unprovoked attacks. Despite this notorious reputation, the white shark does not attack humans to feed, but rather, it most likely bites humans because they are mistaken by the shark as their normal prey of seals and sea lions. Although the white shark rarely consumes a human victim, the severe nature of the wounds resulting from the bite has resulted in death. It is important to note that the probability of white shark attack is incredibly low and less than ten occur throughout the world every year.

It has been almost impossible to assess the status of this species in terms of population size and the impacts of humans. Given our perception of this species, which has been largely shaped by the film industry, this fish has been hunted for decades by trophy hunters for their teeth and jaws. Commercial fishermen have also harvested the species for meat and other products. Like many species of sharks, great whites grow and mature relatively slowly. Combined with its low reproductive rate, that makes this species vulnerable to overfishing, and many countries now offer some level of precautionary protection for the great white shark.

I've had the incredible experience of diving with and studying great white sharks in several parts of the world. Two of these, Guadalupe Island off Mexico and the Neptune Islands off South Australia, are hot spots where relatively large numbers of great whites can be found near seal colonies. In these two areas, I spent hours underwater observing these "maneaters," but with each minute that ticked by, I realized just how poorly understood and mischaracterized these magnificent

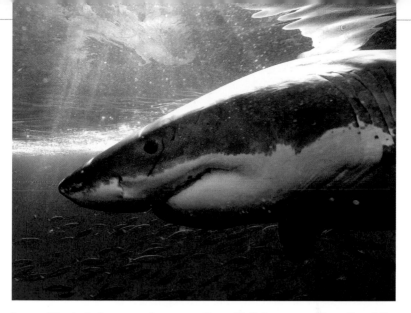

Large white sharks bear scars from encounters with their prey as well as other whites.

fish actually are. I saw no attacks on seals, no attacks on cages, no attacks on boats, and no mind-numbing images of flesh ripped from innocent victims. Instead, I remained mesmerized by a fish perfectly adapted to survive millions of years yet now struggling in a watery world where resources are limited, mates are hard to find, and life can be cut short by a net or a fishing line. A few years later in 2004, a fourteen-foot, 1,700-pound female white shark mistakenly swam into a small New England estuary and became trapped. With an accomplished team of researchers, fishermen, and volunteers, we worked tirelessly on this shark. Our goal was not to kill her or to capture her, but it was simply to set her free. It was achieved on the fourteenth day. In recent years, I have been actively involved with the study of white sharks off the coast of Cape Cod using a variety of tagging technology. For the first time, we are learning about this species in the Atlantic.

SHORTFIN MAKO

Isurus oxyrinchus

The shortfin mako shark is a fast fish—so fast that some scientists feel it is the fastest fish. With its highly streamlined body shape, short fins, strong caudal keel, and lunate tail, this shark is literally built for speed. Although it is not an easy task to measure the straight-line swimming speed of a shark, minimum estimates hover around 30 to 35 miles per hour, while maximum calculations exceed 60 miles per hour. Regardless, any fish armed with sharp teeth, the ability to elevate its body temperature, and moving in excess of 30 miles per hour is a formidable predator. The mako is at the top of the food web and, like the great white, rarely finds itself

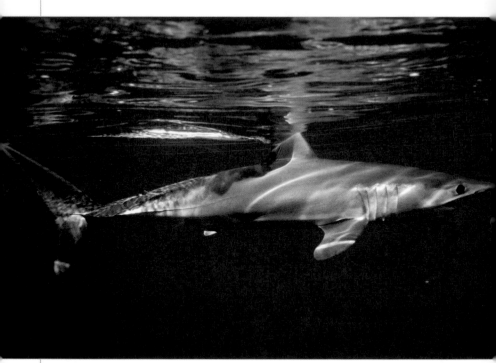

Shortfin mako shark, *Isurus oxyrinchus*

on some other fish's dinner plate.

Off the east coast of the United States, young mako sharks feed predominantly on bluefish—found in 78 percent (by volume) of all mako stomachs examined. It has been estimated that mako sharks consume as much as 14 percent of the bluefish population off the east coast of the United States. There are strong indications that the diet of the mako changes to larger food items as it gets larger, just like that of the great white shark. In the stomach of a 960-pound mako shark, I have found the skull of a harbor porpoise and a whole six-foot blue shark. In another 800-pound mako, I found a forty-pound harbor porpoise bitten into four pieces. Such larger prey maximizes energy efficiency and can sustain the shark for weeks.

SHORTFIN MAKO

- **Identification:** Large-bodied shark with pointed snout; sharply pointed teeth; short pectoral fins; small second dorsal and anal fins; strong caudal keel; no secondary keels. Dark blue dorsal surface, iridescent blue sides, white underside.
- **Size:** Birth: 2.0–2.3 ft.; Maturity: 6.3 ft. (male), 9.0 ft. (female); Maximum: 13 ft.
- **Distribution:** Worldwide from tropical to cool temperate waters.
- **Habitat:** Continental and island shelves and slopes, coastal and oceanic waters.
- **Behavior:** Highly active, fastest swimming shark; highly migratory, exhibits transoceanic movements; occurs singly; known to leap from water.
- **Reproduction:** Ovoviviparous; 12-month gestation; 4–25 pups.
- **Feeding:** Prey items include oceanic fish, including sharks, and invertebrates; large individuals prey on marine mammals.
- **Population Status:** Fished commercially and recreationally throughout the world; population declines documented; IUCN Red List: Vulnerable.

PORBEAGLE

Lamna nasus

The porbeagle shark is truly a cold-water fish. In the western North Atlantic, the center of the porbeagle population is off the coast of Canada. During the fall and winter months, the population expands to as far south as New Jersey but contracts as water temperatures climb in the summer. In recent years, we have been using satellite-based tagging to track the horizontal and vertical behavior of the porbeagle shark in this region. To date, we have found that porbeagles rou-tinely dive to depths in excess of 3,000 feet and move through water temperatures from 68°F on the surface to 36°F at depth. This attests to the incredible heat retention capacity of this shark.

The porbeagle shark has been commercially exploited over the last century and is a good example of how long it takes a shark species to recover from overexploitation. In the 1960s, the Norwegians harvested porbeagle sharks in large numbers off the Canadian and New England coasts, peaking in 1964 at almost 18 million pounds landed.

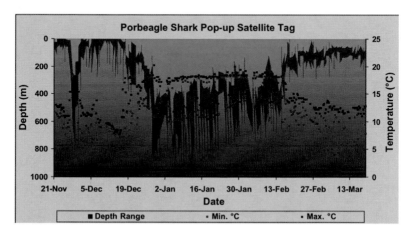

Vertical movements of the porbeagle shark, *Lamna nasus*, as determined by pop-up satellite archival tagging.

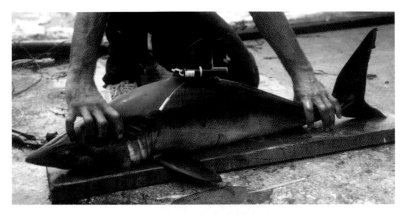

A juvenile porbeagle shark with an acoustic transmitter.

PORBEAGLE

- **Identification:** Stout-bodied shark with short conical snout; sharply pointed teeth with large primary cusp and two smaller secondary cusps; large broad first dorsal fin with white free tip; strong caudal keel; secondary keels on caudal fin. Dark grey-blue dorsal surface fading to pale green sides and white underside.

- **Size:** Birth: 2.3–2.7 ft.; Maturity: 6.9 ft. (male), 8.6 ft. (female); Maximum: 12 ft.

- **Distribution:** Cool temperate waters of the North Atlantic and southern hemisphere.

- **Habitat:** Continental and island shelves and slopes, coastal and oceanic waters.

- **Behavior:** Highly active and migratory; occurs singly or in loose aggregations segregated by size and sex; occurs seasonally from surface to deep water.

- **Reproduction:** Ovoviviparous; 8–9-month gestation; 3–6 pups annually.

- **Feeding:** Prey items include oceanic fish and invertebrates.

- **Population Status:** Fished commercially and recreationally; historical and current population declines well documented; IUCN Red List: Critically Endangered in the Mediterranean and the Northeast Atlantic, Endangered in the Northwest Atlantic, and Vulnerable elsewhere.

If each shark weighed 200 pounds, this amounted to almost 90,000 porbeagles in that single year. The intensity of this fishery caused the population to collapse by 1967, and it was no longer profitable to exploit the species. Catches remained low for the next two decades. This allowed the porbeagle population to slowly rebound until Canadian fishermen began fishing intensively for them in the 1990s, and the recovery was halted. In the late 1990s, the Canadians restricted their annual catch to 2.2 million pounds, but this was insufficient to maintain a stable population, and the population continued to decline. Now, despite continued cutbacks in porbeagle annual quotas (as low as 400,000 pounds.), the population remains overexploited and is only about 11 percent of its original biomass. Clearly, additional management is needed to allow the population to rebuild. In the face of continued fishing mortality, it is projected that recovery of the porbeagle population will take decades.

A complete list of mackerel sharks is on pages 225–226.

FAMILY: Megamouth sharks (Megachasmidae)

¤ **Number of species: 1**

MEGAMOUTH SHARK

Megachasma pelagios

One of the most significant discoveries of the 1970s was that of the megamouth shark. This was no ordinary description of a new species. With the discovery of this shark, scientists had to create a new family, genus, and species. How could such a large species of shark have eluded science until 1976? Largely because the species inhabits deep ocean habitat that has not been regularly exploited until the last couple of decades. Also, the fact that this shark is a filter feeder means that it does not readily bite a hook, so it has eluded most fisheries. Since its discovery, only about 100 additional specimens have been examined.

Although we know very little about the life history of this shark, a single acoustic tracking study

MEGAMOUTH SHARK

- **Identification:** Massive shark with large broad head and broad rounded snout; terminal mouth extending beyond eyes with tiny teeth. Dark grey to brown dorsal surface fading to lighter undersides; lower jaw with dark spots.

- **Size:** Maturity: 13.0 ft. (male), 16.0 ft. (female); Maximum: greater than 18 ft.

- **Distribution:** Worldwide in tropical to cool temperate waters.

- **Habitat:** Continental and island shelves and slopes, coastal and oceanic waters.

- **Behavior:** Largely unknown; migrates vertically to shallows at night, deeper by day; filter feeder.

- **Reproduction:** Details largely unknown; ovoviviparous.

- **Feeding:** Preys on planktonic animals, primarily euphausiid shrimp.

- **Population Status:** Unknown; very rare species; IUCN Red List: Least Concern.

conducted on a live megamouth demonstrated that this shark migrates vertically from deep water during the day to the shallows at night. It is thought that the shark does so to follow and feed on small shrimp that exhibit a similar vertical pattern. Like the two largest fish, the basking and whale sharks, the megamouth is a filter feeder. Based on gross examination of the shark's mouth and gills, researchers hyphothesize that the way a megamouth eats is similar to the feeding method of the rorquals, the largest of the baleen whales. Swimming toward its food, a megamouth opens its jaws, and huge amounts of water flow into its mouth. The pressure of the water stretches and expands the shark's throat like a balloon. The shark then closes its mouth, trapping the water and its prey inside. As the megamouth squeezes its throat closed, water flows out the gill slits, and the food is trapped inside.

FAMILY: Goblin sharks (Mitsukurinidae)

¤ **Number of species: 1**

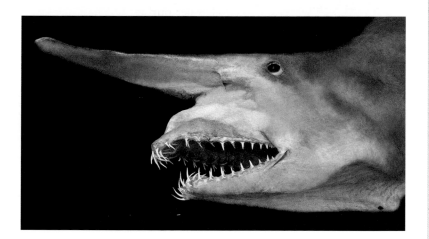

GOBLIN SHARK

Mitsukurina owstoni

Not much can be said about the goblin shark because it is almost as rare as the megamouth. Almost all that is known comes from the examination of dead specimens dragged from the depths by fishing gear. Its protruding jaws under its bladelike snout give it a peculiar look, but unless it's in the act of capturing prey (or dead), its jaws are closed. It is thought that the electrosensory organs (ampullae of Lorenzini) lining the long snout on this shark enable it to sense prey in the darkness of the deep ocean. Once prey is detected, the shark suddenly and rapidly protrudes its jaw to suck the victim into its waiting maw lined with sharp needlelike teeth. Needless to say, one look at a goblin shark and you can see that this common name is no misnomer.

GOBLIN SHARK

- **Identification:** Soft-bodied shark with very long flattened snout; highly protrusible jaws with long pointed needlelike teeth; long caudal fin. Pinkish white coloration.

- **Size:** Maturity: greater than 8.7 ft. (male), greater than 10.5 ft. (female); Maximum: greater than 13 ft.

- **Distribution:** Patchy worldwide in tropical to cool temperate waters.

- **Habitat:** Continental and island shelves and slopes, oceanic waters, seamounts.

- **Behavior:** Largely unknown; bottom-dwelling deepwater fish (300–4,000 feet).

- **Reproduction:** Unknown; likely to be ovoviviparous.

- **Feeding:** Thought to prey on deepwater bony fishes and invertebrates.

- **Population Status:** Unknown; very rare species; IUCN Red List: Least Concern.

FAMILY: Sand Tigers (Odontaspididae)

- **Number of Species:** 3

- **Size:** Large (10.5 feet)

- **Distribution:** Worldwide in tropical and temperate waters.

- **Habitat:** Continental and island shelves and slopes, coastal waters, coral and rocky reefs, bays, estuaries.

- **Behavior:** Slow-moving; most migrate seasonally to higher latitudes; most bottom-dwelling, but some also found from midwater to surface; swallows air to control buoyancy; occur singly, but also aggregate for feeding or reproduction.

- **Reproduction:** Ovoviviparous.

- **Feeding:** Prey items include wide range of fishes and invertebrates.

- **Population Status:** Taken by commercial, recreational fisheries and spearfishermen; population declines documented.

SAND TIGER

Carcharias taurus

Like the nurse shark, the sand tiger is a hardy shark species that is typically kept in public aquariums. Its slow movement, dense body, and gaping mouth lined with protruding teeth make it a perfect aquarium specimen that wows crowds all over the world. But sand tigers are remarkable sharks beyond their ability to entertain the masses. These sharks are able to regulate their buoyancy in the water column by moving to the surface and gulping air into their stomach. This mechanism results in a shark that seemingly hovers in the water, thereby minimizing the energy needed to avoid sinking. But this unique behavior pales to what they do even before they are born. Sand tigers are ovoviviparous, meaning that young develop inside the mother without a placental connection. Sand tiger sharks have taken this reproductive mode to the next level.

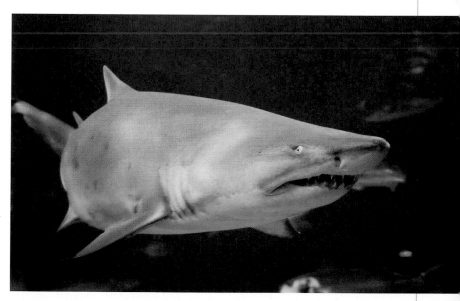

A sand tiger shark can swallow air to regulate bouyancy.

Although numerous eggs are fertilized and develop in the uteri, only two sand tigers are born, one from each uterus, because they feed on each other during development. Called *embryophagy*, this is the ultimate survival of the fittest, as these embryonic sharks compete for life.

SAND TIGER

- **Identification:** Large-bodied shark with short flattened snout; long pointed needlelike teeth with two secondary cusps; two dorsal fins of equal size; long caudal fin with very short lower lobe. Tan to light brown dorsal coloration with dusky spots, white underside.

- **Size:** Birth: 3.1–3.4 ft.; Maturity: 6.3 ft. (male), 7.2 ft. (female); Maximum: 10.5 ft.

- **Distribution:** Worldwide in tropical and temperate waters.

- **Habitat:** Continental and island shelves and slopes, coastal waters, coral and rocky reefs, bays, estuaries.

- **Behavior:** Slow-moving; migrate seasonally to higher latitudes; bottom-dwelling, but also found from midwater to surface; swallows air to control buoyancy; occurs singly, but also aggregates for feeding or reproduction.

- **Reproduction:** Ovoviviparous; 9- to 12-month gestation; 2 pups every two years or so.

- **Feeding:** Prey items include wide range of fishes and invertebrates.

- **Population Status:** Taken by commercial, recreational fisheries and spearfishermen; population declines documented; popular aquarium species; IUCN Red List: some populations are Critically Endangered, others are Vulnerable.

A complete list of sand tiger sharks is on page 226.

FAMILY: Crocodile sharks (Pseudocarchariidae)

¤ **Number of species:** 1

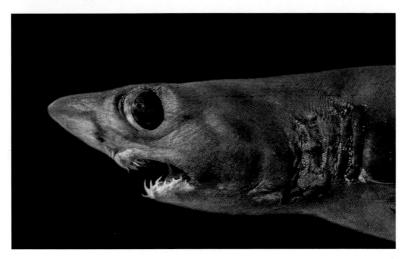

Crocodile shark, *Pseudocarcharias kamoharai*

CROCODILE SHARK *Pseudocarcharias kamoharai*

- **Identification:** Slender-bodied shark with long snout; highly protrusible jaws with long pointed teeth; very large eyes; long gill slits. Grey dorsal coloration fading to light underside.

- **Size:** Birth: 1.3 ft; Maturity: 2.4 ft. (male), 3.0 ft. (female); Maximum: 3.6 ft.

- **Distribution:** Worldwide in tropical waters.

- **Habitat:** Oceanic waters.

- **Behavior:** Largely unknown; occurs from surface to 2,000 feet.

- **Reproduction:** Ovoviviparous; 4 pups.

- **Feeding:** Prey includes bony fishes and invertebrates.

- **Population Status:** Unknown; taken as bycatch in commercial fisheries; IUCN Red List: Near Threatened.

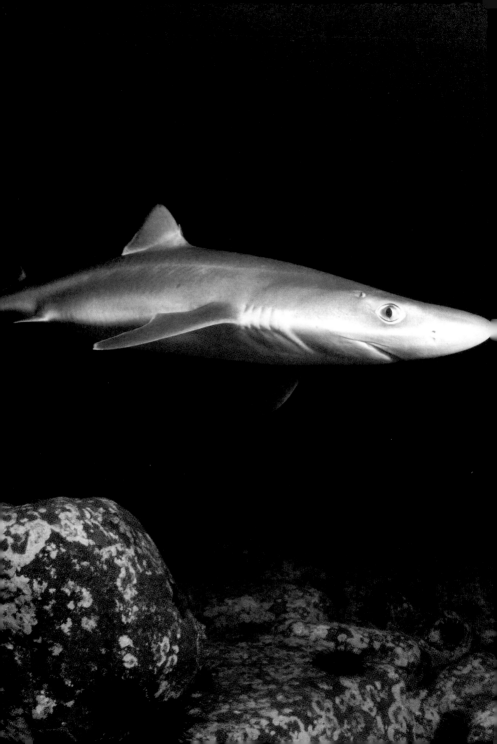

Dogfishes
Order Squaliformes

Dogfishes can easily be recognized by their two similarly sized dorsal fins—some armed with spines, a short snout, and no anal fin. This is the second-largest order, with 25 percent of all living sharks in seven families, and more than 120 species, including the smallest shark, the lantern shark, as well as one of the largest, the Greenland shark.

FAMILY: Gulper sharks (Centrophoridae)

◻ **Number of Species:** 16

◻ **Size:** Small (3 feet) to moderate (6 feet).

◻ **Distribution:** Worldwide in tropical and temperate waters.

◻ **Habitat:** Continental shelves and upper slopes, deepwater generally greater than 3,000 feet.

◻ **Behavior:** Largely unknown; most bottom-dwelling; some species form large aggregations and schools; some nocturnal.

◻ **Reproduction:** Ovoviviparous; 1–12 pups depending on species.

◻ **Feeding:** Prey items include bony fishes, sharks, rays, and invertebrates.

◻ **Population Status:** Unknown; taken in commercial fisheries; population assessments lacking.

Gulper shark, *Centrophorus granulosus*

A complete list of gulper sharks is on pages 228–229.

FAMILY: Kitefin sharks (Dalatiidae)

- ¤ **Number of Species:** 9

- ¤ **Size:** Very small (1 foot) to moderate (6 feet).

- ¤ **Distribution:** Worldwide in tropical and temperate waters.

- ¤ **Habitat:** Continental shelves and upper slopes, deepwater.

- ¤ **Behavior:** Largely unknown; some bottom-dwelling, others swim well off bottom or midwater; some species parasitic on other fishes and marine mammals; some may migrate vertically in the water column from depths at night to shallows by day; some have luminescent organs.

- ¤ **Reproduction:** Ovoviviparous; 6–16 pups, depending on species.

- ¤ **Feeding:** Prey items include deepwater bony fishes and invertebrates; parasitic forms remove bites from other fishes and marine mammals.

- ¤ **Population Status:** Unknown; some taken in commercial fisheries; population assessments lacking.

Kitefin shark, *Dalatias licha*

COOKIECUTTER SHARK

Isistius brasiliensis

The cookiecutter shark is another great example of how sharks have successfully exploited almost every habitat on the planet. This small shark lives in the middle of the ocean from the surface to over 11,000 feet deep, and it makes a living parasitizing large fishes like tunas, swordfish, and large species of sharks; as well as marine mammals like whales, dolphins, and even seals. With its bioluminescent organs, this shark literally glows in the dark, which may attract larger animals. Once within range, the cookiecutter lunges at its prey, uses it suctorial lips, and sinks its sharply pointed upper teeth into the flesh to secure a hold, then cuts deeply into the victim with the

COOKIECUTTER SHARK

- **Identification:** Cigar-shaped shark with short bulbous snout; heavily hinged mouth with suctorial lips and large triangular cutting teeth; no fin spines. Grey to brown coloration with lighter underside; prominent dark collar; ventral surface covered with luminous organs (photophores).

- **Size:** Maturity: 1.2 ft. (male), 1.3 ft. (female); Maximum: 1.6 ft.

- **Distribution:** Patchy worldwide in tropical waters.

- **Habitat:** Oceanic.

- **Behavior:** Generally deepwater, but may migrate vertically to midwater or surface at night; uses hinged mouth and teeth to gouge flesh from other fishes and marine mammals, which it may lure with luminescent organs.

- **Reproduction:** Ovoviviparous; 6–12 pups.

- **Feeding:** Prey includes deepwater fishes and squid; parasitic on other fishes and marine mammals.

- **Population Status:** Unknown; rarely encountered by fisheries; IUCN Red List: Least Concern.

cutting teeth of its lower jaw. The shark rotates its body while closing its deeply hinged jaw, filling its mouth with a plug of flesh. Once the shark has completed the bite, it drops off the host and swims away with a melon-ball-sized meal. These sharks leave behind a characteristic crater wound on their victims. When not successfully attacking large prey, the cookiecutter settles for deepwater fishes and squid. In 2009, a long-distance swimmer attempting to swim from the island of Hawaii to the island of Maui was attacked at twilight—twice—by a cookiecutter shark, the first report of one of these small sharks preying on a live human.

A complete list of kitefin shark species is on page 229.

FAMILY: Bramble sharks (Echinorhinidae)

¤ **Number of Species:** 2

¤ **Size:** Large (to 13 feet).

¤ **Distribution:** Worldwide in tropical and temperate waters.

¤ **Habitat:** Continental and island shelves and slopes, deepwater.

¤ **Behavior:** Largely unknown; bottom-dwelling and sluggish; occur singly or in groups.

¤ **Reproduction:** Ovoviviparous; 15–114 pups, depending on species.

¤ **Feeding:** Prey items include deepwater bony fishes, other sharks, and invertebrates.

¤ **Population Status:** Unknown; rare; some taken as bycatch in commercial fisheries; population assessments lacking.

A complete list of bramble sharks is on page 229.

FAMILY: Lantern sharks (Etmopteridae)

¤ **Number of Species:** 41

¤ **Size:** Very small (8 inches) to small (3 feet).

¤ **Distribution:** Worldwide in tropical and temperate waters.

¤ **Habitat:** Continental and island shelves and slopes, deepwater, sea mounts.

¤ **Behavior:** Largely unknown; bottom-dwelling; occurs singly or in groups.

¤ **Reproduction:** Ovoviviparous; 3–20 pups, depending on species.

¤ **Feeding:** Largely unknown; some items include deepwater bony fishes and invertebrates.

¤ **Population Status:** Unknown; not generally taken by fisheries; population assessments lacking.

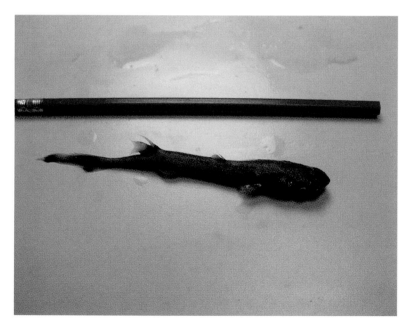

Lantern sharks are the smallest sharks in the world.

DWARF LANTERNSHARK

Etmopterus perryi

I highlight the dwarf lanternshark simply because this is one of the smallest living sharks, with a maximum size of only 8 inches. Science knows virtually nothing about the life history and ecology of this species, and it is found only off the coast of Colombia and Venezuela. The fact that it is rarely, if ever, taken by fisheries indicates that we are not likely to learn much about this species any time soon.

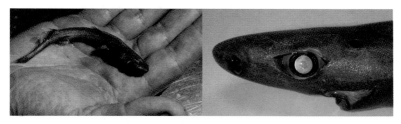

Much of the biology of the dwarf lanternshark remains a mystery.

DWARF LANTERNSHARK

- **Identification:** One of the smallest sharks, with broad flattened head; first dorsal fin smaller than second. Brown dorsal coloration with dark band on caudal fin, black undersides.

- **Size:** Birth: 2.4 in.; Maturity: 7 in. (male), 6 in.; Maximum: 8.3 in.

- **Distribution:** Western North Atlantic off Colombia and Venezuela.

- **Habitat:** Continental upper slope.

- **Behavior:** Unknown.

- **Reproduction:** Ovoviviparous.

- **Feeding:** Unknown.

- **Population Status:** Unknown; not taken by fisheries; IUCN Red List: Data Deficient.

A complete list of lantern sharks is on pages 229–231.

FAMILY: Roughsharks (Oxynotidae)

- ☐ **Number of Species:** 5
- ☐ **Size:** Small (less than 5 feet).
- ☐ **Distribution:** Patchy worldwide in tropical and temperate waters.
- ☐ **Habitat:** Continental and island shelves and slopes, deepwater.
- ☐ **Behavior:** Largely unknown; bottom-dwelling.
- ☐ **Reproduction:** Ovoviviparous.
- ☐ **Feeding:** Largely unknown; some items include deepwater bony fishes and invertebrates.
- ☐ **Population Status:** Unknown; not generally taken by fisheries; population assessments lacking.

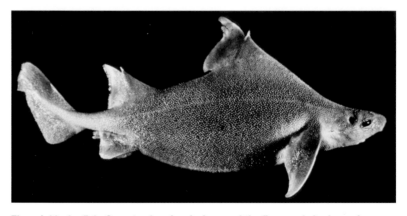

The prickly dogfish, *Oxynotus bruniensis*, is one of the five roughshark species.

A complete list of roughsharks is on page 231.

FAMILY: Sleeper sharks (Somniosidae)

¤ **Number of Species:** 17

¤ **Size:** Small (2.5 feet) to very large (23 feet).

¤ **Distribution:** Patchy worldwide in tropical, temperate, and polar waters.

¤ **Habitat:** Continental and island shelves and slopes, coastal waters, deep water, fiords, bays, and inlets.

¤ **Behavior:** Largely unknown; bottom-dwelling to surface; occur singly, some in groups with size and sex segregation; some sluggish, yet able to capture large active prey.

¤ **Reproduction:** Ovoviviparous; 4–59 pups, depending on species.

¤ **Feeding:** Prey items include bony fishes, sharks, rays, birds, marine mammals, carrion, and invertebrates including the largest species of squids.

¤ **Population Status:** Unknown; taken by commercial fisheries; population assessments lacking.

GREENLAND SHARK
Somniosus microcephalus

For the shark scientist, the Greenland shark is a swimming conundrum. This large shark, which grows to lengths of 24 feet, lives in the one of the most remote and coldest places on earth, the Arctic Circle. Water temperatures are typically at or close to freezing where this animal spends its life. During most of the year, this shark's world is shrouded by 6 feet of ice and darkness. I, along with others who have seen this shark swimming, can attest to the fact that it is incredibly sluggish, almost neutrally buoyant in the water column, and seemingly lifeless when handled (hence, "sleeper" shark). In addition, the eyes of almost every Greenland shark examined

Greenland sharks are thought to hunt and consume seals.

to date are infested with a copepod parasite, *Ommatokoita elongate*, which bores into the shark's cornea and renders it virtually blind. Remarkably, scientists have found the remains of fast-swimming fish and seals in the stomachs of this species. So, how does a lethargic, sluggish, blind shark living in cold Arctic waters under sea ice and shrouded in darkness effectively capture and kill fast-moving prey like seals?

To date, there are few answers to this question, but there is some evidence to support the notion that Greenland sharks are active predators on seals and do so by ambushing their prey slowly and methodically. In 1999, I joined my colleagues George Benz and Nick Caloyianis on an expedition to the Arctic Circle to study the Greenland shark. Over the course of a month, we captured, observed, and acoustically tracked this species under the Arctic ice to study its behavior. Our findings indicate that the shark does not spend all of its time on the bottom but moves frequently to the surface in areas of high ringed seal abundance. We suspect that the sharks were following olfactory cues emanating from ringed seal lairs embedded in the ice. Although the shark has poor visual acuity, we postulate that its large nose allows it to follow an odor trail to the source. Once close to the lair, the shark may rely on stealth, its cryptic coloration, and its electrosensory capabilities to successfully attack and kill its prey. The Greenland shark's mouth and jaws are very similar to those of cookiecutter shark in that it has suctorial lips, grasping teeth, and cutting teeth. Perhaps this allows the shark to firmly hold a seal while it renders a mortal wound.

The flesh of the Greenland shark is considered poisonous, and the Arctic Inuit people have found that it causes drunkenness and paralysis in their dogs when consumed. As such, the species has not been harvested for its

meat, but over the years, the shark has been taken for its liver, which is rich in oil and vitamin A. The Greenland shark does appear to migrate great distances from the Arctic Circle, but it remains very deep when it does so. Several years ago, a Greenland shark was observed by a submersible off the coast of Georgia at a depth of over 7,000 feet.

GREENLAND SHARK

- **Identification:** Large-bodied cigar-shaped shark with bulbous snout; rough skin with hooklike denticles; mouth with suctorial lips and sharply pointed upper teeth and bladelike lower teeth; two dorsal fins equal in size with no spines. Grey to brown mottled coloration.

- **Size:** Birth: 1.3 ft.; Maximum: 21.0 ft.

- **Distribution:** Temperate and polar waters of the North Atlantic and Arctic.

- **Habitat:** Continental and island shelves and slopes, coastal waters, deep-water, fiords, bays, and inlets.

- **Behavior:** Sluggish; bottom-dwelling to surface; occurs singly; able to capture large active prey; suctorial mouth.

- **Reproduction:** Ovoviviparous; 10 pups.

- **Feeding:** Prey includes bony fishes, invertebrates, sharks, birds, marine mammals, carrion.

- **Population Status:** Unknown; taken by commercial fisheries and as bycatch; population assessments lacking; IUCN Red List: Near Threatened.

A complete list of sleeper sharks is on pages 231–232.

FAMILY: Dogfish sharks (Squalidae)

- ¤ **Number of Species:** 28

- ¤ **Size:** Small (4 feet)

- ¤ **Distribution:** Worldwide in tropical and temperate waters.

- ¤ **Habitat:** Continental and island shelves and slopes, coastal waters, bays, river mouths, and inlets.

- ¤ **Behavior:** Highly migratory; most form large schools segregated by size and sex; most are bottom-dwelling, but many also move to the surface.

- ¤ **Reproduction:** Ovoviviparous; 1–20 pups, depending on species.

- ¤ **Feeding:** Prey items include bony fishes, invertebrates, and other sharks.

- ¤ **Population Status:** Some are taken extensively by commercial and recreational fisheries; management has been implemented.

Spiny dogfish are among the most highly exploited shark species in the world.

SPINY DOGFISH

Squalus acanthias

The spiny dogfish may be the most abundant shark in the world. It is found in every ocean with the exception of polar waters, and it has been both the bane and the benefit of fishermen for centuries. As the former, spiny dogfish are ravenous predators that run in packs marauding fishing grounds and fishing gear to fill their voracious appetites. To the benefit of fishermen, spiny dogfish have been harvested all over the world for their meat, which is marketed in Great Britain as fish and chips; as well as for their fins and cartilage. Unfortunately, to the detriment of the species, these harvesting operations have resulted in their overexploitation in almost every area

SPINY DOGFISH

- **Identification:** Small-bodied shark with narrow head and long snout; large spiracles; first dorsal fin larger than the second; sharp dorsal spines. Grey dorsal coloration with white spots on sides, light to white underside.

- **Size:** Birth: 0.7–1.1 ft.; Maturity: 2.0 ft. (male), 2.5 ft. (female); Maximum: 4.0 ft.

- **Distribution:** Worldwide in warm temperate waters.

- **Habitat:** Continental and island shelves and slopes, coastal waters, bays, river mouths, and inlets.

- **Behavior:** Highly migratory, seasonally to higher latitudes; forms large schools segregated by size and sex; found from surface to bottom.

- **Reproduction:** Ovoviviparous; 24-month gestation; 1–20 pups.

- **Feeding:** Prey items include bony fishes and invertebrates.

- **Population Status:** Taken extensively by commercial and recreational fisheries; population assessments show declines in many regions; management has been implemented; IUCN Red List: Critically Endangered in the northeast Atlantic, Endangered in several other locations, Least Concern in Australasia and southern Africa. Vulnerable elsewhere.

in which these fisheries have been prosecuted. Although spiny dogfish are indeed abundant in many areas, their low rate of reproduction seems to lead to their demise when they are fished too heavily. But it is very difficult to have a fishery without impacting the population because fishermen must land large numbers of dogfish to make the trip financially feasible. Due to strict management over the last two decades, the spiny dogfish population off the east coast of the US has rebounded and is now being fished at sustainable levels.

A complete list of dogfish sharks is on pages 232–233.

DOGFISHES 193

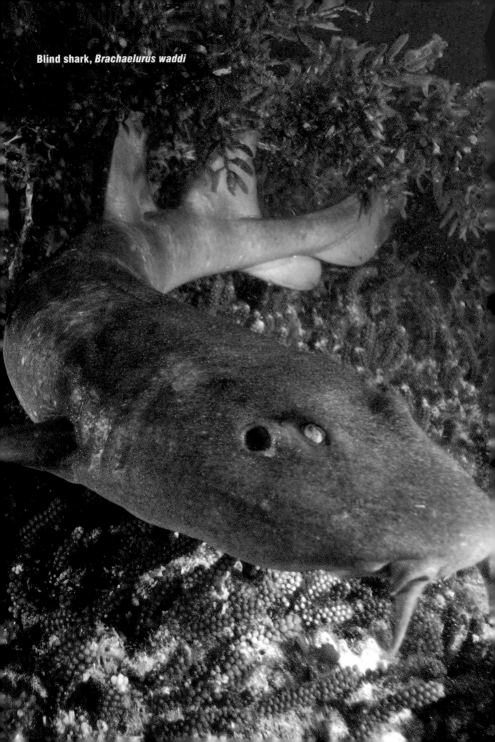
Blind shark, *Brachaelurus waddi*

Carpetsharks
Order Orectolobiformes

Although somewhat similar to the dogfishes, the carpet-sharks have two dorsal fins about the same size but without fin spines, an anal fin, and a mouth that is well in front of the eyes. This order contains seven families, 14 genera, and 45 species, which include the popular nurse shark, the odd-looking wobbegongs, and the world's largest fish, the whale shark.

FAMILY: Blind sharks (Brachaeluridae)

- ¤ **Number of Species:** 2
- ¤ **Size:** Small (4 feet)
- ¤ **Distribution:** Tropical waters of eastern Australia.
- ¤ **Habitat:** Coastal waters, rocky areas, coral reefs, sea grass beds.
- ¤ **Behavior:** Largely unknown; nocturnal, hides in caves and under bottom structures by day.
- ¤ **Reproduction:** Ovoviviparous.
- ¤ **Feeding:** Prey includes small bony fishes and invertebrates.
- ¤ **Population Status:** Unknown; rarely taken by fisheries.

A complete list of blind sharks is on page 226.

FAMILY: Nurse sharks (Ginglymostomatidae)

- ¤ **Number of Species:** 3
- ¤ **Size:** Small (2.5 feet) to large (10.5 feet).
- ¤ **Distribution:** Patchy worldwide in tropical waters.
- ¤ **Habitat:** Continental and island shelves, coastal waters, coral reefs, lagoons, sandy and sea grass areas, and mangroves.
- ¤ **Behavior:** Nocturnal, resting alone or in groups on bottom, under coral heads, and in caves by day; limited home range; uses barbels and snout to search bottom; powerful suction feeders.
- ¤ **Reproduction:** Ovoviviparous.
- ¤ **Feeding:** Prey includes bottom and reef invertebrates, bony fishes, and rays.
- ¤ **Population Status:** Some are taken by commercial and recreational fisheries; population assessments lacking.

NURSE SHARK

Ginglymostoma cirratum

For those who routinely visit large public aquariums or dive among the corals in the tropics, the nurse shark is a familiar sight. These sharks are most commonly seen resting on the bottom in the sand or under coral heads, seemingly sleeping the day away. And this is likely the case, as nurse sharks are active at night.

This somewhat quiet species is anything but boring during the mating time of year. As one of the few species of sharks observed mating, the nurse shark has been extensively studied in the Dry Tortugas off the Florida Keys during the spring and early summer. At this time, males compete to mate with mature females in the shallows. In some cases, the females avoid the males. In others, multiple males seem to work together to ensure that one of them successfully mates with the female. During copulation, the male securely

NURSE SHARK

- **Identification:** Large broad flattened head with rounded snout, small eyes and spiracles, nares with barbels, two dorsal fins broadly rounded. Yellow to brown body coloration; juveniles with small dark spots ringed with lighter pigmentation.

- **Size:** Birth: 0.9–1.1 ft.; Maturity: 7.0 ft. (male), 7.5 ft. (female); Maximum: 10.5 ft.

- **Distribution:** Tropical waters in eastern Pacific and Atlantic.

- **Habitat:** Continental and island shelves, coral reefs, lagoons, sandy flats, sea grass areas, and mangrove keys.

- **Behavior:** Nocturnal; resting alone or in groups on bottom, under coral heads, and in caves by day; uses barbels and snout to search bottom; powerful suction feeder; complex courtship and mating behavior.

- **Reproduction:** Ovoviviparous; 6-month gestation; 20–30 pups.

- **Feeding:** Prey includes bottom and reef invertebrates, bony fishes, and rays.

- **Population Status:** Taken occasionally by recreational and commercial fisheries; population assessments lacking; IUCN Red List: Data Deficient.

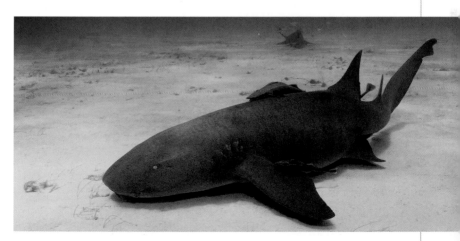

A nurse shark rests on the sand.

takes the female's pectoral fin in his mouth, wraps his tail around hers, inserts one of his claspers into her cloaca, and inseminates her; the whole sequence lasts about two minutes.

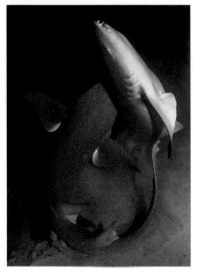

Nurse shark mating in Maldives.

Nurse sharks are rarely implicated in unprovoked attacks on humans. By far, most attacks are provoked by curious divers who decide that the nice shark resting on the bottom must be touched, grabbed, and pulled. Having handled my share of live nurse sharks in Belize, I can tell you that this species is remarkably flexible, with the ability to quite literally bite its own tail. Coupled with a mouth that can generate the suction of a vacuum cleaner in a fraction of a second, this flexibility usually results in a very surprised diver with a shark firmly affixed to his arm. Moral of the story: don't touch a resting shark.

A complete list of nurse sharks is on page 226.

FAMILY: Longtailed carpetsharks (Hemiscylliidae)

- ¤ **Number of Species:** 17

- ¤ **Size:** Small (less than 3 feet)

- ¤ **Distribution:** Tropical waters of the Indian and western Pacific Oceans.

- ¤ **Habitat:** Coastal waters, coral and rocky reefs, intertidal pools, and bays.

- ¤ **Behavior:** Largely unknown; some species are nocturnal, resting in reefs by day.

Brownbanded bambooshark,
Chiloscyllium punctatum

- ¤ **Reproduction:** Oviparous; oval egg cases.

- ¤ **Feeding:** Prey include small bottom fishes and invertebrates.

- ¤ **Population Status:** Unknown; some are taken by commercial fisheries; population assessments lacking.

A complete list of longtailed carpetsharks is on pages 226–227.

FAMILY: Wobbegongs (Orectolobidae)

- ¤ **Number of Species:** 12

- ¤ **Size:** Small (3 feet) to large (10.5 feet)

- ¤ **Distribution:** Tropical to warm temperate waters of the western Pacific Ocean.

- ¤ **Habitat:** Coastal waters, coral and rocky reefs, lagoons, intertidal pools, estuaries, seagrass flats, and bays.

- ¤ **Behavior:** Largely unknown; bottom-dwelling; nocturnal, resting singly or in piles by day; pectoral and pelvic fins used to move about bottom and between tide pools; uses camouflage and suctorial mouth to ambush and inhale prey.

- ¤ **Reproduction:** Ovoviviparous; 12–37 pups, depending on species.

- ¤ **Feeding:** Prey includes bottom fishes, invertebrates, shark and skate egg cases.

- ¤ **Population Status:** Unknown; most species are rare; some are taken by commercial fisheries; population assessments lacking.

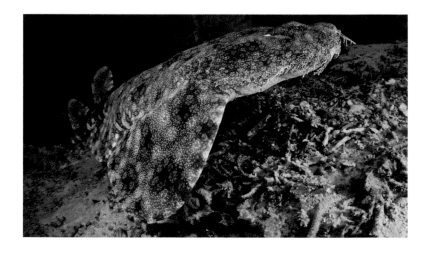

A complete list of wobbegongs is on page 227.

FAMILY: Collared carpetsharks (Parascylliidae)

- **Number of Species:** 7

- **Size:** Very small (1.5 feet) to small (3 feet)

- **Distribution:** Tropical to warm temperate waters of the western Pacific Ocean.

- **Habitat:** Continental and island shelves and upper slopes, coastal waters, coral and rocky reefs, and seagrass flats.

- **Behavior:** Largely unknown; bottom-dwelling; nocturnal, resting by day.

- **Reproduction:** Oviparous; egg cases elongated and flattened.

- **Feeding:** Largely unknown; may feed on bottom invertebrates.

- **Population Status:** Unknown; most species are rare; some are taken as bycatch in commercial fisheries; population assessments lacking.

A complete list of collared carpetsharks is on pages 227–228.

FAMILY: Whale sharks (Rhincodontidae)

¤ **Number of Species: 1**

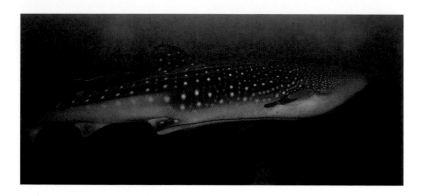

WHALE SHARK

Rhincodon typus

The whale shark is the largest fish on the planet, but there's still a lot we'd like to know about its life history and ecology. Age and growth information is completely lacking, and most of what we know about their reproduction is from a single pregnant female examined in 1995.

Almost all we do know about these massive fishes is related to their feeding ecology. Remarkably, the largest of the sharks, namely this species along with the basking and megamouth sharks, are filter feeders that strain tiny animals from the water column, much like many species of whales. In these sharks, the teeth are tiny and all but useless. Unlike the basking shark, which swims forward passively straining, the whale shark uses suction to vacuum prey into its mouth.

Whale sharks form seasonal feeding aggregations. Like many species, they move great distances to return to productive feeding areas. These movements are generally timed with the onset of coral and fish spawning events. For example,

WHALE SHARK

- **Identification:** Massive-bodied shark with broad flattened head, almost terminal mouth, and short snout; small eyes; sides with three prominent ridges. Grey dorsal coloration with checkerboard pattern of white/yellow spots and transverse bars.

- **Size:** Birth: 1.8–2.1 ft.; Maturity: greater than 20 ft.; Maximum: 41 ft.

- **Distribution:** Worldwide in tropical and warm temperate waters.

- **Habitat:** Continental and island shelves, coastal waters, coral reefs, open ocean.

- **Behavior:** Highly migratory, demonstrates seasonal fidelity to regular feeding sites; filter-feeder; capable of suction feeding.

- **Reproduction:** Ovoviviparous; more than 300 pups.

- **Feeding:** Feeds on plankton as well as slightly larger, free-swimming marine animals.

- **Population Status:** Unknown; taken occasionally by commercial fisheries; population assessments lacking; IUCN Red List: Vulnerable.

whale sharks are known to congregate at Gladden Spit, an area off the coast of Belize, in April and May when snapper fish are spawning.

Exactly how whale sharks locate these productive food patches is a mystery; the small size of their eyes implies that vision is not a keen sense for this species. A 2015 study on three captive whale sharks at the Georgia Aquarium found that these huge fish used olfaction to locate and identify food sources.

Despite its size, the whale shark feeds on very small prey.

FAMILY: Zebra sharks (Stegostomatidae)

¤ **Number of Species: 1**

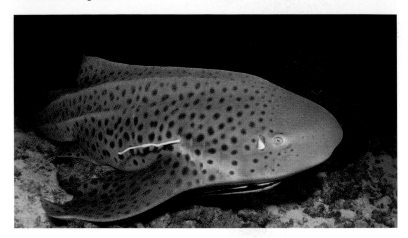

A zebra shark is marked with small brown spots.

ZEBRA SHARK *Stegostoma fasciatum*

- **Identification:** Slender-bodied shark with prominent ridges; small mouth; small barbells; large spiracles; caudal fin as long as its body. Yellow to brown dorsal coloration with small brown spots fading to pale underside; juveniles with vertical yellow stripes and white spots.

- **Size:** Birth: 0.7–1.2 ft.; Maturity: 5.6 ft; Maximum: 8.2 ft.

- **Distribution:** Tropical waters of the Indian and western Pacific Oceans.

- **Habitat:** Coastal waters, coral reefs, and lagoons.

- **Behavior:** Largely unknown; nocturnal, resting on bottom during the day; occurs singly; able to squirm into crevices for food; suction feeder.

- **Reproduction:** Oviparous; dark egg cases secured to substrate.

- **Feeding:** Prey includes small bony fishes and invertebrates sucked from the bottom.

- **Population Status:** Unknown; taken occasionally by commercial fisheries; population assessments lacking; IUCN Red List: Vulnerable.

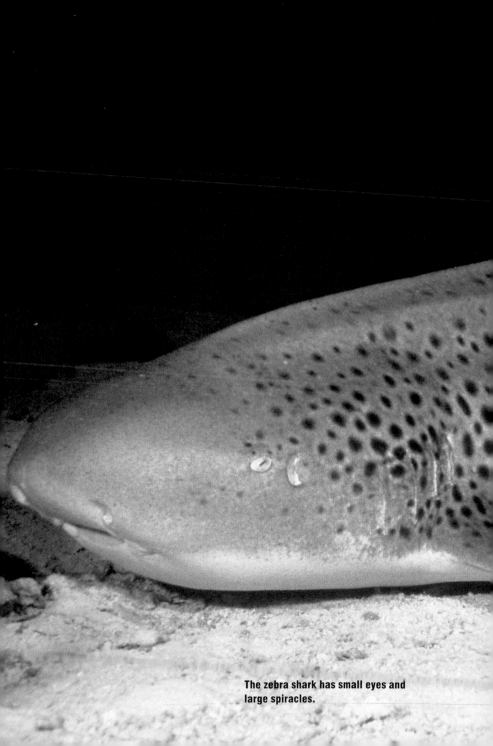

The zebra shark has small eyes and large spiracles.

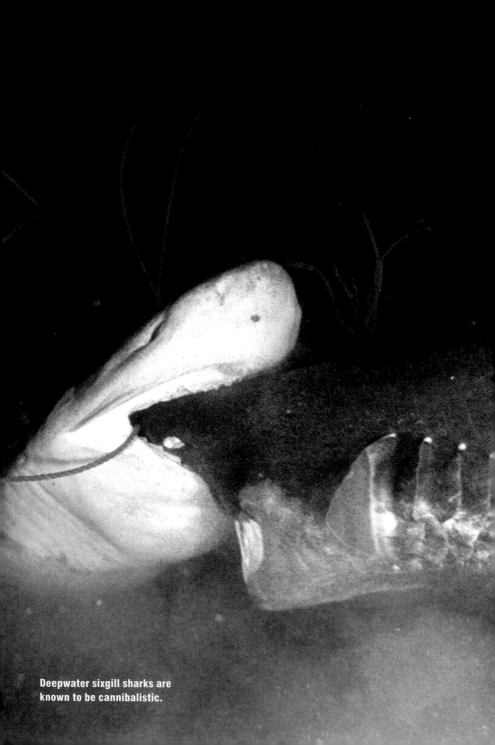

Deepwater sixgill sharks are known to be cannibalistic.

Other Orders of Sharks

The four remaining orders of sharks are relatively small, comprising a total of only five families and thirty-four species. Although small, these orders contain some of the most unusual sharks, with alien shapes and funky attachments. To the casual observer, a couple of these critters don't even look like sharks.

Sawsharks
(Order Pristiophoriformes)

With their long snouts armed with teeth and thin barbels in front of their nares, the sawsharks are very much one of the most unusual and readily identified orders. The group contains only one family and eight species. These sharks are commonly confused with sawfishes, which also have a long snout armed with teeth but are rays (superorder Batoidea, order Pristiformes, family Pristidae), not sharks.

FAMILY: Sawsharks (Pristiophoridae)

- **Number of Species:** 8
- **Size:** Small (4.5 feet)
- **Distribution:** Patchy tropical and temperate waters of the Atlantic, western Indian, and western Pacific Oceans.
- **Habitat:** Continental and island shelves and slopes.
- **Behavior:** Largely unknown; bottom-dwelling, adults deeper than juveniles; some occur in schools and feeding aggregations; uses snout for defense, to find and kill prey, or during courtship and competition.
- **Reproduction:** Ovoviviparous; 6–19 pups, depending on species.
- **Feeding:** Prey includes small bony fishes and invertebrates.
- **Population Status:** Unknown; some taken as bycatch in commercial fisheries.

Japanese sawshark, *Pristiophorus japonicus*

A complete list of sawsharks is on page 228.

Cow and Frilled Sharks

(Order Hexanchiformes)

The cow or frilled sharks have only one dorsal fin and six or seven gill slits. Although it contains two families and four genera, this group has only six recognized species.

FAMILY: Frilled sharks (Chlamydoselachidae)

¤ **Number of Species: 2**

Frilled shark,
Chlamydoselachus anguineus

FRILLED SHARK *Chlamydoselachus anguineus*

- **Identification:** Eel-shaped shark with snakelike head and short snout; large terminal mouth with three-cusped teeth; six gill slits; pectoral fins smaller than pelvics; brown coloration.

- **Size:** Birth: 1.3 ft.; Maturity: 3.0 ft. (male), 4.3 ft. (female); Maximum: 6.4 ft.

- **Distribution:** Patchy worldwide in tropical and temperate waters.

- **Habitat:** Continental shelves and slopes.

- **Behavior:** Poorly known; occurs on bottom as well as at the surface.

- **Reproduction:** Ovoviviparous; 6–12 pups.

- **Feeding:** Prey includes fishes and squid.

- **Population Status:** Unknown; taken as bycatch in commercial fisheries; IUCN Red List: Near Threatened.

A complete list of cow and frilled sharks is on page 225.

FAMILY: Cow sharks (Hexanchidae)

- ¤ **Number of Species:** 4

- ¤ **Size:** Small (4 feet) to very large (16 feet).

- ¤ **Distribution:** Patchy worldwide in tropical and temperate waters.

- ¤ **Habitat:** Continental shelves and upper slopes.

- ¤ **Behavior:** Most are active, slow-swimming sharks capable of bursts of speed; found close to bottom, but occasionally at surface and close inshore; occur alone or in small groups; some active at night; probably migratory.

- ¤ **Reproduction:** Ovoviviparous; 6–108 pups depending on species.

- ¤ **Feeding:** Very broad range of prey items including bony fishes, sharks, rays, invertebrates, marine mammals, and carrion.

- ¤ **Population Status:** Unknown; taken in commercial and recreational fisheries; population assessments lacking.

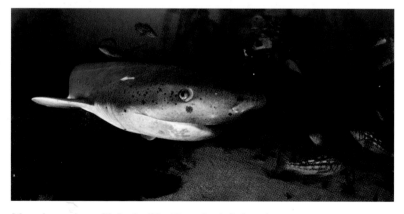

A broadnose sevengill shark glides through a kelp forest.

A complete list of cow sharks is on page 225.

OTHER ORDERS OF SHARKS

Horn and Bullhead Sharks

(Order Heterodontiformes)

The horn and bullhead sharks have short stout bodies, large heads, and piglike snouts. Like the dogfishes, the horn sharks have two equally sized dorsal fins with spines, but these sharks have an anal fin. This order contains only one family, and nine species.

FAMILY: Horn sharks (Heterodontidae)

- ¤ **Number of Species:** 9
- ¤ **Size:** Small (5 feet)
- ¤ **Distribution:** Patchy in tropical and temperate waters of the Indian and Pacific Oceans
- ¤ **Habitat:** Continental shelf, coastal waters, coral reefs, rocky areas, kelp beds.
- ¤ **Behavior:** Bottom-dwelling sluggish sharks; active at night; swim slowly or crawl over kelp beds, rocky and sandy bottoms; corkscrew-shaped egg cases deposited in crevices; one species migratory.
- ¤ **Reproduction:** Oviparous.
- ¤ **Feeding:** Prey includes bottom invertebrates.
- ¤ **Population Status:** Unknown; not taken in large numbers by fisheries; some kept in captivity.

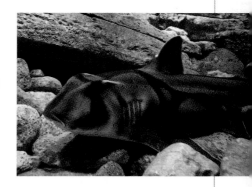

Port Jackson shark *Heterodontus portusjacksoni*

A complete list of horn and bullhead sharks is on pages 224–225.

Angelsharks
(Order Squatiniformes)

The angelsharks are best characterized by their flattened bodies and mouths situated at the tips of their snouts (*terminal* mouth). Of all the sharks, these really look most like a cross between a shark and a ray. All of the species in this order fall in one genus and a single family.

FAMILY: Angelsharks (Squatinidae)

- ¤ **Number of Species:** 22

- ¤ **Size:** Small (3 feet) to moderate (6 feet)

- ¤ **Distribution:** Patchy worldwide in temperate waters.

- ¤ **Habitat:** Continental shelves and upper slopes.

- ¤ **Behavior:** Poorly known sharks with patchy distribution; bottom dwelling buried in mud and sand; ambush prey by flexing body, raising head, and protruding jaws to inhale prey; some active at night.

- ¤ **Reproduction:** Ovoviviparous.

- ¤ **Feeding:** Prey includes small bottom fishes and invertebrates.

- ¤ **Population Status:** Taken in commercial fisheries worldwide; population assessments lacking, but signs of local depletion.

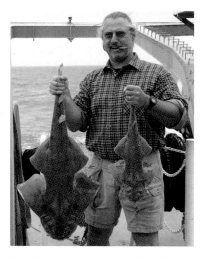

Atlantic angelshark or sand devil,
Squatina dumeril

A complete list of angelsharks is on pages 233–234.

BIBLIOGRAPHY

Carrier, J.C., J.A. Musick, and M.R. Heithaus (editors). 2004. *Biology of Sharks and Their Relatives.* CRC Press, Boca Raton, FL.

Castro, J. 1983. *The Sharks of North American Waters.* Texas A&M University Press, College Station, TX.

Compagno, L. 1984. *FAO Species Catalog,* Vol. 4, *Sharks of the World,* Part 1: Hexanchiformes to Lamniformes. United Nations Food and Agriculture Organization, Rome.

Compagno, L. 1984. *FAO Species Catalog,* Vol. 4, *Sharks of the World,* Part 2: Carcharhiniformes. United Nations Food and Agriculture Organization, Rome.

Compagno, L. 1988. *Sharks of the Order Carcharhiniformes.* Princeton University Press, Princeton, NJ.

Compagno, L., M. Dando, and S. Fowler. 2005. *Sharks of the World.* Princeton University Press, Princeton, NJ.

Hamlett, W.C. (editor). 1999. *Sharks, Skates, and Rays: the Biology of Elasmobranch Fishes.* The Johns Hopkins University Press, Baltimore, MD.

Helfman, G.S., B.B. Collette, and D.E. Facey. 1997. *The Diversity of Fishes.* Blackwell Science, Malden, MA.

Klimley, A.P., and D.G. Ainley (editors). 1996. *Great White Sharks: the Biology of* Carcharodon caroharias. Academic Press, Sand Diego, CA.

Schulze-Haugen, M., T. Corey, and N.E. Kohler. 2003. *Sharks, Tunas, and Billfishes of the U.S. Atlantic and Gulf of Mexico.* R.I. Sea Grant, Narrangansett, RI.

Shark Classifications and Names

The following lists shows how we classify and name all known shark orders, families, genera, and species. This allows you to see how various species, genera, families, and orders of sharks are classified and organized.

Sharks by Scientific Classification	
Order: Carcharhiniformes (ground sharks)	
Family: Carcharhinidae (requiem sharks)	
Carcharhinus acronotus	Blacknose shark
Carcharhinus albimarginatus	Silvertip shark
Carcharhinus altimus	Bignose shark
Carcharhinus amblyrhynchoides	Graceful shark
Carcharhinus amblyrhynchos	Blacktail reef shark
Carcharhinus amboinensis	Pigeye shark
Carcharhinus borneensis	Borneo shark
Carcharhinus brachyurus	Copper shark
Carcharhinus brevipinna	Spinner shark
Carcharhinus cautus	Nervous shark
Carcharhinus cerdale	Pacific smalltail shark
Carcharhinus coatesi	Coates' whitecheek shark
Carcharhinus dussumieri	Whitecheek shark
Carcharhinus falciformis	Silky shark
Carcharhinus fitzroyensis	Creek whaler
Carcharhinus galapagensis	Galapagos shark
Carcharhinus hemiodon	Pondicherry shark
Carcharhinus humani	Human's whaler shark

Sharks by Scientific Classification

Carcharhinus isodon	Finetooth shark
Carcharhinus leiodon	Smooth tooth blacktip shark
Carcharhinus leucas	Bull shark
Carcharhinus limbatus	Blacktip shark
Carcharhinus longimanus	Oceanic whitetip shark
Carcharhinus macloti	Hardnose shark
Carcharhinus macrops	[NO ENGLISH NAME]
Carcharhinus melanopterus	Blacktip reef shark
Carcharhinus obscurus	Dusky shark
Carcharhinus perezii	Caribbean reef shark
Carcharhinus plumbeus	Sandbar shark
Carcharhinus porosus	Smalltail shark
Carcharhinus sealei	Blackspot shark
Carcharhinus signatus	Night shark
Carcharhinus sorrah	Spot-tail shark
Carcharhinus tilstoni	Australian blacktip shark
Carcharhinus tjutjot	[NO ENGLISH NAME]
Galeocerdo cuvier	Tiger shark
Glyphis fowlerae	Borneo river shark
Glyphis gangeticus	Ganges shark
Glyphis garricki	Northern river shark
Glyphis glyphis	Speartooth shark
Glyphis siamensis	Irrawaddy river shark
Isogomphodon oxyrhynchus	Daggernose shark
Lamiopsis temminckii	Broadfin shark
Lamiopsis tephrodes	Sharptooth lemon shark
Loxodon macrorhinus	Sliteye shark
Nasolamia velox	Whitenose shark

Sharks by Scientific Classification

Negaprion acutidens	Sicklefin lemon shark
Negaprion brevirostris	Lemon shark
Prionace glauca	Blue shark
Rhizoprionodon acutus	Milk shark
Rhizoprionodon lalandii	Brazilian sharpnose shark
Rhizoprionodon longurio	Pacific sharpnose shark
Rhizoprionodon oligolinx	Grey sharpnose shark
Rhizoprionodon porosus	Caribbean sharpnose shark
Rhizoprionodon taylori	Australian sharpnose shark
Rhizoprionodon terraenovae	Atlantic sharpnose shark
Scoliodon laticaudus	Spadenose shark
Scoliodon macrorhynchos	Pacific Spadenose Shark
Triaenodon obesus	Whitetip reef shark

Order: Carcharhiniformes (ground sharks)

Family: Leptochariidae (barbeled sharks)

Leptocharias smithii	Barbeled Houndshark

Family: Hemigaleidae (weasel sharks)

Chaenogaleus macrostoma	Hooktooth shark
Hemigaleus australiensis	Australian weasel shark
Hemigaleus microstoma	Sicklefin weasel shark
Hemipristis elongatus	Snaggletooth shark
Paragaleus leucolomatus	Whitetip weasel shark
Paragaleus pectoralis	Atlantic weasel shark
Paragaleus randalli	Slender weasel shark
Paragaleus tengi	Straighttooth weasel shark

Family: Proscylliidae (finback catsharks)

Ctenacis fehlmanni	Harlequin catshark
Eridacnis barbouri	Cuban ribbontail catshark

Sharks by Scientific Classification

Eridacnis radcliffei	Pygmy ribbontail catshark
Eridacnis sinuans	African ribbontail catshark
Proscyllium habereri	Graceful catshark
Proscyllium magnificum	Magnificent catshark
Proscyllium venustum	Spotted smooth dogfish
Family: Pseudotriakidae (false catsharks)	
Gollum attenuatus	Slender smooth-hound
Gollum suluensis	Sulu gollumshark
Planonasus parini	Dwarf false catshark
Pseudotriakis microdon	False catshark
Family: Scyliorhinidae (catsharks)	
Apristurus albisoma	White-bodied catshark
Apristurus ampliceps	Roughskin catshark
Apristurus aphyodes	White ghost catshark
Apristurus australis	Pinocchio catshark
Apristurus breviventralis	Shortbelly catshark
Apristurus brunneus	Brown catshark
Apristurus bucephalus	Bighead catshark
Apristurus canutus	Hoary catshark
Apristurus exsanguis	Flaccid catshark
Apristurus fedorovi	Stout catshark
Apristurus garricki	Garrick's catshark
Apristurus gibbosus	Humpback catshark
Apristurus herklotsi	Longfin catshark
Apristurus indicus	Smallbelly catshark
Apristurus internatus	Shortnose demon catshark
Apristurus investigatoris	Broadnose catshark
Apristurus japonicus	Japanese catshark

Sharks by Scientific Classification	
Apristurus kampae	Longnose catshark
Apristurus laurussonii	Iceland catshark
Apristurus longicephalus	Longhead catshark
Apristurus macrorhynchus	Flathead catshark
Apristurus macrostomus	Broadmouth catshark
Apristurus manis	Ghost catshark
Apristurus melanoasper	Black roughscale catshark
Apristurus microps	Smalleye catshark
Apristurus micropterygeus	Smalldorsal catshark
Apristurus nakayai	Milk-eye catshark
Apristurus nasutus	Largenose catshark
Apristurus parvipinnis	Smallfin catshark
Apristurus pinguis	Fat catshark
Apristurus platyrhynchus	Borneo catshark
Apristurus profundorum	Deep-water catshark
Apristurus riveri	Broadgill catshark
Apristurus saldanha	Saldanha catshark
Apristurus sibogae	Pale catshark
Apristurus sinensis	South China catshark
Apristurus spongiceps	Spongehead catshark
Apristurus stenseni	Panama ghost catshark
Asymbolus analis	Australian spotted catshark
Asymbolus funebris	Blotched catshark
Asymbolus galacticus	Starry catshark
Asymbolus occiduus	Western spotted catshark
Asymbolus pallidus	Pale spotted catshark
Asymbolus parvus	Dwarf catshark
Asymbolus rubiginosus	Orange spotted catshark

Sharks by Scientific Classification

Asymbolus submaculatus	Variegated catshark
Asymbolus vincenti	Gulf catshark
Atelomycterus baliensis	Bali catshark
Atelomycterus erdmanni	Spotted-belly catshark
Atelomycterus fasciatus	Banded sand catshark
Atelomycterus macleayi	Australian marbled catshark
Atelomycterus marmoratus	Coral catshark
Atelomycterus marnkalha	Eastern banded catshark
Aulohalaelurus kanakorum	Kanakorum catshark
Aulohalaelurus labiosus	Australian blackspot catshark
Bythaelurus alcockii	Arabian catshark
Bythaelurus canescens	Dusky catshark
Bythaelurus clevai	Broadhead cat shark
Bythaelurus dawsoni	New Zealand catshark
Bythaelurus giddingsi	Galapagos catshark
Bythaelurus hispidus	Bristly catshark
Bythaelurus immaculatus	Spotless catshark
Bythaelurus incanus	Sombre catshark
Bythaelurus lutarius	Mud catshark
Cephaloscyllium albipinnum	Whitefin swellshark
Cephaloscyllium cooki	Cook's swellshark
Cephaloscyllium fasciatum	Reticulated swellshark
Cephaloscyllium hiscosellum	Australian reticulate swellshark
Cephaloscyllium isabellum	Draughtsboard shark
Cephaloscyllium laticeps	Australian swellshark
Cephaloscyllium pictum	Painted swellshark
Cephaloscyllium sarawakensis	Sarawak pygmy swellshark
Cephaloscyllium signourum	Flagtail swellshark

Sharks by Scientific Classification

Cephaloscyllium silasi	Indian swellshark
Cephaloscyllium speccum	Speckled swellshark
Cephaloscyllium stevensi	Steven's swellshark
Cephaloscyllium sufflans	Balloon shark
Cephaloscyllium umbratile	Blotchy swell shark
Cephaloscyllium variegatum	Saddled swellshark
Cephaloscyllium ventriosum	Swellshark
Cephaloscyllium zebrum	Narrowbar swellshark
Cephalurus cephalus	Lollipop catshark
Figaro boardmani	Australian sawtail catshark
Figaro striatus	Northern sawtail shark
Galeus antillensis	Antilles catshark
Galeus arae	Roughtail catshark
Galeus atlanticus	Atlantic sawtail catshark
Galeus cadenati	Longfin sawtail catshark
Galeus eastmani	Gecko catshark
Galeus gracilis	Slender sawtail catshark
Galeus longirostris	Longnose sawtail cat shark
Galeus melastomus	Blackmouth catshark
Galeus mincaronei	Southern sawtail catshark
Galeus murinus	Mouse catshark
Galeus nipponensis	Broadfin sawtail catshark
Galeus piperatus	Peppered catshark
Galeus polli	African sawtail catshark
Galeus priapus	Phallic catshark
Galeus sauteri	Blacktip sawtail catshark
Galeus schultzi	Dwarf sawtail catshark
Galeus springeri	Springer's sawtail catshark

Sharks by Scientific Classification

Halaelurus boesemani	Speckled catshark
Halaelurus buergeri	Blackspotted catshark
Halaelurus lineatus	Lined catshark
Halaelurus maculosus	Indonesian speckled catshark
Halaelurus natalensis	Tiger catshark
Halaelurus quagga	Quagga catshark
Halaelurus sellus	Rusty catshark
Haploblepharus edwardsii	Puffadder shyshark
Haploblepharus fuscus	Brown shyshark
Haploblepharus kistnasamyi	Natal shyshark
Haploblepharus pictus	Dark shyshark
Holohalaelurus favus	Honeycomb Izak
Holohalaelurus grennian	Grinning Izak
Holohalaelurus melanostigma	Crying Izak
Holohalaelurus punctatus	African spotted catshark
Holohalaelurus regani	Izak catshark
Parmaturus albimarginatus	White-tip catshark
Parmaturus albipenis	White-clasper catshark
Parmaturus bigus	Beige catshark
Parmaturus campechiensis	Campeche catshark
Parmaturus lanatus	Velvet catshark
Parmaturus macmillani	McMillan's cat shark
Parmaturus melanobranchus	Blackgill catshark
Parmaturus pilosus	Salamander shark
Parmaturus xaniurus	Filetail catshark
Pentanchus profundicolus	Onefin catshark
Poroderma africanum	Striped catshark
Poroderma pantherinum	Leopard catshark

Sharks by Scientific Classification

Schroederichthys bivius	Narrowmouthed catshark
Schroederichthys chilensis	Redspotted catshark
Schroederichthys maculatus	Narrowtail catshark
Schroederichthys saurisqualus	Lizard catshark
Schroederichthys tenuis	Slender catshark
Scyliorhinus besnardi	Polkadot catshark
Scyliorhinus boa	Boa catshark
Scyliorhinus canicula	Lesser spotted dogfish
Scyliorhinus capensis	Yellowspotted catshark
Scyliorhinus cervigoni	West African catshark
Scyliorhinus comoroensis	Comoro cat shark
Scyliorhinus garmani	Brownspotted catshark
Scyliorhinus haeckelii	Freckled catshark
Scyliorhinus hesperius	Whitesaddled catshark
Scyliorhinus meadi	Blotched catshark
Scyliorhinus retifer	Chain catshark
Scyliorhinus stellaris	Nursehound
Scyliorhinus tokubee	Izu catshark
Scyliorhinus torazame	Cloudy catshark
Scyliorhinus torrei	Dwarf catshark
Family: Sphyrnidae (hammerheads)	
Eusphyra blochii	Winghead shark
Sphyrna corona	Scalloped bonnethead
Sphyrna couardi	Whitefin hammerhead
Sphyrna gilberti	Carolina hammerhead
Sphyrna lewini	Scalloped hammerhead
Sphyrna media	Scoophead
Sphyrna mokarran	Great hammerhead

Sharks by Scientific Classification

Sphyrna tiburo	Bonnethead
Sphyrna tudes	Smalleye hammerhead
Sphyrna zygaena	Smooth hammerhead
Family Triakidae (houndsharks)	
Furgaleus macki	Whiskery shark
Galeorhinus galeus	Tope shark
Gogolia filewoodi	Sailback houndshark
Hemitriakis abdita	Deepwater sicklefin houndshark
Hemitriakis complicofasciata	Ocellate topeshark
Hemitriakis falcata	Sicklefin houndshark
Hemitriakis indroyonoi	Indonesian houndshark
Hemitriakis japanica	Japanese topeshark
Hemitriakis leucoperiptera	Whitefin topeshark
Hypogaleus hyugaensis	Blacktip tope
Iago garricki	Longnose houndshark
Iago omanensis	Bigeye houndshark
Mustelus albipinnis	Whitemargin smooth-hound
Mustelus antarcticus	Gummy shark
Mustelus asterias	Starry smooth-hound
Mustelus californicus	Gray smooth-hound
Mustelus canis	Dusky smooth-hound
Mustelus dorsalis	Sharptooth smooth-hound
Mustelus fasciatus	Striped smooth-hound
Mustelus griseus	Spotless smooth-hound
Mustelus henlei	Brown smooth-hound
Mustelus higmani	Smalleye smooth-hound
Mustelus lenticulatus	Spotted estuary smooth-hound
Mustelus lunulatus	Sicklefin smooth-hound

Sharks by Scientific Classification

Mustelus manazo	Starspotted smooth-hound
Mustelus mangalorensis	[NO ENGLISH NAME]
Mustelus mento	Speckled smooth-hound
Mustelus minicanis	Venezuelan dwarf smooth-hound
Mustelus mosis	Arabian smooth-hound
Mustelus mustelus	Smooth-hound
Mustelus norrisi	Narrowfin smooth-hound
Mustelus palumbes	Whitespotted smooth-hound
Mustelus punctulatus	Blackspotted smooth-hound
Mustelus ravidus	Australian grey smooth-hound
Mustelus schmitti	Narrownose smooth-hound
Mustelus sinusmexicanus	Gulf smoothhound
Mustelus stevensi	White-spotted gummy shark
Mustelus walkeri	Eastern spotted gummy shark
Mustelus whitneyi	Humpback smooth-hound
Mustelus widodoi	White-fin smooth-hound
Scylliogaleus quecketti	Flapnose houndshark
Triakis acutipinna	Sharpfin houndshark
Triakis maculata	Spotted houndshark
Triakis megalopterus	Sharptooth houndshark
Triakis scyllium	Banded houndshark
Triakis semifasciata	Leopard shark
Order: Heterodontiformes (Horn and Bullhead Sharks)	
Family: Heterodontidae (horn and bullhead sharks)	
Heterodontus francisci	Horn shark
Heterodontus galeatus	Crested bullhead shark
Heterodontus japonicus	Japanese bullhead shark
Heterodontus mexicanus	Mexican hornshark

Sharks by Scientific Classification

Heterodontus omanensis	Oman bullhead shark
Heterodontus portusjacksoni	Port Jackson shark
Heterodontus quoyi	Galapagos bullhead shark
Heterodontus ramalheira	Whitespotted bullhead shark
Heterodontus zebra	Zebra bullhead shark

Order: Hexanchiformes (cow and frilled sharks)

Family: Chlamydoselachidae (frilled sharks)

Chlamydoselachus africana	African frilled shark
Chlamydoselachus anguineus	Frilled shark

Family Hexanchidae (cow sharks)

Heptranchias perlo	Sharpnose sevengill shark
Hexanchus griseus	Bluntnose sixgill shark
Hexanchus nakamurai	Bigeyed sixgill shark
Notorynchus cepedianus	Broadnose sevengill shark

Order: Lamniformes (mackerel sharks)

Family: Alopiidae (thresher sharks)

Alopias pelagicus	Pelagic thresher
Alopias superciliosus	Bigeye thresher
Alopias vulpinus	Thresher shark

Family: Cetorhinidae (basking sharks)

Cetorhinus maximus	Basking shark

Family: Lamnidae (mackerel sharks)

Carcharodon carcharias	Great white shark
Isurus oxyrinchus	Shortfin mako
Isurus paucus	Longfin mako
Lamna ditropis	Salmon shark
Lamna nasus	Porbeagle

Sharks by Scientific Classification

Family: Megachasmidae (megamouth sharks)

Megachasma pelagios	Megamouth shark

Family :Mitsukurinidae (goblin sharks)

Mitsukurina owstoni	Goblin shark

Family: Odontaspididae (sand tiger sharks)

Carcharias taurus	Sand tiger
Odontaspis ferox	Smalltooth sand tiger
Odontaspis noronhai	Bigeye sand tiger

Family: Pseudocarchariidae (crocodile sharks)

Pseudocarcharias kamoharai	Crocodile shark

Order: Orectolobiformes (carpet sharks)

Family: Brachaeluridae (blind sharks)

Brachaelurus waddi	Blind shark
Heteroscyllium colcloughi	Bluegray carpetshark

Family: Ginglymostomatidae (nurse sharks)

Ginglymostoma cirratum	Nurse shark
Ginglymostoma unami	[NO ENGLISH NAME]
Nebrius ferrugineus	Tawny nurse shark
Pseudoginglymostoma brevicaudatum	Short-tail nurse shark

Family: Hemiscylliidae (longtailed carpetsharks)

Chiloscyllium arabicum	Arabian carpetshark
Chiloscyllium burmensis	Burmese bambooshark
Chiloscyllium caeruleopunctatum	Bluespotted bambooshark
Chiloscyllium griseum	Grey bambooshark
Chiloscyllium hasseltii	Hasselt's bambooshark
Chiloscyllium indicum	Slender bambooshark
Chiloscyllium plagiosum	Whitespotted bambooshark
Chiloscyllium punctatum	Brownbanded bambooshark

Sharks by Scientific Classification

Hemiscyllium freycineti	Indonesia speckled carpetshark
Hemiscyllium galei	Cenderwasih epaulette shark
Hemiscyllium hallstromi	Papuan epaulette shark
Hemiscyllium halmahera	Halmahera epaulette shark
Hemiscyllium henryi	Triton epaulette shark
Hemiscyllium michaeli	Leopard epaulette shark
Hemiscyllium ocellatum	Epaulette shark
Hemiscyllium strahani	Hooded carpetshark
Hemiscyllium trispeculare	Speckled carpetshark
Family: Orectolobidae (wobbegongs)	
Eucrossorhinus dasypogon	Tasselled wobbegong
Orectolobus floridus	Floral banded wobbegong
Orectolobus halei	Banded wobbegong
Orectolobus hutchinsi	Western wobbegong
Orectolobus japonicus	Japanese wobbegong
Orectolobus leptolineatus	Indonesian wobbegong
Orectolobus maculatus	Spotted wobbegong
Orectolobus ornatus	Ornate wobbegong
Orectolobus parvimaculatus	Dwarf spotted wobbegong
Orectolobus reticulatus	Network wobbegong
Orectolobus wardi	Northern wobbegong
Sutorectus tentaculatus	Cobbler wobbegong
Family: Parascylliidae (collared carpetsharks)	
Cirrhoscyllium expolitum	Barbelthroat carpetshark
Cirrhoscyllium formosanum	Taiwan saddled carpetshark
Cirrhoscyllium japonicum	Saddle carpetshark
Parascyllium collare	Collared carpetshark
Parascyllium elongatum	Elongate carpetshark

Sharks by Scientific Classification

Parascyllium ferrugineum	Rusty carpetshark
Parascyllium sparsimaculatum	Ginger carpetshark
Parascyllium variolatum	Necklace carpetshark
Family: Rhincodontidae (whale sharks)	
Rhincodon typus	Whale shark
Family Stegostomatidae (zebra sharks)	
Stegostoma fasciatum	Zebra shark
Order: Pristiophoriformes (sawsharks)	
Family: Pristiophoridae (sawsharks)	
Pliotrema warreni	Sixgill sawshark
Pristiophorus cirratus	Longnose sawshark
Pristiophorus delicatus	Tropical sawshark
Pristiophorus japonicus	Japanese sawshark
Pristiophorus lanae	Lana's sawshark
Pristiophorus nancyae	African dwarf sawshark
Pristiophorus nudipinnis	Shortnose sawshark
Pristiophorus schroederi	Bahamas sawshark
Order: Squaliformes (Dogfishes)	
Family: Centrophoridae (gulper sharks)	
Centrophorus atromarginatus	Dwarf gulper shark
Centrophorus granulosus	Gulper shark
Centrophorus harrissoni	Dumb gulper shark
Centrophorus isodon	Blackfin gulper shark
Centrophorus lusitanicus	Lowfin gulper shark
Centrophorus moluccensis	Smallfin gulper shark
Centrophorus seychellorum	Seychelles gulper shark
Centrophorus squamosus	Leafscale gulper shark
Centrophorus tessellatus	Mosaic gulper shark

Sharks by Scientific Classification

Centrophorus uyato	Little gulper shark
Centrophorus westraliensis	Western gulper shark
Centrophorus zeehaani	Southern dogfish
Deania calcea	Birdbeak dogfish
Deania hystricosa	Rough longnose dogfish
Deania profundorum	Arrowhead dogfish
Deania quadrispinosa	Longsnout dogfish
Family: Dalatiidae (kitefin sharks)	
Dalatias licha	Kitefin shark
Euprotomicroides zantedeschia	Taillight shark
Euprotomicrus bispinatus	Pygmy shark
Heteroscymnoides marleyi	Longnose pygmy shark
Isistius brasiliensis	Cookiecutter shark
Isistius plutodus	Largetooth cookiecutter shark
Mollisquama parini	Pocket shark
Squaliolus aliae	Smalleye pygmy shark
Squaliolus laticaudus	Spined pygmy shark
Family: Echinorhinidae (bramble sharks)	
Echinorhinus brucus	Bramble shark
Echinorhinus cookei	Prickly shark
Family: Etmopteridae (lantern sharks)	
Aculeola nigra	Hooktooth dogfish
Centroscyllium excelsum	Highfin dogfish
Centroscyllium fabricii	Black dogfish
Centroscyllium granulatum	Granular dogfish
Centroscyllium kamoharai	Bareskin dogfish
Centroscyllium nigrum	Combtooth dogfish
Centroscyllium ornatum	Ornate dogfish

Sharks by Scientific Classification

Centroscyllium ritteri	Whitefin dogfish
Etmopterus baxteri	New Zealand lanternshark
Etmopterus bigelowi	Blurred smooth lanternshark
Etmopterus brachyurus	Shorttail lanternshark
Etmopterus bullisi	Lined lanternshark
Etmopterus burgessi	Broad-snout lanternshark
Etmopterus carteri	Cylindrical lanternshark
Etmopterus caudistigmus	Tailspot lanternshark
Etmopterus compagnoi	Brown lanternshark
Etmopterus decacuspidatus	Combtoothed lanternshark
Etmopterus dianthus	Pink lanternshark
Etmopterus dislineatus	Lined lanternshark
Etmopterus evansi	Blackmouth lanternshark
Etmopterus fusus	Pygmy lanternshark
Etmopterus gracilispinis	Broadbanded lanternshark
Etmopterus granulosus	Southern lanternshark
Etmopterus hillianus	Caribbean lanternshark
Etmopterus joungi	Shortfin smooth lanternshark
Etmopterus litvinovi	Smalleye lanternshark
Etmopterus lucifer	Blackbelly lanternshark
Etmopterus molleri	Mollers lanternshark
Etmopterus perryi	Dwarf lanternshark
Etmopterus polli	African lanternshark
Etmopterus princeps	Great lanternshark
Etmopterus pseudosqualiolus	False lanternshark
Etmopterus pusillus	Smooth lanternshark
Etmopterus pycnolepis	Dense-scale lanternshark
Etmopterus robinsi	West Indian lanternshark

Sharks by Scientific Classification

Etmopterus schultzi	Fringefin lanternshark
Etmopterus sculptus	Sculpted lanternshark
Etmopterus sentosus	Thorny lanternshark
Etmopterus spinax	Velvet belly
Etmopterus splendidus	Splendid lanternshark
Etmopterus tasmaniensis	Tasmanian lanternshark
Etmopterus unicolor	Brown lanternshark
Etmopterus viator	Traveler lanternshark
Etmopterus villosus	Hawaiian lanternshark
Etmopterus virens	Green lanternshark
Miroscyllium sheikoi	Rasptooth dogfish
Trigonognathus kabeyai	Viper dogfish
Family: Oxynotidae (roughsharks)	
Oxynotus bruniensis	Prickly dogfish
Oxynotus caribbaeus	Caribbean roughshark
Oxynotus centrina	Angular roughshark
Oxynotus japonicus	Japanese roughshark
Oxynotus paradoxus	Sailfin roughshark
Family: Somniosidae (sleeper sharks)	
Centroscymnus coelolepis	Portuguese dogfish
Centroscymnus owstoni	Roughskin dogfish
Centroselachus crepidater	Longnose velvet dogfish
Proscymnodon macracanthus	Largespine velvet dogfish
Proscymnodon plunketi	Plunket's shark
Scymnodalatias albicaudi	Whitetail dogfish
Scymnodalatias garricki	Azores dogfish
Scymnodalatias oligodon	Sparsetooth dogfish
Scymnodalatias sherwoodi	Sherwood dogfish

Sharks by Scientific Classification

Scymnodon ringens	Knifetooth dogfish
Somniosus antarcticus	Southern sleeper shark
Somniosus longus	Frog shark
Somniosus microcephalus	Greenland shark
Somniosus pacificus	Pacific sleeper shark
Somniosus rostratus	Little sleeper shark
Zameus ichiharai	Japanese velvet dogfish
Zameus squamulosus	Velvet dogfish
Family: Squalidae (dogfish sharks)	
Cirrhigaleus asper	Roughskin spurdog
Cirrhigaleus australis	Southern Mandarin dogfish
Cirrhigaleus barbifer	Mandarin dogfish
Squalus acanthias	Spiny dogfish
Squalus albifrons	Eastern highfin spurdog
Squalus altipinnis	Western highfin spurdog
Squalus blainville	Longnose spurdog
Squalus brevirostris	Japanese shortnose spurdog
Squalus bucephalus	Bighead spurdog
Squalus chloroculus	Greeneye spurdog
Squalus crassispinus	Fatspine spurdog
Squalus cubensis	Cuban dogfish
Squalus edmundsi	Edmund's spurdog
Squalus formosus	Taiwan spurdog
Squalus grahami	Eastern longnose spurdog
Squalus griffini	Northern spiny dogfish
Squalus hemipinnis	Indonesian shortsnout spurdog
Squalus japonicus	Japanese spurdog
Squalus lalannei	Seychelles spurdog

Sharks by Scientific Classification

Squalus megalops	Shortnose spurdog
Squalus melanurus	Blacktailed spurdog
Squalus mitsukurii	Shortspine spurdog
Squalus montalbani	Indonesian greeneye spurdog
Squalus nasutus	Western longnose spurdog
Squalus notocaudatus	Bartail spurdog
Squalus rancureli	Cyrano spurdog
Squalus raoulensis	Kermadec spiny dogfish
Squalus suckleyi	Pacific spiny dogfish
Order: Squatiniformes (angelsharks)	
Family: Squatinidae (angelsharks)	
Squatina aculeata	Sawback angelshark
Squatina africana	African angelshark
Squatina albipunctata	Eastern angelshark
Squatina argentina	Argentine angelshark
Squatina australis	Australian angelshark
Squatina caillieti	Cailliet 's angelshark
Squatina californica	Pacific angelshark
Squatina dumeril	Atlantic angelshark
Squatina formosa	Taiwan angleshark
Squatina guggenheim	Angular angelshark
Squatina heteroptera	Disparate angelshark
Squatina japonica	Japanese angelshark
Squatina legnota	Indonesian angelshark
Squatina mexicana	Mexican angelshark
Squatina nebulosa	Clouded angelshark
Squatina occulta	Hidden angelshark
Squatina oculata	Smoothback angelshark

Sharks by Scientific Classification

Squatina pseudocellata	Western angelshark
Squatina punctata	Angular angelshark
Squatina squatina	Angelshark
Squatina tergocellata	Ornate angelshark
Squatina tergocellatoides	Ocellated angelshark

Sharks by Common Name

[NO ENGLISH NAME]	*Carcharhinus macrops*
[NO ENGLISH NAME]	*Carcharhinus tjutjot*
[NO ENGLISH NAME]	*Ginglymostoma unami*
[NO ENGLISH NAME]	*Mustelus mangalorensis*
African angelshark	*Squatina africana*
African dwarf sawshark	*Pristiophorus nancyae*
African frilled shark	*Chlamydoselachus africana*
African lanternshark	*Etmopterus polli*
African ribbontail catshark	*Eridacnis sinuans*
African sawtail catshark	*Galeus polli*
African spotted catshark	*Holohalaelurus punctatus*
Angelshark	*Squatina squatina*
Angular angelshark	*Squatina guggenheim*
Angular angelshark	*Squatina punctata*
Angular roughshark	*Oxynotus centrina*
Antilles catshark	*Galeus antillensis*
Arabian carpetshark	*Chiloscyllium arabicum*
Arabian catshark	*Bythaelurus alcockii*
Arabian smooth-hound	*Mustelus mosis*
Argentine angelshark	*Squatina argentina*
Arrowhead dogfish	*Deania profundorum*

Sharks by Common Name

Atlantic angelshark	*Squatina dumeril*
Atlantic sawtail catshark	*Galeus atlanticus*
Atlantic sharpnose shark	*Rhizoprionodon terraenovae*
Atlantic weasel Shark	*Paragaleus pectoralis*
Australian angelshark	*Squatina australis*
Australian blackspot catshark	*Aulohalaelurus labiosus*
Australian blacktip shark	*Carcharhinus tilstoni*
Australian grey smooth-hound	*Mustelus ravidus*
Australian marbled catshark	*Atelomycterus macleayi*
Australian reticulate swellshark	*Cephaloscyllium hiscosellum*
Australian sawtail catshark	*Figaro boardmani*
Australian sharpnose shark	*Rhizoprionodon taylori*
Australian spotted catshark	*Asymbolus analis*
Australian swellshark	*Cephaloscyllium laticeps*
Australian weasel shark	*Hemigaleus australiensis*
Azores dogfish	*Scymnodalatias garricki*
Bahamas sawshark	*Pristiophorus schroederi*
Bali catshark	*Atelomycterus baliensis*
Balloon shark	*Cephaloscyllium sufflans*
Banded houndshark	*Triakis scyllium*
Banded sand catshark	*Atelomycterus fasciatus*
Banded wobbegong	*Orectolobus halei*
Barbeled houndshark	*Leptocharias smithii*
Barbelthroat carpetshark	*Cirrhoscyllium expolitum*
Bareskin dogfish	*Centroscyllium kamoharai*
Bartail spurdog	*Squalus notocaudatus*
Basking shark	*Cetorhinus maximus*
Beige catshark	*Parmaturus bigus*

Sharks by Common Name

Bigeye houndshark	*Iago omanensis*
Bigeye sand tiger	*Odontaspis noronhai*
Bigeye thresher	*Alopias superciliosus*
Bigeyed sixgill shark	*Hexanchus nakamurai*
Bighead catshark	*Apristurus bucephalus*
Bighead spurdog	*Squalus bucephalus*
Bignose shark	*Carcharhinus altimus*
Birdbeak dogfish	*Deania calcea*
Black dogfish	*Centroscyllium fabricii*
Black roughscale catshark	*Apristurus melanoasper*
Blackbelly lanternshark	*Etmopterus lucifer*
Blackfin gulper shark	*Centrophorus isodon*
Blackgill catshark	*Parmaturus melanobranchus*
Blackmouth catshark	*Galeus melastomus*
Blackmouth lanternshark	*Etmopterus evansi*
Blacknose shark	*Carcharhinus acronotus*
Blackspot shark	*Carcharhinus sealei*
Blackspotted catshark	*Halaelurus buergeri*
Blackspotted smooth-hound	*Mustelus punctulatus*
Blacktail reef shark	*Carcharhinus amblyrhynchos*
Blacktailed spurdog	*Squalus melanurus*
Blacktip reef shark	*Carcharhinus melanopterus*
Blacktip sawtail catshark	*Galeus sauteri*
Blacktip shark	*Carcharhinus limbatus*
Blacktip tope	*Hypogaleus hyugaensis*
Blind shark	*Brachaelurus waddi*
Blotched catshark	*Asymbolus funebris*
Blotched catshark	*Scyliorhinus meadi*

Sharks by Common Name	
Blotchy swellshark	*Cephaloscyllium umbratile*
Blue shark	*Prionace glauca*
Bluegray carpetshark	*Heteroscyllium colcloughi*
Bluespotted bambooshark	*Chiloscyllium caeruleopunctatum*
Bluntnose sixgill shark	*Hexanchus griseus*
Blurred smooth lanternshark	*Etmopterus bigelowi*
Boa catshark	*Scyliorhinus boa*
Bonnethead	*Sphyrna tiburo*
Borneo catshark	*Apristurus platyrhynchus*
Borneo river shark	*Glyphis fowlerae*
Borneo shark	*Carcharhinus borneensis*
Bramble shark	*Echinorhinus brucus*
Brazilian sharpnose shark	*Rhizoprionodon lalandii*
Bristly catshark	*Bythaelurus hispidus*
Broad-snout lanternshark	*Etmopterus burgessi*
Broadbanded lanternshark	*Etmopterus gracilispinis*
Broadfin sawtail catshark	*Galeus nipponensis*
Broadfin shark	*Lamiopsis temminckii*
Broadgill catshark	*Apristurus riveri*
Broadhead catshark	*Bythaelurus clevai*
Broadmouth catshark	*Apristurus macrostomus*
Broadnose catshark	*Apristurus investigatoris*
Broadnose sevengill shark	*Notorynchus cepedianus*
Brown catshark	*Apristurus brunneus*
Brown lanternshark	*Etmopterus compagnoi*
Brown lanternshark	*Etmopterus unicolor*
Brown shyshark	*Haploblepharus fuscus*
Brown smooth-hound	*Mustelus henlei*

Sharks by Common Name

Brownbanded bambooshark	*Chiloscyllium punctatum*
Brownspotted catshark	*Scyliorhinus garmani*
Bull shark	*Carcharhinus leucas*
Burmese bambooshark	*Chiloscyllium burmensis*
Cailliet's angelshark	*Squatina caillieti*
Campeche catshark	*Parmaturus campechiensis*
Caribbean lanternshark	*Etmopterus hillianus*
Caribbean reef shark	*Carcharhinus perezii*
Caribbean roughshark	*Oxynotus caribbaeus*
Caribbean sharpnose shark	*Rhizoprionodon porosus*
Carolina hammerhead	*Sphyrna gilberti*
Cenderwasih epaulette shark	*Hemiscyllium galei*
Chain catshark	*Scyliorhinus retifer*
Clouded angelshark	*Squatina nebulosa*
Cloudy catshark	*Scyliorhinus torazame*
Coates' whitecheek shark	*Carcharhinus coatesi*
Cobbler wobbegong	*Sutorectus tentaculatus*
Collared carpetshark	*Parascyllium collare*
Combtooth dogfish	*Centroscyllium nigrum*
Combtoothed lanternshark	*Etmopterus decacuspidatus*
Comoro catshark	*Scyliorhinus comoroensis*
Cook's swellshark	*Cephaloscyllium cooki*
Cookiecutter shark	*Isistius brasiliensis*
Copper shark	*Carcharhinus brachyurus*
Coral catshark	*Atelomycterus marmoratus*
Creek whaler	*Carcharhinus fitzroyensis*
Crested bullhead shark	*Heterodontus galeatus*
Crocodile shark	*Pseudocarcharias kamoharai*

Sharks by Common Name

Crying Izak	*Holohalaelurus melanostigma*
Cuban dogfish	*Squalus cubensis*
Cuban ribbontail catshark	*Eridacnis barbouri*
Cylindrical lanternshark	*Etmopterus carteri*
Cyrano spurdog	*Squalus rancureli*
Daggernose shark	*Isogomphodon oxyrhynchus*
Dark shyshark	*Haploblepharus pictus*
Deep-water catshark	*Apristurus profundorum*
Deepwater sicklefin houndshark	*Hemitriakis abdita*
Dense-scale lanternshark	*Etmopterus pycnolepis*
Disparate angelshark	*Squatina heteroptera*
Draughtsboard shark	*Cephaloscyllium isabellum*
Dumb gulper shark	*Centrophorus harrissoni*
Dusky catshark	*Bythaelurus canescens*
Dusky shark	*Carcharhinus obscurus*
Dusky smooth-hound	*Mustelus canis*
Dwarf catshark	*Asymbolus parvus*
Dwarf catshark	*Scyliorhinus torrei*
Dwarf false catshark	*Planonasus parini*
Dwarf gulper shark	*Centrophorus atromarginatus*
Dwarf lanternshark	*Etmopterus perryi*
Dwarf sawtail catshark	*Galeus schultzi*
Dwarf spotted wobbegong	*Orectolobus parvimaculatus*
Eastern angelshark	*Squatina albipunctata*
Eastern banded catshark	*Atelomycterus marnkalha*
Eastern highfin spurdog	*Squalus albifrons*
Eastern longnose spurdog	*Squalus grahami*
Eastern spotted gummy shark	*Mustelus walkeri*

Sharks by Common Name

Edmund's spurdog	*Squalus edmundsi*
Elongate carpetshark	*Parascyllium elongatum*
Epaulette shark	*Hemiscyllium ocellatum*
False catshark	*Pseudotriakis microdon*
False lanternshark	*Etmopterus pseudosqualiolus*
Fat catshark	*Apristurus pinguis*
Fatspine spurdog	*Squalus crassispinus*
Filetail catshark	*Parmaturus xaniurus*
Finetooth shark	*Carcharhinus isodon*
Flaccid catshark	*Apristurus exsanguis*
Flagtail swellshark	*Cephaloscyllium signourum*
Flapnose houndshark	*Scylliogaleus quecketti*
Flathead catshark	*Apristurus macrorhynchus*
Floral banded wobbegong	*Orectolobus floridus*
Freckled catshark	*Scyliorhinus haeckelii*
Frilled shark	*Chlamydoselachus anguineus*
Fringefin lanternshark	*Etmopterus schultzi*
Frog shark	*Somniosus longus*
Galapagos bullhead shark	*Heterodontus quoyi*
Galapagos catshark	*Bythaelurus giddingsi*
Galapagos shark	*Carcharhinus galapagensis*
Ganges shark	*Glyphis gangeticus*
Garrick's catshark	*Apristurus garricki*
Gecko catshark	*Galeus eastmani*
Ghost catshark	*Apristurus manis*
Ginger carpetshark	*Parascyllium sparsimaculatum*
Goblin shark	*Mitsukurina owstoni*
Graceful catshark	*Proscyllium habereri*

Sharks by Common Name

Graceful shark	*Carcharhinus amblyrhynchoides*
Granular dogfish	*Centroscyllium granulatum*
Gray smoothhound	*Mustelus californicus*
Great hammerhead	*Sphyrna mokarran*
Great lanternshark	*Etmopterus princeps*
Great white shark	*Carcharodon carcharias*
Green lanternshark	*Etmopterus virens*
Greeneye spurdog	*Squalus chloroculus*
Greenland shark	*Somniosus microcephalus*
Grey bambooshark	*Chiloscyllium griseum*
Grey sharpnose shark	*Rhizoprionodon oligolinx*
Grinning Izak	*Holohalaelurus grennian*
Gulf catshark	*Asymbolus vincenti*
Gulf smoothhound	*Mustelus sinusmexicanus*
Gulper shark	*Centrophorus granulosus*
Gummy shark	*Mustelus antarcticus*
Halmahera epaulette shark	*Hemiscyllium halmahera*
Hardnose shark	*Carcharhinus macloti*
Harlequin catshark	*Ctenacis fehlmanni*
Hasselt's bambooshark	*Chiloscyllium hasseltii*
Hawaiian lanternshark	*Etmopterus villosus*
Hidden angelshark	*Squatina occulta*
Highfin dogfish	*Centroscyllium excelsum*
Hoary catshark	*Apristurus canutus*
Honeycomb Izak	*Holohalaelurus favus*
Hooded carpetshark	*Hemiscyllium strahani*
Hooktooth dogfish	*Aculeola nigra*
Hooktooth shark	*Chaenogaleus macrostoma*

Sharks by Common Name

Horn shark	*Heterodontus francisci*
Human's whaler shark	*Carcharhinus humani*
Humpback catshark	*Apristurus gibbosus*
Humpback smooth-hound	*Mustelus whitneyi*
Iceland catshark	*Apristurus laurussonii*
Indian swellshark	*Cephaloscyllium silasi*
Indonesia speckled carpetshark	*Hemiscyllium freycineti*
Indonesian angelshark	*Squatina legnota*
Indonesian greeneye spurdog	*Squalus montalbani*
Indonesian houndshark	*Hemitriakis indroyonoi*
Indonesian shortsnout spurdog	*Squalus hemipinnis*
Indonesian speckled catshark	*Halaelurus maculosus*
Indonesian wobbegong	*Orectolobus leptolineatus*
Irrawaddy river shark	*Glyphis siamensis*
Izak catshark	*Holohalaelurus regani*
Izu catshark	*Scyliorhinus tokubee*
Japanese angelshark	*Squatina japonica*
Japanese bullhead shark	*Heterodontus japonicus*
Japanese catshark	*Apristurus japonicus*
Japanese roughshark	*Oxynotus japonicus*
Japanese sawshark	*Pristiophorus japonicus*
Japanese shortnose spurdog	*Squalus brevirostris*
Japanese spurdog	*Squalus japonicus*
Japanese topeshark	*Hemitriakis japanica*
Japanese velvet dogfish	*Zameus ichiharai*
Japanese wobbegong	*Orectolobus japonicus*
Kanakorum catshark	*Aulohalaelurus kanakorum*
Kermadec spiny dogfish	*Squalus raoulensis*

Sharks by Common Name

Kitefin shark	*Dalatias licha*
Knifetooth dogfish	*Scymnodon ringens*
Lana's sawshark	*Pristiophorus lanae*
Largenose catshark	*Apristurus nasutus*
Largespine velvet dogfish	*Proscymnodon macracanthus*
Largetooth cookiecutter shark	*Isistius plutodus*
Leafscale gulper shark	*Centrophorus squamosus*
Lemon shark	*Negaprion brevirostris*
Leopard catshark	*Poroderma pantherinum*
Leopard epaulette shark	*Hemiscyllium michaeli*
Leopard shark	*Triakis semifasciata*
Lesser spotted dogfish	*Scyliorhinus canicula*
Lined catshark	*Halaelurus lineatus*
Lined lanternshark	*Etmopterus bullisi*
Lined lanternshark	*Etmopterus dislineatus*
Little gulper shark	*Centrophorus uyato*
Little sleeper shark	*Somniosus rostratus*
Lizard catshark	*Schroederichthys saurisqualus*
Lollipop catshark	*Cephalurus cephalus*
Longfin catshark	*Apristurus herklotsi*
Longfin mako	*Isurus paucus*
Longfin sawtail catshark	*Galeus cadenati*
Longhead catshark	*Apristurus longicephalus*
Longnose catshark	*Apristurus kampae*
Longnose houndshark	*Iago garricki*
Longnose pygmy shark	*Heteroscymnoides marleyi*
Longnose sawshark	*Pristiophorus cirratus*
Longnose sawtail catshark	*Galeus longirostris*

Sharks by Common Name

Longnose spurdog	*Squalus blainville*
Longnose velvet dogfish	*Centroselachus crepidater*
Longsnout dogfish	*Deania quadrispinosa*
Lowfin gulper shark	*Centrophorus lusitanicus*
Magnificent catshark	*Proscyllium magnificum*
Mandarin dogfish	*Cirrhigaleus barbifer*
McMillan's catshark	*Parmaturus macmillani*
Megamouth shark	*Megachasma pelagios*
Mexican angelshark	*Squatina mexicana*
Mexican hornshark	*Heterodontus mexicanus*
Milk shark	*Rhizoprionodon acutus*
Milk-eye catshark	*Apristurus nakayai*
Mollers lanternshark	*Etmopterus molleri*
Mosaic gulper shark	*Centrophorus tessellatus*
Mouse catshark	*Galeus murinus*
Mud catshark	*Bythaelurus lutarius*
Narrowbar swellshark	*Cephaloscyllium zebrum*
Narrowfin smooth-hound	*Mustelus norrisi*
Narrowmouthed catshark	*Schroederichthys bivius*
Narrownose smooth-hound	*Mustelus schmitti*
Narrowtail catshark	*Schroederichthys maculatus*
Natal shyshark	*Haploblepharus kistnasamyi*
Necklace carpetshark	*Parascyllium variolatum*
Nervous shark	*Carcharhinus cautus*
Network wobbegong	*Orectolobus reticulatus*
New Zealand catshark	*Bythaelurus dawsoni*
New Zealand lanternshark	*Etmopterus baxteri*
Night shark	*Carcharhinus signatus*

Sharks by Common Name

Northern river shark	*Glyphis garricki*
Northern sawtail shark	*Figaro striatus*
Northern spiny dogfish	*Squalus griffini*
Northern wobbegong	*Orectolobus wardi*
Nurse shark	*Ginglymostoma cirratum*
Nursehound	*Scyliorhinus stellaris*
Oceanic whitetip shark	*Carcharhinus longimanus*
Ocellate topeshark	*Hemitriakis complicofasciata*
Ocellated angelshark	*Squatina tergocellatoides*
Oman bullhead shark	*Heterodontus omanensis*
Onefin catshark	*Pentanchus profundicolus*
Orange spotted catshark	*Asymbolus rubiginosus*
Ornate angelshark	*Squatina tergocellata*
Ornate dogfish	*Centroscyllium ornatum*
Ornate wobbegong	*Orectolobus ornatus*
Pacific angelshark	*Squatina californica*
Pacific sharpnose shark	*Rhizoprionodon longurio*
Pacific sleeper shark	*Somniosus pacificus*
Pacific smalltail shark	*Carcharhinus cerdale*
Pacific spadenose shark	*Scoliodon macrorhynchos*
Pacific spiny dogfish	*Squalus suckleyi*
Painted swellshark	*Cephaloscyllium pictum*
Pale catshark	*Apristurus sibogae*
Pale spotted catshark	*Asymbolus pallidus*
Panama ghost catshark	*Apristurus stenseni*
Papuan epaulette shark	*Hemiscyllium hallstromi*
Pelagic thresher	*Alopias pelagicus*
Peppered catshark	*Galeus piperatus*

Sharks by Common Name

Phallic catshark	*Galeus priapus*
Pigeye shark	*Carcharhinus amboinensis*
Pink lanternshark	*Etmopterus dianthus*
Pinocchio catshark	*Apristurus australis*
Plunket's shark	*Proscymnodon plunketi*
Pocket shark	*Mollisquama parini*
Polkadot catshark	*Scyliorhinus besnardi*
Pondicherry shark	*Carcharhinus hemiodon*
Porbeagle	*Lamna nasus*
Port Jackson shark	*Heterodontus portusjacksoni*
Portuguese dogfish	*Centroscymnus coelolepis*
Prickly dogfish	*Oxynotus bruniensis*
Prickly shark	*Echinorhinus cookei*
Puffadder shyshark	*Haploblepharus edwardsii*
Pygmy lanternshark	*Etmopterus fusus*
Pygmy ribbontail catshark	*Eridacnis radcliffei*
Pygmy shark	*Euprotomicrus bispinatus*
Quagga catshark	*Halaelurus quagga*
Rasptooth dogfish	*Miroscyllium sheikoi*
Redspotted catshark	*Schroederichthys chilensis*
Reticulated swellshark	*Cephaloscyllium fasciatum*
Rough longnose dogfish	*Deania hystricosa*
Roughskin catshark	*Apristurus ampliceps*
Roughskin dogfish	*Centroscymnus owstoni*
Roughskin spurdog	*Cirrhigaleus asper*
Roughtail catshark	*Galeus arae*
Rusty carpetshark	*Parascyllium ferrugineum*
Rusty catshark	*Halaelurus sellus*

Sharks by Common Name

Saddle carpetshark	*Cirrhoscyllium japonicum*
Saddled swellshark	*Cephaloscyllium variegatum*
Sailback houndshark	*Gogolia filewoodi*
Sailfin roughshark	*Oxynotus paradoxus*
Salamander shark	*Parmaturus pilosus*
Saldanha catshark	*Apristurus saldanha*
Salmon shark	*Lamna ditropis*
Sandbar shark	*Carcharhinus plumbeus*
Sand tiger	*Carcharias taurus*
Sarawak pygmy swellshark	*Cephaloscyllium sarawakensis*
Sawback angelshark	*Squatina aculeata*
Scalloped bonnethead	*Sphyrna corona*
Scalloped hammerhead	*Sphyrna lewini*
Scoophead	*Sphyrna media*
Sculpted lanternshark	*Etmopterus sculptus*
Seychelles gulper shark	*Centrophorus seychellorum*
Seychelles spurdog	*Squalus lalannei*
Sharpfin houndshark	*Triakis acutipinna*
Sharpnose sevengill shark	*Heptranchias perlo*
Sharptooth houndshark	*Triakis megalopterus*
Sharptooth lemon shark	*Lamiopsis tephrodes*
Sharptooth smooth-hound	*Mustelus dorsalis*
Sherwood dogfish	*Scymnodalatias sherwoodi*
Short-tail nurse shark	*Pseudoginglymostoma brevicaudatum*
Shortbelly catshark	*Apristurus breviventralis*
Shortfin mako	*Isurus oxyrinchus*
Shortfin smooth lanternshark	*Etmopterus joungi*
Shortnose demon catshark	*Apristurus internatus*

Sharks by Common Name

Shortnose sawshark	*Pristiophorus nudipinnis*
Shortnose spurdog	*Squalus megalops*
Shortspine spurdog	*Squalus mitsukurii*
Shorttail lanternshark	*Etmopterus brachyurus*
Sicklefin hound shark	*Hemitriakis falcata*
Sicklefin lemon shark	*Negaprion acutidens*
Sicklefin smooth-hound	*Mustelus lunulatus*
Sicklefin weasel shark	*Hemigaleus microstoma*
Silky shark	*Carcharhinus falciformis*
Silvertip shark	*Carcharhinus albimarginatus*
Sixgill sawshark	*Pliotrema warreni*
Slender bambooshark	*Chiloscyllium indicum*
Slender catshark	*Schroederichthys tenuis*
Slender sawtail catshark	*Galeus gracilis*
Slender smooth-hound	*Gollum attenuatus*
Slender weasel shark	*Paragaleus randalli*
Sliteye shark	*Loxodon macrorhinus*
Smallbelly catshark	*Apristurus indicus*
Smalldorsal catshark	*Apristurus micropterygeus*
Smalleye catshark	*Apristurus microps*
Smalleye hammerhead	*Sphyrna tudes*
Smalleye lantern shark	*Etmopterus litvinovi*
Smalleye pygmy shark	*Squaliolus aliae*
Smalleye smooth-hound	*Mustelus higmani*
Smallfin catshark	*Apristurus parvipinnis*
Smallfin gulper shark	*Centrophorus moluccensis*
Smalltail shark	*Carcharhinus porosus*
Smalltooth sand tiger	*Odontaspis ferox*

Sharks by Common Name

Smooth hammerhead	*Sphyrna zygaena*
Smooth lanternshark	*Etmopterus pusillus*
Smooth tooth blacktip shark	*Carcharhinus leiodon*
Smooth-hound	*Mustelus mustelus*
Smoothback angelshark	*Squatina oculata*
Snaggletooth shark	*Hemipristis elongatus*
Sombre catshark	*Bythaelurus incanus*
South China catshark	*Apristurus sinensis*
Southern dogfish	*Centrophorus zeehaani*
Southern lanternshark	*Etmopterus granulosus*
Southern Mandarin dogfish	*Cirrhigaleus australis*
Southern sawtail catshark	*Galeus mincaronei*
Southern sleeper shark	*Somniosus antarcticus*
Spadenose shark	*Scoliodon laticaudus*
Sparsetooth dogfish	*Scymnodalatias oligodon*
Speartooth shark	*Glyphis glyphis*
Speckled carpetshark	*Hemiscyllium trispeculare*
Speckled catshark	*Halaelurus boesemani*
Speckled smooth-hound	*Mustelus mento*
Speckled swellshark	*Cephaloscyllium speccum*
Spined pygmy shark	*Squaliolus laticaudus*
Spinner shark	*Carcharhinus brevipinna*
Spiny dogfish	*Squalus acanthias*
Splendid lanternshark	*Etmopterus splendidus*
Spongehead catshark	*Apristurus spongiceps*
Spot-tail shark	*Carcharhinus sorrah*
Spotless catshark	*Bythaelurus immaculatus*
Spotless smooth-hound	*Mustelus griseus*

Sharks by Common Name

Spotted estuary smooth-hound	*Mustelus lenticulatus*
Spotted houndshark	*Triakis maculata*
Spotted smooth dogfish	*Proscyllium venustum*
Spotted wobbegong	*Orectolobus maculatus*
Spotted-belly catshark	*Atelomycterus erdmanni*
Springer's sawtail catshark	*Galeus springeri*
Starry catshark	*Asymbolus galacticus*
Starry smooth-hound	*Mustelus asterias*
Starspotted smooth-hound	*Mustelus manazo*
Steven's swellshark	*Cephaloscyllium stevensi*
Stout catshark	*Apristurus fedorovi*
Straighttooth weasel shark	*Paragaleus tengi*
Striped catshark	*Poroderma africanum*
Striped smooth-hound	*Mustelus fasciatus*
Sulu gollumshark	*Gollum suluensis*
Swellshark	*Cephaloscyllium ventriosum*
Taillight shark	*Euprotomicroides zantedeschia*
Tailspot lanternshark	*Etmopterus caudistigmus*
Taiwan angleshark	*Squatina formosa*
Taiwan saddled carpetshark	*Cirrhoscyllium formosanum*
Taiwan spurdog	*Squalus formosus*
Tasmanian lanternshark	*Etmopterus tasmaniensis*
Tasselled wobbegong	*Eucrossorhinus dasypogon*
Tawny nurse shark	*Nebrius ferrugineus*
Thorny lanternshark	*Etmopterus sentosus*
Thresher shark	*Alopias vulpinus*
Tiger catshark	*Halaelurus natalensis*
Tiger shark	*Galeocerdo cuvier*

Sharks by Common Name

Tope shark	*Galeorhinus galeus*
Traveler lanternshark	*Etmopterus viator*
Triton epaulette shark	*Hemiscyllium henryi*
Tropical sawshark	*Pristiophorus delicatus*
Variegated catshark	*Asymbolus submaculatus*
Velvet belly	*Etmopterus spinax*
Velvet catshark	*Parmaturus lanatus*
Velvet dogfish	*Zameus squamulosus*
Venezuelan dwarf smoothhound	*Mustelus minicanis*
Viper dogfish	*Trigonognathus kabeyai*
West African catshark	*Scyliorhinus cervigoni*
West Indian lanternshark	*Etmopterus robinsi*
Western angelshark	*Squatina pseudocellata*
Western gulper shark	*Centrophorus westraliensis*
Western highfin spurdog	*Squalus altipinnis*
Western longnose spurdog	*Squalus nasutus*
Western spotted catshark	*Asymbolus occiduus*
Western wobbegong	*Orectolobus hutchinsi*
Whale shark	*Rhincodon typus*
Whiskery shark	*Furgaleus macki*
White ghost catshark	*Apristurus aphyodes*
White-bodied catshark	*Apristurus albisoma*
White-clasper catshark	*Parmaturus albipenis*
White-fin smooth-hound	*Mustelus widodoi*
White-spotted gummy shark	*Mustelus stevensi*
White-tip catshark	*Parmaturus albimarginatus*
Whitecheek shark	*Carcharhinus coatesi*
Whitefin dogfish	*Centroscyllium ritteri*

Sharks by Common Name

Whitefin hammerhead	*Sphyrna couardi*
Whitefin swellshark	*Cephaloscyllium albipinnum*
Whitefin topeshark	*Hemitriakis leucoperiptera*
Whitemargin smooth-hound	*Mustelus albipinnis*
Whitenose shark	*Nasolamia velox*
Whitesaddled catshark	*Scyliorhinus hesperius*
Whitespotted bambooshark	*Chiloscyllium plagiosum*
Whitespotted bullhead shark	*Heterodontus ramalheira*
Whitespotted smooth-hound	*Mustelus palumbes*
Whitetail dogfish	*Scymnodalatias albicaudi*
Whitetip reef shark	*Triaenodon obesus*
Whitetip weasel shark	*Paragaleus leucolomatus*
Winghead shark	*Eusphyra blochii*
Yellowspotted catshark	*Scyliorhinus capensis*
Zebra bullhead shark	*Heterodontus zebra*
Zebra shark	*Stegostoma fasciatum*

Sharks by Scientific Name

Aculeola nigra	Hooktooth dogfish
Alopias pelagicus	Pelagic thresher
Alopias superciliosus	Bigeye thresher
Alopias vulpinus	Thresher shark
Apristurus albisoma	White-bodied catshark
Apristurus ampliceps	Roughskin catshark
Apristurus aphyodes	White ghost catshark
Apristurus australis	Pinocchio catshark
Apristurus breviventralis	Shortbelly catshark
Apristurus brunneus	Brown catshark

Sharks by Scientific Name

Apristurus bucephalus	Bighead catshark
Apristurus canutus	Hoary catshark
Apristurus exsanguis	Flaccid catshark
Apristurus fedorovi	Stout catshark
Apristurus garricki	Garrick's catshark
Apristurus gibbosus	Humpback catshark
Apristurus herklotsi	Longfin catshark
Apristurus indicus	Smallbelly catshark
Apristurus internatus	Shortnose demon catshark
Apristurus investigatoris	Broadnose catshark
Apristurus japonicus	Japanese catshark
Apristurus kampae	Longnose catshark
Apristurus laurussonii	Iceland catshark
Apristurus longicephalus	Longhead catshark
Apristurus macrorhynchus	Flathead catshark
Apristurus macrostomus	Broadmouth catshark
Apristurus manis	Ghost catshark
Apristurus melanoasper	Black roughscale catshark
Apristurus microps	Smalleye catshark
Apristurus micropterygeus	Smalldorsal catshark
Apristurus nakayai	Milk-eye catshark
Apristurus nasutus	Largenose catshark
Apristurus parvipinnis	Smallfin catshark
Apristurus pinguis	Fat catshark
Apristurus platyrhynchus	Borneo catshark
Apristurus profundorum	Deep-water catshark
Apristurus riveri	Broadgill catshark
Apristurus saldanha	Saldanha catshark

Sharks by Scientific Name

Apristurus sibogae	Pale catshark
Apristurus sinensis	South China catshark
Apristurus spongiceps	Spongehead catshark
Apristurus stenseni	Panama ghost catshark
Asymbolus analis	Australian spotted catshark
Asymbolus funebris	Blotched catshark
Asymbolus galacticus	Starry catshark
Asymbolus occiduus	Western spotted catshark
Asymbolus pallidus	Pale spotted catshark
Asymbolus parvus	Dwarf catshark
Asymbolus rubiginosus	Orange spotted catshark
Asymbolus submaculatus	Variegated catshark
Asymbolus vincenti	Gulf catshark
Atelomycterus baliensis	Bali catshark
Atelomycterus erdmanni	Spotted-belly catshark
Atelomycterus fasciatus	Banded sand catshark
Atelomycterus macleayi	Australian marbled catshark
Atelomycterus marmoratus	Coral catshark
Atelomycterus marnkalha	Eastern banded catshark
Aulohalaelurus kanakorum	Kanakorum catshark
Aulohalaelurus labiosus	Australian blackspot catshark
Brachaelurus waddi	Blind shark
Bythaelurus alcockii	Arabian catshark
Bythaelurus canescens	Dusky catshark
Bythaelurus clevai	Broadhead catshark
Bythaelurus dawsoni	New Zealand catshark
Bythaelurus giddingsi	Galapagos catshark
Bythaelurus hispidus	Bristly catshark

Sharks by Scientific Name

Bythaelurus immaculatus	Spotless catshark
Bythaelurus incanus	Sombre catshark
Bythaelurus lutarius	Mud catshark
Carcharhinus acronotus	Blacknose shark
Carcharhinus albimarginatus	Silvertip shark
Carcharhinus altimus	Bignose shark
Carcharhinus amblyrhynchoides	Graceful shark
Carcharhinus amblyrhynchos	Blacktail reef shark
Carcharhinus amboinensis	Pigeye shark
Carcharhinus borneensis	Borneo shark
Carcharhinus brachyurus	Copper shark
Carcharhinus brevipinna	Spinner shark
Carcharhinus cautus	Nervous shark
Carcharhinus cerdale	Pacific smalltail shark
Carcharhinus coatesi	Coates' whitecheek shark
Carcharhinus dussumieri	Whitecheek shark
Carcharhinus falciformis	Silky shark
Carcharhinus fitzroyensis	Creek whaler
Carcharhinus galapagensis	Galapagos shark
Carcharhinus hemiodon	Pondicherry shark
Carcharhinus humani	Human's whaler shark
Carcharhinus isodon	Finetooth shark
Carcharhinus leiodon	Smooth tooth blacktip shark
Carcharhinus leucas	Bull shark
Carcharhinus limbatus	Blacktip shark
Carcharhinus longimanus	Oceanic whitetip shark
Carcharhinus macloti	Hardnose shark
Carcharhinus macrops	[NO ENGLISH NAME]

Sharks by Scientific Name

Carcharhinus melanopterus	Blacktip reef shark
Carcharhinus obscurus	Dusky shark
Carcharhinus perezii	Caribbean reef shark
Carcharhinus plumbeus	Sandbar shark
Carcharhinus porosus	Smalltail shark
Carcharhinus sealei	Blackspot shark
Carcharhinus signatus	Night shark
Carcharhinus sorrah	Spot-tail shark
Carcharhinus tilstoni	Australian blacktip shark
Carcharhinus tjutjot	[NO ENGLISH NAME]
Carcharias taurus	Sand tiger
Carcharodon carcharias	Great white shark
Centrophorus atromarginatus	Dwarf gulper shark
Centrophorus granulosus	Gulper shark
Centrophorus harrissoni	Dumb gulper shark
Centrophorus isodon	Blackfin gulper shark
Centrophorus lusitanicus	Lowfin gulper shark
Centrophorus moluccensis	Smallfin gulper shark
Centrophorus seychellorum	Seychelles gulper shark
Centrophorus squamosus	Leafscale gulper shark
Centrophorus tessellatus	Mosaic gulper shark
Centrophorus uyato	Little gulper shark
Centrophorus westraliensis	Western gulper shark
Centrophorus zeehaani	Southern dogfish
Centroscyllium excelsum	Highfin dogfish
Centroscyllium fabricii	Black dogfish
Centroscyllium granulatum	Granular dogfish
Centroscyllium kamoharai	Bareskin dogfish

Sharks by Scientific Name

Centroscyllium nigrum	Combtooth dogfish
Centroscyllium ornatum	Ornate dogfish
Centroscyllium ritteri	Whitefin dogfish
Centroscymnus coelolepis	Portuguese dogfish
Centroscymnus owstoni	Roughskin dogfish
Centroselachus crepidater	Longnose velvet dogfish
Cephaloscyllium albipinnum	Whitefin swellshark
Cephaloscyllium cooki	Cook's swellshark
Cephaloscyllium fasciatum	Reticulated swellshark
Cephaloscyllium hiscosellum	Australian reticulate swellshark
Cephaloscyllium isabellum	Draughtsboard shark
Cephaloscyllium laticeps	Australian swellshark
Cephaloscyllium pictum	Painted swellshark
Cephaloscyllium sarawakensis	Sarawak pygmy swellshark
Cephaloscyllium signourum	Flagtail swellshark
Cephaloscyllium silasi	Indian swellshark
Cephaloscyllium speccum	Speckled swellshark
Cephaloscyllium stevensi	Steven's swellshark
Cephaloscyllium sufflans	Balloon shark
Cephaloscyllium umbratile	Blotchy swellshark
Cephaloscyllium variegatum	Saddled swellshark
Cephaloscyllium ventriosum	Swellshark
Cephaloscyllium zebrum	Narrowbar swellshark
Cephalurus cephalus	Lollipop catshark
Cetorhinus maximus	Basking shark
Chaenogaleus macrostoma	Hooktooth shark
Chiloscyllium arabicum	Arabian carpetshark
Chiloscyllium burmensis	Burmese bambooshark

Sharks by Scientific Name

Chiloscyllium caeruleopunctatum	Bluespotted bambooshark
Chiloscyllium griseum	Grey bambooshark
Chiloscyllium hasseltii	Hasselt's bambooshark
Chiloscyllium indicum	Slender bambooshark
Chiloscyllium plagiosum	Whitespotted bambooshark
Chiloscyllium punctatum	Brownbanded bambooshark
Chlamydoselachus africana	African frilled shark
Chlamydoselachus anguineus	Frilled shark
Cirrhigaleus asper	Roughskin spurdog
Cirrhigaleus australis	Southern Mandarin dogfish
Cirrhigaleus barbifer	Mandarin dogfish
Cirrhoscyllium expolitum	Barbelthroat carpetshark
Cirrhoscyllium formosanum	Taiwan saddled carpetshark
Cirrhoscyllium japonicum	Saddle carpetshark
Ctenacis fehlmanni	Harlequin catshark
Dalatias licha	Kitefin shark
Deania calcea	Birdbeak dogfish
Deania hystricosa	Rough longnose dogfish
Deania profundorum	Arrowhead dogfish
Deania quadrispinosa	Longsnout dogfish
Echinorhinus brucus	Bramble shark
Echinorhinus cookei	Prickly shark
Eridacnis barbouri	Cuban ribbontail catshark
Eridacnis radcliffei	Pygmy ribbontail catshark
Eridacnis sinuans	African ribbontail catshark
Etmopterus baxteri	New Zealand lanternshark
Etmopterus bigelowi	Blurred smooth lanternshark
Etmopterus brachyurus	Shorttail lanternshark

APPENDIX

Sharks by Scientific Name

Etmopterus bullisi	Lined lanternshark
Etmopterus burgessi	Broad-snout lanternshark
Etmopterus carteri	Cylindrical lanternshark
Etmopterus caudistigmus	Tailspot lanternshark
Etmopterus compagnoi	Brown lanternshark
Etmopterus decacuspidatus	Combtoothed lanternshark
Etmopterus dianthus	Pink lanternshark
Etmopterus dislineatus	Lined lanternshark
Etmopterus evansi	Blackmouth lanternshark
Etmopterus fusus	Pygmy lanternshark
Etmopterus gracilispinis	Broadbanded lanternshark
Etmopterus granulosus	Southern lanternshark
Etmopterus hillianus	Caribbean lanternshark
Etmopterus joungi	Shortfin smooth lanternshark
Etmopterus litvinovi	Smalleye lanternshark
Etmopterus lucifer	Blackbelly lanternshark
Etmopterus molleri	Mollers lanternshark
Etmopterus perryi	Dwarf lanternshark
Etmopterus polli	African lanternshark
Etmopterus princeps	Great lanternshark
Etmopterus pseudosqualiolus	False lanternshark
Etmopterus pusillus	Smooth lanternshark
Etmopterus pycnolepis	Dense-scale lanternshark
Etmopterus robinsi	West Indian lanternshark
Etmopterus schultzi	Fringefin lanternshark
Etmopterus sculptus	Sculpted lanternshark
Etmopterus sentosus	Thorny lanternshark
Etmopterus spinax	Velvet belly

Sharks by Scientific Name

Etmopterus splendidus	Splendid lanternshark
Etmopterus tasmaniensis	Tasmanian lanternshark
Etmopterus unicolor	Brown lanternshark
Etmopterus viator	Traveler lanternshark
Etmopterus villosus	Hawaiian lanternshark
Etmopterus virens	Green lanternshark
Eucrossorhinus dasypogon	Tasselled wobbegong
Euprotomicroides zantedeschia	Taillight shark
Euprotomicrus bispinatus	Pygmy shark
Eusphyra blochii	Winghead shark
Figaro boardmani	Australian sawtail catshark
Figaro striatus	Northern sawtail shark
Furgaleus macki	Whiskery shark
Galeocerdo cuvier	Tiger shark
Galeorhinus galeus	Tope shark
Galeus antillensis	Antilles Catshark
Galeus arae	Roughtail catshark
Galeus atlanticus	Atlantic sawtail catshark
Galeus cadenati	Longfin sawtail catshark
Galeus eastmani	Gecko catshark
Galeus gracilis	Slender sawtail catshark
Galeus longirostris	Longnose sawtail catshark
Galeus melastomus	Blackmouth catshark
Galeus mincaronei	Southern sawtail catshark
Galeus murinus	Mouse catshark
Galeus nipponensis	Broadfin sawtail catshark
Galeus piperatus	Peppered catshark
Galeus polli	African sawtail catshark

APPENDIX

Sharks by Scientific Name

Galeus priapus	Phallic catshark
Galeus sauteri	Blacktip sawtail catshark
Galeus schultzi	Dwarf sawtail catshark
Galeus springeri	Springer's sawtail catshark
Ginglymostoma cirratum	Nurse shark
Ginglymostoma unami	[NO ENGLISH NAME]
Glyphis fowlerae	Borneo river shark
Glyphis gangeticus	Ganges shark
Glyphis garricki	Northern river shark
Glyphis glyphis	Speartooth shark
Glyphis siamensis	Irrawaddy river shark
Gogolia filewoodi	Sailback houndshark
Gollum attenuatus	Slender smooth-hound
Gollum suluensis	Sulu gollumshark
Halaelurus boesemani	Speckled catshark
Halaelurus buergeri	Blackspotted catshark
Halaelurus lineatus	Lined catshark
Halaelurus maculosus	Indonesian speckled catshark
Halaelurus natalensis	Tiger catshark
Halaelurus quagga	Quagga catshark
Halaelurus sellus	Rusty catshark
Haploblepharus edwardsii	Puffadder shyshark
Haploblepharus fuscus	Brown shyshark
Haploblepharus kistnasamyi	Natal shyshark
Haploblepharus pictus	Dark shyshark
Hemigaleus australiensis	Australian weasel shark
Hemigaleus microstoma	Sicklefin weasel shark
Hemipristis elongatus	Snaggletooth shark

Sharks by Scientific Name

Hemiscyllium freycineti	Indonesia speckled carpetshark
Hemiscyllium galei	Cenderwasih epaulette shark
Hemiscyllium hallstromi	Papuan epaulette shark
Hemiscyllium halmahera	Halmahera epaulette shark
Hemiscyllium henryi	Triton epaulette shark
Hemiscyllium michaeli	Leopard epaulette shark
Hemiscyllium ocellatum	Epaulette shark
Hemiscyllium strahani	Hooded carpetshark
Hemiscyllium trispeculare	Speckled carpetshark
Hemitriakis abdita	Deepwater sicklefin houndshark
Hemitriakis complicofasciata	Ocellate topeshark
Hemitriakis falcata	Sicklefin houndshark
Hemitriakis indroyonoi	Indonesian houndshark
Hemitriakis japanica	Japanese topeshark
Hemitriakis leucoperiptera	Whitefin topeshark
Heptranchias perlo	Sharpnose sevengill shark
Heterodontus francisci	Horn shark
Heterodontus galeatus	Crested bullhead shark
Heterodontus japonicus	Japanese bullhead shark
Heterodontus mexicanus	Mexican hornshark
Heterodontus omanensis	Oman bullhead shark
Heterodontus portusjacksoni	Port Jackson shark
Heterodontus quoyi	Galapagos bullhead shark
Heterodontus ramalheira	Whitespotted bullhead shark
Heterodontus zebra	Zebra bullhead shark
Heteroscyllium colcloughi	Bluegray carpetshark
Heteroscymnoides marleyi	Longnose pygmy shark
Hexanchus griseus	Bluntnose sixgill shark

Sharks by Scientific Name

Hexanchus nakamurai	Bigeyed sixgill shark
Holohalaelurus favus	Honeycomb Izak
Holohalaelurus grennian	Grinning Izak
Holohalaelurus melanostigma	Crying Izak
Holohalaelurus punctatus	African spotted catshark
Holohalaelurus regani	Izak catshark
Hypogaleus hyugaensis	Blacktip tope
Iago garricki	Longnose houndshark
Iago omanensis	Bigeye houndshark
Isistius brasiliensis	Cookiecutter shark
Isistius plutodus	Largetooth cookiecutter shark
Isogomphodon oxyrhynchus	Daggernose shark
Isurus oxyrinchus	Shortfin mako
Isurus paucus	Longfin mako
Lamiopsis temminckii	Broadfin shark
Lamiopsis tephrodes	Sharptooth lemon shark
Lamna ditropis	Salmon shark
Lamna nasus	Porbeagle
Leptocharias smithii	Barbeled houndshark
Loxodon macrorhinus	Sliteye shark
Megachasma pelagios	Megamouth shark
Miroscyllium sheikoi	Rasptooth dogfish
Mitsukurina owstoni	Goblin shark
Mollisquama parini	Pocket shark
Mustelus albipinnis	Whitemargin smooth-hound
Mustelus antarcticus	Gummy shark
Mustelus asterias	Starry smooth-hound
Mustelus californicus	Gray smooth-hound

Sharks by Scientific Name

Mustelus canis	Dusky smooth-hound
Mustelus dorsalis	Sharptooth smooth-hound
Mustelus fasciatus	Striped smooth-hound
Mustelus griseus	Spotless smooth-hound
Mustelus henlei	Brown smooth-hound
Mustelus higmani	Smalleye smooth-hound
Mustelus lenticulatus	Spotted estuary smooth-hound
Mustelus lunulatus	Sicklefin smooth-hound
Mustelus manazo	Starspotted smooth-hound
Mustelus mangalorensis	[NO ENGLISH NAME]
Mustelus mento	Speckled smooth-hound
Mustelus minicanis	Venezuelan dwarf smooth-hound
Mustelus mosis	Arabian smooth-hound
Mustelus mustelus	Smooth-hound
Mustelus norrisi	Narrowfin smooth-hound
Mustelus palumbes	Whitespotted smooth-hound
Mustelus punctulatus	Blackspotted smooth-hound
Mustelus ravidus	Australian grey smooth-hound
Mustelus schmitti	Narrownose smooth-hound
Mustelus sinusmexicanus	Gulf smooth-hound
Mustelus stevensi	White-spotted gummy shark
Mustelus walkeri	Eastern spotted gummy shark
Mustelus whitneyi	Humpback smooth-hound
Mustelus widodoi	White-fin smooth-hound
Nasolamia velox	Whitenose shark
Nebrius ferrugineus	Tawny nurse shark
Negaprion acutidens	Sicklefin lemon shark
Negaprion brevirostris	Lemon shark

Sharks by Scientific Name

Notorynchus cepedianus	Broadnose sevengill shark
Odontaspis ferox	Smalltooth sand tiger
Odontaspis noronhai	Bigeye sand tiger
Orectolobus floridus	Floral banded wobbegong
Orectolobus halei	Banded wobbegong
Orectolobus hutchinsi	Western wobbegong
Orectolobus japonicus	Japanese wobbegong
Orectolobus leptolineatus	Indonesian wobbegong
Orectolobus maculatus	Spotted wobbegong
Orectolobus ornatus	Ornate wobbegong
Orectolobus parvimaculatus	Dwarf spotted wobbegong
Orectolobus reticulatus	Network wobbegong
Orectolobus wardi	Northern wobbegong
Oxynotus bruniensis	Prickly dogfish
Oxynotus caribbaeus	Caribbean roughshark
Oxynotus centrina	Angular roughshark
Oxynotus japonicus	Japanese roughshark
Oxynotus paradoxus	Sailfin roughshark
Paragaleus leucolomatus	Whitetip weasel shark
Paragaleus pectoralis	Atlantic weasel shark
Paragaleus randalli	Slender weasel shark
Paragaleus tengi	Straighttooth weasel shark
Parascyllium collare	Collared carpetshark
Parascyllium elongatum	Elongate carpetshark
Parascyllium ferrugineum	Rusty carpetshark
Parascyllium sparsimaculatum	Ginger carpetshark
Parascyllium variolatum	Necklace carpetshark
Parmaturus albimarginatus	White-tip catshark

Sharks by Scientific Name

Parmaturus albipenis	White-clasper catshark
Parmaturus bigus	Beige catshark
Parmaturus campechiensis	Campeche catshark
Parmaturus lanatus	Velvet catshark
Parmaturus macmillani	McMillan's catshark
Parmaturus melanobranchus	Blackgill catshark
Parmaturus pilosus	Salamander shark
Parmaturus xaniurus	Filetail catshark
Pentanchus profundicolus	Onefin catshark
Planonasus parini	Dwarf false catshark
Pliotrema warreni	Sixgill sawshark
Poroderma africanum	Striped catshark
Poroderma pantherinum	Leopard catshark
Prionace glauca	Blue shark
Pristiophorus cirratus	Longnose sawshark
Pristiophorus delicatus	Tropical sawshark
Pristiophorus japonicus	Japanese sawshark
Pristiophorus lanae	Lana's sawshark
Pristiophorus nancyae	African dwarf sawshark
Pristiophorus nudipinnis	Shortnose sawshark
Pristiophorus schroederi	Bahamas sawshark
Proscyllium habereri	Graceful catshark
Proscyllium magnificum	Magnificent catshark
Proscyllium venustum	Spotted smooth dogfish
Proscymnodon macracanthus	Largespine velvet dogfish
Proscymnodon plunketi	Plunket's shark
Pseudocarcharias kamoharai	Crocodile shark
Pseudoginglymostoma brevicaudatum	Short-tail nurse shark

Sharks by Scientific Name

Pseudotriakis microdon	False catshark
Rhincodon typus	Whale shark
Rhizoprionodon acutus	Milk shark
Rhizoprionodon lalandii	Brazilian sharpnose shark
Rhizoprionodon longurio	Pacific sharpnose shark
Rhizoprionodon oligolinx	Grey sharpnose shark
Rhizoprionodon porosus	Caribbean sharpnose shark
Rhizoprionodon taylori	Australian sharpnose shark
Rhizoprionodon terraenovae	Atlantic sharpnose shark
Schroederichthys bivius	Narrowmouthed catshark
Schroederichthys chilensis	Redspotted catshark
Schroederichthys maculatus	Narrowtail catshark
Schroederichthys saurisqualus	Lizard catshark
Schroederichthys tenuis	Slender catshark
Scoliodon laticaudus	Spadenose shark
Scoliodon macrorhynchos	Pacific spadenose shark
Scyliorhinus besnardi	Polkadot catshark
Scyliorhinus boa	Boa catshark
Scyliorhinus canicula	Lesser spotted dogfish
Scyliorhinus capensis	Yellowspotted catshark
Scyliorhinus cervigoni	West African catshark
Scyliorhinus comoroensis	Comoro catshark
Scyliorhinus garmani	Brownspotted catshark
Scyliorhinus haeckelii	Freckled catshark
Scyliorhinus hesperius	Whitesaddled catshark
Scyliorhinus meadi	Blotched catshark
Scyliorhinus retifer	Chain catshark
Scyliorhinus stellaris	Nursehound

Sharks by Scientific Name

Scyliorhinus tokubee	Izu catshark
Scyliorhinus torazame	Cloudy catshark
Scyliorhinus torrei	Dwarf catshark
Scylliogaleus quecketti	Flapnose houndshark
Scymnodalatias albicaudi	Whitetail dogfish
Scymnodalatias garricki	Azores dogfish
Scymnodalatias oligodon	Sparsetooth dogfish
Scymnodalatias sherwoodi	Sherwood dogfish
Scymnodon ringens	Knifetooth dogfish
Somniosus antarcticus	Southern sleeper shark
Somniosus longus	Frog shark
Somniosus microcephalus	Greenland shark
Somniosus pacificus	Pacific sleeper shark
Somniosus rostratus	Little sleeper shark
Sphyrna corona	Scalloped bonnethead
Sphyrna couardi	Whitefin hammerhead
Sphyrna gilberti	Carolina hammerhead
Sphyrna lewini	Scalloped hammerhead
Sphyrna media	Scoophead
Sphyrna mokarran	Great hammerhead
Sphyrna tiburo	Bonnethead
Sphyrna tudes	Smalleye hammerhead
Sphyrna zygaena	Smooth hammerhead
Squaliolus aliae	Smalleye pygmy shark
Squaliolus laticaudus	Spined pygmy shark
Squalus acanthias	Spiny dogfish
Squalus albifrons	Eastern highfin spurdog
Squalus altipinnis	Western highfin spurdog

Sharks by Scientific Name

Squalus blainville	Longnose spurdog
Squalus brevirostris	Japanese shortnose spurdog
Squalus bucephalus	Bighead spurdog
Squalus chloroculus	Greeneye spurdog
Squalus crassispinus	Fatspine spurdog
Squalus cubensis	Cuban dogfish
Squalus edmundsi	Edmund's spurdog
Squalus formosus	Taiwan spurdog
Squalus grahami	Eastern longnose spurdog
Squalus griffini	Northern spiny dogfish
Squalus hemipinnis	Indonesian shortsnout spurdog
Squalus japonicus	Japanese spurdog
Squalus lalannei	Seychelles spurdog
Squalus megalops	Shortnose spurdog
Squalus melanurus	Blacktailed spurdog
Squalus mitsukurii	Shortspine spurdog
Squalus montalbani	Indonesian greeneye spurdog
Squalus nasutus	Western longnose spurdog
Squalus notocaudatus	Bartail spurdog
Squalus rancureli	Cyrano spurdog
Squalus raoulensis	Kermadec spiny dogfish
Squalus suckleyi	Pacific spiny dogfish
Squatina aculeata	Sawback angelshark
Squatina africana	African angelshark
Squatina albipunctata	Eastern angelshark
Squatina argentina	Argentine angelshark
Squatina australis	Australian angelshark
Squatina caillieti	Cailliet's angelshark

Sharks by Scientific Name

Squatina californica	Pacific angelshark
Squatina dumeril	Atlantic angelshark
Squatina formosa	Taiwan angleshark
Squatina guggenheim	Angular angelshark
Squatina heteroptera	Disparate angelshark
Squatina japonica	Japanese angelshark
Squatina legnota	Indonesian angelshark
Squatina mexicana	Mexican angelshark
Squatina nebulosa	Clouded angelshark
Squatina occulta	Hidden angelshark
Squatina oculata	Smoothback angelshark
Squatina pseudocellata	Western angelshark
Squatina punctata	Angular angelshark
Squatina squatina	Angelshark
Squatina tergocellata	Ornate angelshark
Squatina tergocellatoides	Ocellated angelshark
Stegostoma fasciatum	Zebra shark
Sutorectus tentaculatus	Cobbler wobbegong
Triaenodon obesus	Whitetip reef shark
Triakis acutipinna	Sharpfin houndshark
Triakis maculata	Spotted houndshark
Triakis megalopterus	Sharptooth houndshark
Triakis scyllium	Banded houndshark
Triakis semifasciata	Leopard shark
Trigonognathus kabeyai	Viper dogfish
Zameus ichiharai	Japanese velvet dogfish
Zameus squamulosus	velvet dogfish

INDEX

Note: Photograph references are indicated by **boldface** type.

Endpaper images by Shutterstock/Stefan Pircher and Shutterstock/Andrea Izzotti, used under license.

© Gregory Skomal: pages 2, 8, 16 (bottom), 30, 31, 32 (bottom), 33 (top), 34 (all), 37, 38, 40, 41, 44 (all), 46, 47, 48 (all), 52, 54, 55, 57, 58 (left, inset), 59 (all), 61, 62, 63 (all), 65, 66 (bottom), 67 (top, middle), 69, 71, 72 (all), 73 (top), 75, 76 (top), 77, 78, 79, 83 (top left, top right, middle), 84, 85, 86 (top left, middle), 88 (all), 89 (all), 90 (top, middle left, bottom), 91, 93, 96, 98 (right), 99, 101, 102, 103, 106, 109, 118, 119, 121, 124, 125, 142, 143, 146, 148, 152, 159, 165, 166, 168, 169, 179, 188, and 191.

Shutterstock, images used under license, by frantisekhojdysz, pages 9 and 139; Michael Bogner, page 12; Fiona Ayerst; Michael Bogner, page 13; pages 14 and 67 (bottom); Ivan Smuk, page 19 (bottom); mj007, page 23; Brian Lasenby, page 32; Andrea Izzotti, page 45; cbpix, page 49; Matt9122, pages 51, 117, and 140; Elsa Hoffmann, page 66 (top); nicolas.voisin44, page 73 (bottom); A Cotton Photo, page 82; Fineart1, page 95; Havoc, page 100; Greg Amptman, pages 105 and 210; Kristina Vackova, page 112; Joost van Uffelen. page 114; kaschibo, pages 116, 141, and 19; Derek Heasley. page 161; Valeri Potapova, page 175; Nicolas.voisin44, page 198; Ethan Daniels, page 200; Rich Carey, page 204; DJ Mattaar, page 211.

© Amos Nachoum/SeaPics.com: page 1.
©iStockphoto.com/Tony Link Design: page 15.
© Greg Amptman, http://underseadiscoveries.com: pages 16 (top) and 192.
© Victoria Skomal Wilchinsky, medical & scientific illustrations, vwilchinsk@aol.com: pages 18, 19 (all), 28 (all), 29 (all).
© Ken Mostello, KMostello@expertek.com: pages 21, 24, 50, 53, 74, 83 (bottom), 90 (middle right), 92, 110, 129, 131, 142, 202, and 203.

© H. Wes Pratt, Jr/NOAA-NMFS: pages 33 (bottom), 58 (right top, right bottom), 86 (top right, bottom), 188, and 225.
© David Shogren: page 36.
© Nancy Kohler/Patricia Turner/NOAA-NMFS: page 60.
Courtesy of Woods Hole Oceanographic Institution: page 64 (middle and bottom).
© David McElroy: pages 68 and 76 (bottom).
© Tim Smith: page 86 (top middle).
© Wayne Davis: page 98 (left).
© Doug Perrine/SeaPics.com: pages 122 and 144 (bottom).
© Thomas Vignaud: page 128.
© Dave Ebert: pages 132, 133, and 134.
© Masa Ushioda/SeaPics.com: pages 144 (top) and 144 (top).
© Tim Voorheis/William Chaprales: page 158.
© Rudie Kuiter/SeaPics.com: pages 180, 186, and 209.
© George Benz/Ash Bullard: pages 184, 185 (all), and 212.
© Andy Murch/SeaPics.com: 194.
© James T. McKnight, mcknight4@comcast.net: page 199.
© Emory Kristof: page 206.
© David B. Fleetham/SeaPics.com: page 127.
© iStockphoto.com/Armando Villalta: page 132.
© John C. Lewis/SeaPics.com: page 135.
© Mark Conlin/SeaPics.com: page 137.
© Scott Michael/SeaPics.com: page 138.
© Mick McMurray/SeaPics.com: page 146.
© Franco Banfi/SeaPics.com: page 155.
© Bruce Rasner/SeaPics.com: page 171.
© David Shen/SeaPics.com: page 173.
© Stephen Kajiura/SeaPics.com: page 177.
© BorisPamikov/iStock: page 178.
© Jeremy Stafford-Deitsch/SeaPics.com: page 205.
© Makoto Kubo/e-Photography/SeaPics.com: page 208.
© iStockphoto.com/Cyro Pintos: page 209.
© Firefly Productions/Corbis: front cover
© iStockphoto.com/Jane: spine
© iStockphoto.com/Pete Collins: folios

ABOUT THE AUTHOR

Dr. Gregory Skomal is an accomplished marine biologist, underwater explorer, photographer, aquarist, and author. He has been a senior fisheries biologist with Massachusetts Marine Fisheries since 1987 and currently heads up the Massachusetts Shark Research Program (MSRP). He is also an adjunct professor at the University of Massachusetts School of Marine Science, and an adjunct scientist at the Woods Hole Oceanographic Institution in Woods Hole, Massachusetts. He holds a master's degree from the University of Rhode Island and a Ph.D. from Boston University.

Through the MSRP, Greg has been actively involved in the study of life history, ecology, and physiology of sharks. His shark research has spanned multiple fish habitats around the globe, taking him from the frigid waters of the Arctic Circle to coral reefs in the tropical central Pacific Ocean. Much of his current research centers on the use of acoustic telemetry, satellite-based technology, and animal-borne imaging to assess the physiological impacts of capture stress on the post-release survivorship and behavior of sharks.

He has written dozens of scientific research papers and has appeared in a number of film and television documentaries, including programs for National Geographic, Discovery Channel, ESPN, and numerous television networks. Although his research passion for the last thirty-three years has centered on sharks, he has been an avid aquarist for over thirty years, having written eleven books on aquarium keeping.

ABOUT CIDER MILL PRESS BOOK PUBLISHERS

Good ideas ripen with time. From seed to harvest, Cider Mill Press brings fine reading, information, and entertainment together between the covers of its creatively crafted books. Our Cider Mill bears fruit twice a year, publishing a new crop of titles each spring and fall.

Visit us on the Web at
www.cidermillpress.com
or write to us at
PO Box 454
12 Spring Street
Kennebunkport, Maine 04046

CIDER MILL
PRESS

BOOK
PUBLISHERS

ABOUT THE AUTHOR

Dr. Gregory Skomal is an accomplished marine biologist, underwater explorer, photographer, aquarist, and author. He has been a senior fisheries biologist with Massachusetts Marine Fisheries since 1987 and currently heads up the Massachusetts Shark Research Program (MSRP). He is also an adjunct professor at the University of Massachusetts School of Marine Science, and an adjunct scientist at the Woods Hole Oceanographic Institution in Woods Hole, Massachusetts. He holds a master's degree from the University of Rhode Island and a Ph.D. from Boston University.

Through the MSRP, Greg has been actively involved in the study of life history, ecology, and physiology of sharks. His shark research has spanned multiple fish habitats around the globe, taking him from the frigid waters of the Arctic Circle to coral reefs in the tropical central Pacific Ocean. Much of his current research centers on the use of acoustic telemetry, satellite-based technology, and animal-borne imaging to assess the physiological impacts of capture stress on the post-release survivorship and behavior of sharks.

He has written dozens of scientific research papers and has appeared in a number of film and television documentaries, including programs for National Geographic, Discovery Channel, ESPN, and numerous television networks. Although his research passion for the last thirty-three years has centered on sharks, he has been an avid aquarist for over thirty years, having written eleven books on aquarium keeping.

ABOUT CIDER MILL PRESS BOOK PUBLISHERS

Good ideas ripen with time. From seed to harvest, Cider Mill Press brings fine reading, information, and entertainment together between the covers of its creatively crafted books. Our Cider Mill bears fruit twice a year, publishing a new crop of titles each spring and fall.

Visit us on the Web at
www.cidermillpress.com
or write to us at
PO Box 454
12 Spring Street
Kennebunkport, Maine 04046

CIDER MILL PRESS

BOOK PUBLISHERS

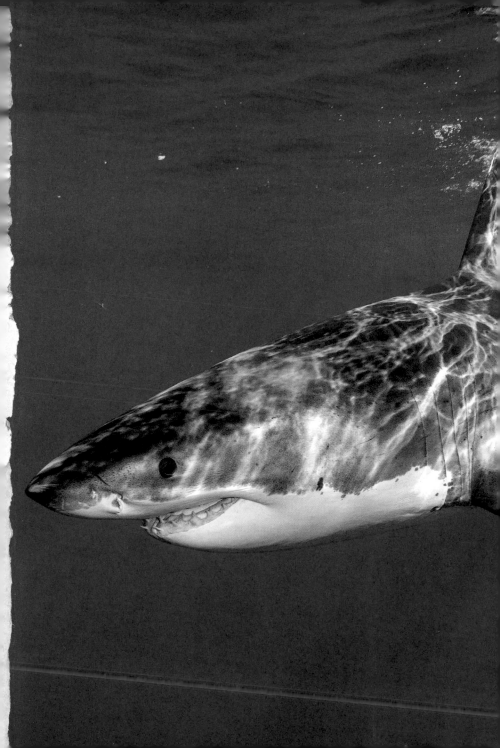